D0115069

6 Billion Others

Portraits of Humanity from Around the World

A Project by Yann Arthus-Bertrand in association with GoodPlanet
Realized by Sibylle d'Orgeval and Baptiste Rouget-Luchaire

ABRAMS, NEW YORK

CONTENTS

English-Language Edition:
Rebecca Kaplan, Editor
Shawn Dahl, Designer
Jules Thomson, Production Manager

Library of Congress Cataloging-in-Publication Data

Arthus-Bertrand, Yann.
 [6 milliards d'autres. English]
 6 billion others : portrait of humanity from around the world / by Yann Arthus-Bertrand.
 p. cm.
 ISBN 978-0-8109-8383-0
 1. Portrait photography. 2. Human beings. 3. Social values. 4. Interviews. 5. Arthus-Bertrand,
 Yann. I. Title. II. Title: Six billion others.
 TR680.A78513 2009
 779'.2—dc22

A project by Yann Arthus-Bertrand and the GoodPlanet Association
Directed by Sibylle d'Orgeval and Baptiste Rouget-Luchaire
Éditions de La Martinière

Editorial manager of the book for GoodPlanet: Emmanuelle Gachet / Editorial manager of the
book for Éditions de La Martinière: Isabelle Grison / Graphical design: Marion Laurens for
Research Studio / Layout: Audrey Hette / Cover: David Millet and Alban Courtine /

Translation from the French: Timothy Stroud

All the images in this book were taken by the 6 Billion Others team. They are either digital
photographs or extracts from videos.

Originally published in French under the title 6 milliards d'Autres by Éditions de La Martinière,
Paris, 2009.

Printed and bound in China
10 9 8 7 6 5 4 3 2 1

THE ART OF BOOKS SINCE 1949

115 West 18th Street
New York, NY 10011
www.abramsbooks.com

PREFACE

It all started when the helicopter I was using broke down one day in Mali. While waiting for the pilot, I spent an entire day talking with a man from the local village. He told me about his daily life, his hopes, and his fears: His only ambition was to feed his children. With my work for a magazine interrupted, I plunged into life's most basic concerns. He looked me straight in the eye and uttered no complaint, no demand, no resentment. I had set out to photograph the landscape and instead been captivated by the face and words of this man.

Afterward, flying over the planet to make the book *Earth from Above,* I often wondered what I could learn about the men and women I saw below me. I dreamt of being able to hear their words and comprehend what it is that unites us. Because, seen from above, the Earth appears like one immense expanse to be shared between us all. But as soon as I returned to the ground, the problems began. I found myself faced by bureaucratic rigidity in each country and, above all, by the reality of the borders established by man, the most symbolic of the difficulties that prevent us from living together.

We live in an incredible period. Everything moves at mad speed. I am sixty, and when I think of how my parents lived, I am astounded. Today we have available to us extraordinary communications tools: we can see and know everything, and the mass of information in circulation has never been so great. All that is very positive. However—and this is the irony—we still know very little about our neighbors. Today, the only action we can take is to move toward the Other. To understand him or her. Because in the battles we will have to fight in the future, whether against poverty or climatic change, it will not be possible for us to act alone. The time has passed when we were able to think only of ourselves or our close community. From now on, it will be impossible for us to ignore what it is that unites us all and the responsibilities that that entails.

There are more than 6 billion of us on the planet, and there will be no durable development if we do not manage to live together.

That is why 6 Billion Others is so close to my heart. I believe in this project because it concerns every one of us, and because it is a stimulus to act. I hope that in turn you will all want to take greater interest in those around you, listen to the Other, and will help to make 6 Billion Others live by adding your own testimony as an expression of the desire for us all to live together.

Yann Arthus-Bertrand

HUMANITY SEEN BY HUMANS

Like all sexed forms of life, humans live and die. They can only survive as a race, as humanity. The generations that follow one another are not content to fight the test of time through the transmission of their collective genetic inheritance alone: They use their mean, allotted timespan to enrich the wealth of questionings and comprehensions, emotions and revolts, creations and marvels that have been accumulated over the millennia and disseminated today among the six billion members of our species.

We have succeeded in building and developing humanity thanks to several flaws in nature; mutations, the fruits of chance, have equipped us with a hypertrophied brain that has allowed us to perfect language of unequalled subtlety. The combination of words and looks turn our interactions into creative events that give rise to an Us that is behaviorally infinitely richer than You and I as isolated individuals. By recognizing the Other as a contributor who enables me to be more than myself, I escape the preprogrammed destiny that the universe imposes on each of its elements. The fruit of the labor of human beings, humanity has become the matrix of each one of us: It is through humanity that we all metamorphose into people.

Represented here are a few of those others who are our source. They are happy to look us straight in the eye and to tell us the essential truths of their inner selves.

They have all apparently been enriched by their personal histories of social interaction. But they are rendered yet richer, though unwittingly, by all the links that their thoughts have forged with the thoughts of others, whether those others have lived at the same or a different moment in time. The individuals we see and hear have not always formulated those thoughts, but nonetheless, on thousands of occasions, they have been penetrated by them, the bearers of all the materials and secrets that contribute to the realization of each unique individual—the impermanent consequence of a genealogical tree that encompasses the whole of humanity. Listening to and watching these individuals, we understand that the course of their lives could have intertwined with that of our own.

They and we have a common obsession: the future. The future that does not exist, but which we, human beings, imagine will exist. Like us, they too would like to tame that future. The past is fixed, the present escapes us; only the future depends on us. Let us turn it into a new dawn.

Albert Jaquard

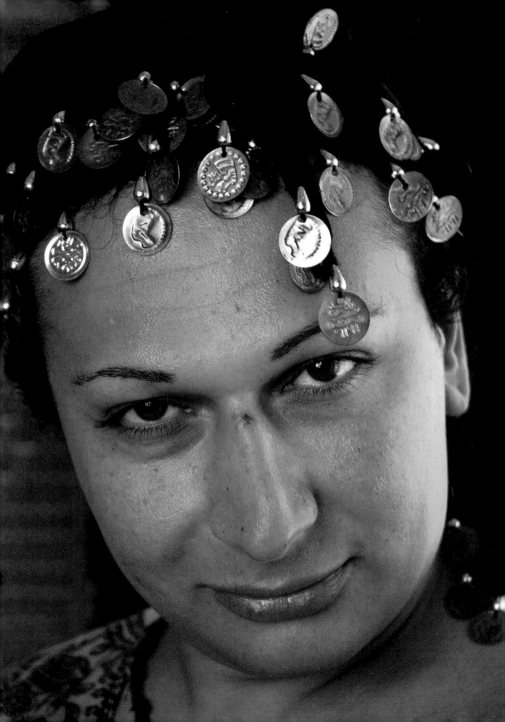

Hazel

Lives in Turkey

When I was little, I wanted to pass under a rainbow ... hoping to become a woman as quickly as possible.

Background / I was born in Istanbul in 1975, and I'm thirty-one years old. I was born under the sign of Aquarius. My family is from Erzincan; I'm an Alevi. I finished high school. I live with my family. In the context of Turkey and a cosmopolitan city like Istanbul, I can say that I'm the only transsexual who lives with her family and who does not prostitute herself. I made the choice to be with my family. My name is Hazel. Like everybody, I have plans for the future: My goal is to be a woman, to live like a woman; I'll probably never be a mother as I won't be able to give birth, that's not a luxury I enjoy. To satisfy my wish to be a woman, I'll only be able to give love and small gifts to the children of my girlfriends.

Memories / When I was in high school my grades were good, and I never skipped a day. But given my situation, my teachers told me, "Imagine a large basket of oranges; they're all good except for one that's rotten, and that orange is you. And you have to leave." I shall never forget it ... they expelled me from school. My school life was over, but I didn't give up, I passed my exams through a correspondence course. I finished high school, but it was like a knife wound that has injured me for life. My family got a hint of my sexual inclinations when I was three. I was immediately taken to see a psychiatrist and a urologist. The problem reappeared when I was at school; even my late teacher said to my mother, "Madam, your child is different, you should show him to someone." But my case has never been resolved; it still exists today, and I have become the person I am. I'm a woman trapped in a man's body.

Dreams as a child / When I was six or seven, I used to dream about wedding dresses. I used to put a balloon under my clothes and pretend I was giving birth without a cesarean. I took glass drops from a chandelier and made earrings out of them; I stole my sister's sanitary napkins and poured paint on them to pretend that I was having a period. I'm a great dreamer. Perhaps it was my dreams that have brought me this far. When I was little, I wanted to pass under a rainbow: In Turkey there is a sort of belief that says a man who passes under a rainbow will turn into a woman and vice versa. After every rain shower, I would wait for a rainbow to appear, then run like crazy hoping to become a woman as quickly as possible.

Family / I would love to have my own family: me, my partner, and our child. For me the family is a very special institution that I respect enormously, but I have ruled out this possibility for me. Why is it important for me to have my own family? Because it would be my family. In the family I come from, I loved my father very much—he's dead now—and my mother too, but I didn't get a proper childhood: There were violence, arguments, and alcohol, which is why I don't drink. Today what is important to me is my family—the family that belongs to me, to Hazel. I have always remained slightly apart from the family I grew up in.

Identity / Today I carry a blue identity card, a man's ID. In Turkey, officially I'm a man, and I always say I'm the most courageous. That's because I carry a blue ID, but in public I dress like a woman: That's a really radical attitude. You have to be a man in Turkey: Here you're either blue or pink, you support either the Fenerbahçe or Galatasaray soccer team, you're either black or white. There's never any middle ground; we live in a country with lots of problems. This isn't Iran, thank God, but I have suffered a great deal. If I get panic attacks, it's because of Turkey. In my opinion Turkey is a paradise for homosexuals as so far I've never been refused by a man. When a man prefers me to a woman, like me, he is in fact homosexual by nature. In Turkey, gay men are "transsexualized" because it is a very Manichean country: You're either a woman or a man—you're obliged to choose. I'm a transsexual who was originally a homosexual.

Love / Men in Turkey don't know what love is; they understand nothing of the female spirit. I'm not only talking about myself—I have plenty of married girlfriends who constantly tell me, "In Turkey, women simply mean sex, and sex means screwing." It's not true! To me women mean sensuality, the gentleness of physical harmony, the tenderness of a look. It's like a serenade!

Womanliness / I think I'm more womanly than a woman. It's impossible for me to behave like a real woman! Our behavior is more feminine than a woman's, maybe a little exaggerated. We often have lots of expectations, whether to do with love or understanding; we're very sensitive and sentimental. I find that men are pretty unhappy

with their lives, but I've never liked women! I don't like them at all! They're my worst enemy. I don't like women, I tell that to everyone. I am The Woman, that's all!

Hardship/Identity / Being a transsexual in Turkey is a story in itself. Every time I put a skirt on, it made me miserable. Me, Hazel, who has suffered such harsh winters, I have never allowed myself to be defeated. There have been days when I've gone down like the Titanic, but I've always resurfaced because that's who I am! There's no other Hazel!

Femininity/Identity / On one hand I feel like a woman, but on the other I have the body of a man, and I live with that contradiction. The last time someone criticized me, I asked her, "And you, the last time you went to the toilet, did you ask yourself if you were going to pee standing up or sitting down? Do you have to go through that? I do!" When I told her that, she understood.

Discrimination / No discrimination? That will never happen ... it's nothing but a dream, it's purely theoretical, it will never happen in Turkey. I haven't suffered just because of my sexual choices but also because of my cultural identity, because Alevis aren't much appreciated in this country. I've also been insulted because of my character, because stupid people don't suffer psycho-neurotic problems like I do; they can't think. I have an IQ of 120, but I'm forever searching for stability. The other day I bumped into a man I know, and straightaway he started to ask me questions about sex. I said to him, "Hazel doesn't equal 'sex!' Talk to me about the world! Talk to me about Ataturk, the Bosporus, about fish, about anything! But don't talk to me about sex! Enough, I can't take it anymore!"

The meaning of life / I want to reply to this question with a song: "I was like waves, then I calmed myself, I ran after you and then I tired myself out, I have loved thousand of beauties but last I loved you."

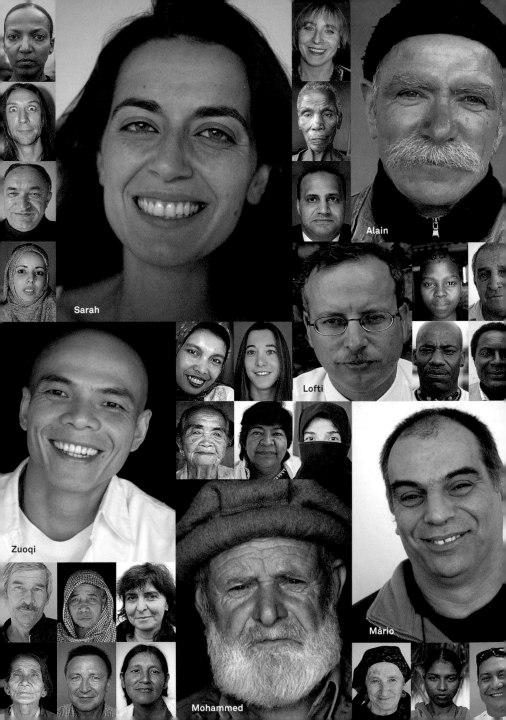

Sarah

Alain

Lofti

Zuoqi

Mário

Mohammed

WHAT WERE YOUR CHILDHOOD DREAMS?

Zuoqi / *Lives in Yunnan, China*
There's one dream I've had ever since I was very small, a very profound dream, in which I have a special power that allows me to be someone like Superman! And I still have this dream today!

Alain / *Lives in France*
I remember when we were kids, I had friends whose parents had an attic. There was a bed there, and we spent all day in the attic with an old geography atlas. We made the bed into a plane. We'd all jump on it and take off, taking the atlas with us. We'd travel to South America, we'd fly over Amazonia, we'd go to Canada. We made up stories flying everywhere while staying in the attic.

Màrio / *Lives in Portugal*
My dream was to be a pilot. Why? I don't know. To be in the air, to live in the air, to be a pilot. Perhaps that's why now I'm a taxi driver. I like to joke that I'm at the controls of my plane and that I have to look after my passengers. That was the dream I had as a boy.

Mohammed / *Lives in Pakistan*
My teacher, Hashmat Ullah Khan at Gilgit High School no. 1, asked all of his students, "What do you want to be?" Some said a doctor, others something else. I remember that I said I wanted to become the nation's father.

Lofti / *Lives in Tunisia*
When you ask youngsters what they dream of becoming, one will dream of being a doctor, another an engineer, another a pilot ... whereas we, at a certain moment, left these personal dreams behind us and began to think of the general good.

Sarah / *Lives in Tel Aviv, Israel*
At the age of thirteen or fourteen I went to see my parents and told them, "I want to change the world." When I told them that, I was thinking of going into politics. It seems to me that since then I've kept that desire to bring change, to change the world.

My dream was to be a pilot. ... Perhaps that's why now I'm a taxi driver.

Bekkram / *Lives in Chechnya*

What can a child who lives in a town in ruins dream about? Probably, back then, I was already dreaming about the rebirth of our town. I remember how, before the first war, we used to go with my parents to go into the parks and visit every Christmas tree. We never missed a fountain that was opened in our town. All that I still remember. After that war, of course, I missed all that very much, and I began to dream about life before the war.

Kunping / *Lives in Yunnan, China*

My dream, when I was a child, was to fight in a war because in all the Chinese films there was a war.

Leni / *Lives in Ohio*

I wanted to be a soldier. My family served this country when we were thought of as Negroes, with all the bad things that African Americans suffered. My family experienced slavery, but it always served this country. My family, particularly during and after slavery, during the Jim Crow period, thought that it was important to contribute to the good of the country so that later no one could say that you hadn't done anything. So, it was always important to us. That's why I wanted to be a soldier, which is what I became.

Mohamed / *Lives in Mali*

All my dreams came true. They all came true. I have a sword, a knife, a leather sack—any man's pride—the big bubu in today's style, and the indigo turban. Even as I speak, I have the sword, bag, and knife.

Gloria Julia / *Lives in Buenos Aires, Argentina*

When I was young I used to dream something incredible that later came true . . . it was to be a dancer. I always wanted to dance, to dance on a stage, with lights and an audience. It's wonderful for me that I was able to make this dream come true. I'm sixty years old, and I still dance on stage. And it makes me really happy!

Clément / *Lives in Benin*

When I was little my first goal was to have a field. If a woman knows that you have enough to eat, she'll come and marry you. If she marries you, God will give you something—children, life— that's what our forefathers taught us. If you don't work, no woman will come. It's the food she sees that makes her come. Then God will give you animals, a sheep, a young goat, eggs, and children. If you don't do that, you won't have anything.

All my dreams came true. They all came true.

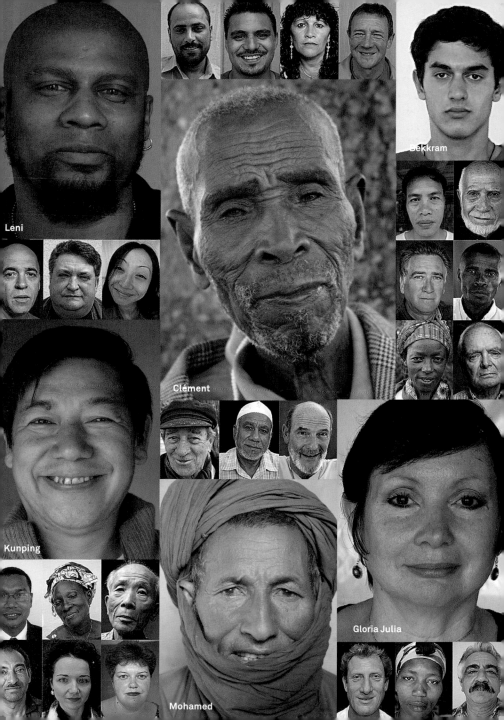

Leni

Clément

Dekkram

Kunping

Gloria Julia

Mohamed

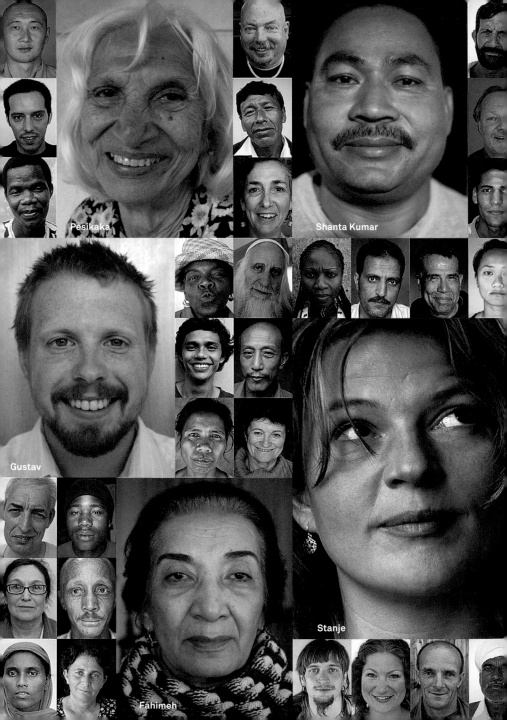

Pesikaka

Shanta Kumar

Gustav

Stanje

Fahimeh

Pesikaka / *Lives in Tamil Nadu, India*
I had the same dream as all women: getting married and having children. I wanted to have a thousand boys so we could have our own cricket team! It was sort of absurd, now I think back on it! Because, you know, Bombay is the home of cricket.

Fahimeh / *Lives in Iran*
One of my dreams was to become a boy, because boys have more freedom. They could play and jump. We girls were told that we shouldn't jump, as our virginity would be lost. I didn't understand either how part of a girl could be lost or why I couldn't jump. I saw my brothers quite happy: They could relieve themselves there in the village, no problem, while we girls had to go and visit the toilets. Girls always have to protect themselves; sometimes we were told Houlou (peach) so we would close our mouths, so that they wouldn't be too open; we didn't have the right to look people in the eye, or the right to laugh out loud.

Stanje / *Lives in The Netherlands*
There's a story they tell. I'll tell it to you since it's very funny, especially today. Amsterdam has many prostitutes, who work behind windows. The women are very pretty. That's what they do all day. The question I asked my mom, when I was little, was, "Who are those women? What do they do?" My mom would say, "Those women keep the city's love." It's a noble way to describe a whore. But I asked, "What do they do there?" "They hug lonely people and get money." "That's why they have nice dresses?" "Yes, that's why." I thought, "I want to do that. I want have nice dresses and hug men."

Gustav / *Lives in Sweden*
When I was young I used to dream of being a "chainsaw driver" and a tractor driver; that's what I thought was really cool. I had a paper chainsaw, and I'd walk about the house cutting everything up. I also considered being a carpenter. But what's really strange about all that is that I'm really clumsy with my hands. I've broken nearly everything I've bought at Ikea.

Shanta Kumar / *Lives in Nepal*
When I was at school—at that time my mother was still alive—at lunchtime all my friends would go to eat their meal, while I, on the day the airplane used to arrive, I'd go and lie down in the courtyard to watch it. And there I used to wonder how it could fly, so I went to look for books with pictures of airplanes, and I told myself that one day I'd be a pilot. And then sometimes cars would come too. I used to watch them as well, and I wondered how they worked. When one of them stopped, I used to go close to see it better, and I said to myself that one day I'd drive them too. That was really my big ambition. Sadly, owing to the death of my mother, I wasn't able to have a good education.

Hun / *Lives in Cambodia*
When I was little all I wanted to do was study, nothing else.

Vassili / *Lives in Siberia, Russia*
My childhood dream was to see what things were like in other countries, because I was born in Siberia, and the summer there is very short. I wanted to go where it was very hot, somewhere in Africa, for example. Every time I read a story, it would carry me away. I was attracted by places where there was no winter. In Siberia the winter is very long; the cold lasts for almost six months, whereas summer is just two or three months long. That's why I dreamed of hot places, but my dream never came true.

Putali / *Lives in Nepal*
I would've loved to go abroad. Living here, we just live to eat. And time passes by. I had this dream, but nobody came to take me away. That's it.

Lucie / *Lives in France*
At the age of eight or nine I was given a globe. It was a globe that was also a bedside light. I was fascinated by it: When I saw the countries I had the feeling I was there. There was one in particular: Here I was here in France, at the tip of the continent, and on the other side was Vladivostok in Russia. I said to myself, "Right, when I'm big I'll go to Russia, to Vladivostok." That desire stayed with me always, always, until the day I went. I was twenty-six or twenty-seven, I'd been sent to work in the Caucasus, in Chechnya. One holiday, I took the Transsiberian with my husband as far as Irkutsk, in the footsteps of Michael Strogoff. I thought to myself, "Right, now either I go south to Uzbekistan or I go to Vladivostok." Then I thought, "Lucie, don't be an idiot, learn from others. You know very well that going to a place you've dreamed about means that the dream will be destroyed, and you'll end up disappointed. It's better to hang onto your dream." Particularly since I know that Vladivostok is nothing special. So I decided to drop the idea and not go there. I preferred to keep my childhood dream. However, I got halfway there, and it's as though I'd really done it.

One dream I've had since I was very small … I have a special power that allows me to be like Superman. I still have this dream today.

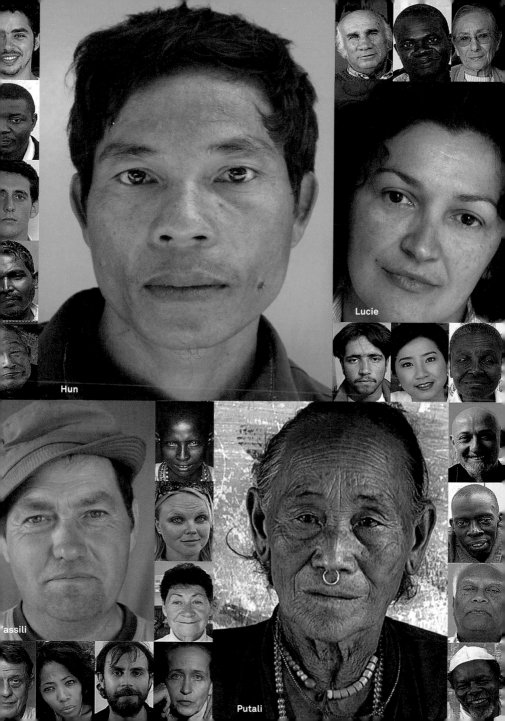

Lucie

Hun

assili

Putali

Mark

Lives in Moscow, Russia

In each car there were four KGB agents, and they never left us.

Background / My name's Mark, I'm twenty-six. I'm married. I was born in the village of Ust-Nera in Yakutsk. I work as a television correspondent.

Memories / While our father was in prison, we used to live with my mother in the town of Kirzhach, in the region of Vladimir. It was more like a village of small houses with gardens, vegetable patches . . . and our neighbors had cows. I was very young, but I remember two houses nearby. My mother and I were on very good terms with the people who lived in these two houses, but to all the others we were "enemies of the people." In fact, it's very surprising for a Russian village, because now that I travel a great deal around Russia, I have to say that most people don't give a damn about labels! What's important to them is what you're really like. But that was the Soviet era, when power was abused: People were very afraid, and in order not to stain their reputations, they preferred not to talk to us. The only people who liked and helped us were the old women in these two houses. Later, my father was released: It was 1984. He was a doctor and wanted to find work in the medical field but was unable to practice in the village where we lived just because he was an enemy of the people. Instead, he found work in a village twenty-five miles away. He bought a motorcycle and every morning left for work, sometimes taking me with him. Of course, people don't care if the doctor is an enemy of the people or not. The only important thing is whether or not he's good at his job! That was why he was liked, and why I was liked too. These are the most striking memories I have of when I used to visit the sick with my father. One of my strong early memories—something that I think is weird for foreigners to understand—is the endless number of cars that used to follow us around. In each car there were four KGB agents, and they never left us. We even had a family game, which

we called Lose the Shadow. They were always following us, and my parents used to hide forbidden books, like those by Solzhenitsyn, in the clothes I wore as a baby.

Love / Love is something wonderful because more often than not you don't know where the love comes from that you feel for someone you don't know at all. A person appears, and all of a sudden you fall in love. But when you become a father, it's not so much love you feel in your soul as a sense of responsibility for your children, and perhaps a certain fear. Often this fear is unfounded, and you understand straight-away that you're going to protect them from all possible problems and misfortunes. However, you're already just about at a breaking point . . . you're worried: Anxiety's the right word, almost panic.

Sacrificing your life / Of course I'm always ready to give up my life for my wife and daughter. They're the most important element in my life. I can't imagine living without them.

Work / It can happen that a journalist has to drop his camera and microphone and try to rescue someone in a burning car. I'm exaggerating of course, but this dilemma can literally tear a man apart. On the one hand you want to film, and on the other you want to help—I think that the right thing to do is to help. But it's not a conflict, in reality it's another story.

Freedom / In my opinion the worst thing about this country is how the freedom of the press is affected. It's not even censorship, which of course exists; it's self-censorship. When a man wants to say something but has reason to worry about himself: "It'd probably be better if I didn't say that, and, it'd be better if I were to say this differently . . ."

Changing country / The system of government in this country is difficult to describe. If it's a democracy, it's certainly a controlled one. I feel there's a real danger that our political régime could head toward a dictatorship, and that's very sad. On the other hand, I can't name a single political system that I like. As for politics, I think that it's impossible for a politician to remain honest and upright.

What is saddest of all is that the majority is content with dictatorship.

The future of your country / What is saddest of all is that the majority is happy with dictatorship. I'm sure that in years to come the majority of Russians will have a better standard of living: Salaries will rise, hospitals will be built … but there'll be a minority for whom life will worsen.

Hardship / It's difficult to say which is the most difficult. It's Chechnya and the North Caucasus; I've been there eight times already. I love that place and the people are extraordinary. Compared with Russians or those people who live in Russia, I prefer the Chechens. Because there, if you knock at a door late at night in a remote little village, you'll be given food and drink and a bed, because if they don't they'll feel ashamed. But if you go just fifty miles from Moscow and knock at a door, at best the man who opens it will be drunk and have a rifle in his hand! And he'll shout at you. It's worrying, because those people who have such wonderful personal qualities are doomed to a miserable existence and their lives are permanently in danger.

Progress / Twenty years ago, my parents used to communicate with many friends abroad. One day a foreigner told them of a new invention, in which someone fed a sheet of paper into a box in one place, and, in another country, that same sheet of paper came out of another box! He said it was a means of communication and called it a fax machine. My parents didn't believe it!

Message / It's a dream for many to be able to say something to the population of the world. I hope that people don't forget their sense of humor. A sad person is morally handicapped. The more joyful we are, the better it is!

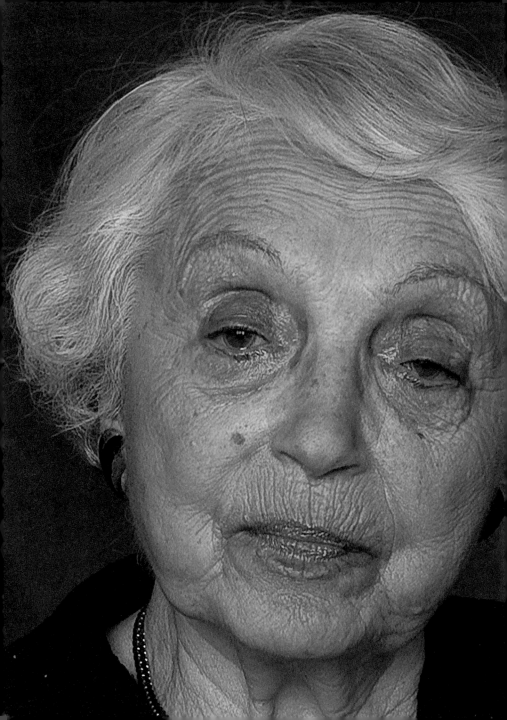

Moussia

Lives in Tel Aviv, Israel

You're my daughter, therefore I love you, but I didn't want you.

Background/ My name is Moussia and I'm eighty-six years old. I was born in Russia, but I spent my youth in France. I'm married and have two children. In 1960 we left for Israel following a brutal decision, one taken in just half an hour, the purpose of which was to find, above all for me, a place where we could live well. If you want me to tell you something personal: I have an indestructible faith in life!

Learned from your parents / I had a very unhappy and lonely childhood. If I had to define myself, I'd say that I'm a loner, and that all my strength comes from that fact: When I have difficulties, I don't drag anyone else in. But with my parents, my childhood was very hard: I was rejected as a daughter, and so I swore to myself when I was young never to make anyone else suffer what I was going through. This oath has been the driving force of my existence, my moral support.

Memories / My most difficult moment was when I was five years old. We had just fled from Russia, where the revolution was in full swing. We had ended up in Paris. I didn't know my parents: My father and mother were doctors and had been sent away, one to the Caucasus and the other to Siberia. I was raised by my grandparents, and it was. . . . I knew heaven on earth, until I was five years old. When I came to Paris, I only spoke a few words of French. In my relationship with my parents, I said, "Monsieur Papa, Madame Maman." I thought that these were their names. They said, "Stop doing that. We say daddy and mommy. Daddy and Mommy are first names. That's it." One day, as I was out with mom on a street in Paris—it was Rue Réaumur—I looked at mom, like a child who'd learned to love and be loved, and said, "Maman, why don't you love me?" My mother answered, "You're my daughter, therefore I love you, but I didn't want you." In front of that revelation, in front of that woman's courage, in front of that truth, it was over: I was made.

Family / A family is a process of creation. It is not something you are given. You create it with sorrow and with joy, but above all you create it without resentment. My son was born during the war, and that is how I wanted it to be. In such circumstances, when life is denied to you, I had to give life to be able to believe in it again. In spite of everything, in spite of the war—we were students, without anything to our names—I had to have a child!

Handing on / What I passed on to my children is firstly to know how to look and know how to listen. There are so many things to hear and see. And then, they are three, four essential things. Do not lie—not because it's immoral, but because it's complicated. There is so much to remember, and in the end, you get in trouble. Second, do not envy—I instilled this through games—because there is no limit. You can lose yourself through envy. You don't know who you are or what you want. That's one thing. And then, don't be a coward, don't hurt anyone, with respect to yourself. Be forthright, whatever might result. Do you think that might be something to do with my Russian background? "It's destiny! It's written!" . . . I don't know.

Work / I didn't have time to use my skills! I wanted to be a children's doctor. But there was the war. . . . I'm Jewish, and so studying was forbidden to me, everything was forbidden, life was forbidden. But, in spite of it all, I studied literature at the Sorbonne so I could have a diploma. . . . During the war, when I was in Switzerland, I worked in the camps, cleaned toilets, waited tables, looked after children, and all that. Later, I attended Piaget's courses on psychology in Geneva. There I was able to make one of my greatest dreams come true, that of being in contact with children and of helping to rekindle a little spark of joy in them. I wasn't able to study in France any longer. I had to make a choice, it was either my husband's engineering studies or my own.

Love / I'll try and be brief! We were both refugees. My husband had managed to cross through Germany and Poland. After getting out of prison, I reached Switzerland from France through Saint-Julien in the mountains. How can you not believe in destiny? Soaked by the same rain, at practically the same hour, my husband crossed the border from Germany into Switzerland and me from France into Switzerland! And a month later, at the same hour, we met in a camp. At the same time, the same day, in the same rain. He told me about his research projects, his plans for building a center. At twenty-one he had lost everything, and all of a sudden, at the age of twenty-five, a woman popped up in his life. We were good friends who did menial jobs together. And one day I shared a sardine with him that was supposed to last me three days. I asked myself, "Why him? Why share this sardine with him?" And I realized that I

loved him. Well, I arranged to meet him, I plucked up my courage and said to him, "You know, I love you." D'you know what he answered? "What a disaster!" I fainted. There we are! To be continued in the next episode! Now we've been married for more than sixty-five years!

Violence / As far as I'm concerned, violence is our civilization's greatest failing. I believe wholeheartedly that there is something divine in human beings! That may seem crazy to a non-believer, but sometimes I catch a glimmer, a revelation, of this quality in someone's expression. Several times I came across Nazis during my escape. Each time the man was alone, and I'd look him straight in the eye and say, "Listen, I'm Jewish, do what you want with me." And on each occasion he was so amazed that he let me pass. That didn't happen just once or twice but often, and you know, my eyes don't shine ultraviolet rays that dissolve the other's will. The first thing I look at in a person is the eyes because they don't lie. Whatever you do—smile, grimace, blow your cheeks out—the eyes tell the whole story, and that's what I focus on.

Forgiveness / I've experienced every type of suffering there is. For example, my sister, who's ten years younger than me, was very disturbed by the war. I don't understand her. In spite of all my husband's efforts to draw closer to her, she fluctuates between love and hate. Occasionally love will get the upper hand for a short while, but it'll soon be swamped once again by a frightening hate. Probably because she had to do without her mother. I think I understand how she suffers But she's made me suffer terribly, wickedly, and knowingly. The last time we saw one another was in court, when she was accusing me of having robbed her, of having opened a safe. Pure invention, but it gave her ammunition for her hate. I told myself that if she's like that, she must be really suffering, so I tried to find out what the matter was, saying, "It's absurd, we've not got time for this." She answered that she didn't want to know me anymore. Not forgive? There's nothing to forgive. Something dreadful is going on inside her. Forgive what? I prefer to follow my own path, but the pain remains. I've been to therapy and analyzed myself many times … but if she knocked at my door today or telephoned me, good Lord, what a reception I'd give her! And the same for the Nazis, there's nothing to forgive. It's too immense, too incomprehensible. Who am I to judge you and to say, "I forgive you?" It's ridiculous … ridiculous.

I've seen pretty much everything in my life, but I try to stay positive.

Happiness / Frankly, I don't know what happiness is. I see it as though it were on the other side of a mirror: I'm happy for those I care about, for those I've helped, but there's something inside of me that's too tough to pierce. I've never known happy periods, only moments ... the birth of my children, for example. However, I was never an overly devoted mother. I let them have as much freedom as possible. I wanted them to be strong, modest, generous. I haven't known happy periods because the past is too painful. How can I put it? The great, the terrible problem is: Why have my loved ones departed? Why am I still here? Complete happiness isn't possible. Proof of that is given by the fact that even when my husband tells me he's happy, he has the most awful expression on his face. ... Yes, I'm happy, because we were saved from a horrible death and because our children are thriving.

Fear / My greatest fear? I'm not afraid as long as I can face up to things. I've seen fear, I've seen death, and I'm not afraid. No, really! What I'm afraid of is being crippled, of being in charge of others, but death, I've made a deal with it. The traditional image of death makes me angry: That human carcass carrying a scythe. No! Death is good, death is sweet and true; it tells the world what we have been. Look at the faces of the dead: They're peaceful, at rest. Finally, the suffering is over! Why make them seem horrible? No, I'm not scared of death.

Dreams today / My dream now is just to keep going. I know that life has to come to an end ... tomorrow, the day after, but I'm not afraid. It's already extraordinary that my husband and I are still active at eighty-six. But from now on, we're just watching on. We keep smiling, despite the difficulties; we watch our children and their families. They're good and modest, like we wanted them. What more could we ask for?

Crying / I often cry in secret, each time our son and his children go back to America. But they're internal tears, hidden tears that no one gets to see. When our son went off to war, we sent him off with broad smiles and a big "good-bye" from the window. We didn't cry.

Lessons of life / I've learnt everything from my children. For example, how to turn your life into a catastrophe. How to—it's the custom these days—make money. But they're so miserable, these millionaires! I've learned to be happy with what I have and not to envy others. Really, it makes me happy to see my neighbors' luxury. One day in Paris, about sixty years ago, I went into Cartier's jewelry shop and said, "You have such wonderful things! Would you allow me just to have a look? I can't buy anything, I just want to look." Well, the jeweler showed me some extraordinarily valuable pieces. I went out full of joy, made rich by all I had seen, without being able to own it.

Difficult to say / There's nothing that can't be said, even if it's painful, even if it's ugly, when there're things that are impossible to understand. ... I've seen pretty much everything in my life, but I try to stay positive—there's always something to do, something to improve. Above all, don't make judgments. Try to understand others. Time will reveal so many things; with time you learn so much that if you dwell on small-minded, petty thoughts, Heavens above, you'll fritter away your life. Move on, children, move on, you understand me, you've been treated badly, you've been left, you've been tricked—OK, move on and find the best you can. There's always something to be done.

The meaning of life / The meaning of life? Oh well, everything in my life! Just for today: not to cause others trouble. To maintain my dignity and to be respected. That's it, that's my aim in life: To keep my dignity. To be able to say to myself, "Right, I've done some damn stupid things in my time, but it hasn't been so bad." And in the end I laugh about them. My husband was supposed to receive an enormous sum of money from the Germans. We said, "No!" The money can't make amends for the atrocities. Make a profit out of our families who were sent to the gas ovens? No way! I'm not accusing those others who did; we've even helped some to win compensation. But, to me, to actually accept it is quite incomprehensible.

Message / First of all, look at each other, look yourselves in the eyes. Not just he's white, he's black, he's good-looking, he's ugly, he's tall, he's short, he's round-shouldered, and so on. Look each other deep in the eyes. There you'll see yourself as well as the other.

Talk / Ten years ago I never spoke about myself. Never. My mouth was zipped. But later I realized how little people know about the past. I thought that it was a duty I had to those who died, and I wrote a book that was translated into Hebrew. The message has to be handed on so that they didn't die for nothing. Talk is precious; on the other hand, silence is dangerous, in your personal life, as part of a couple, and with children. Some will say, "That old dear bores us stiff!" All the same, it's true: As long as you talk about the dead, they're still alive.

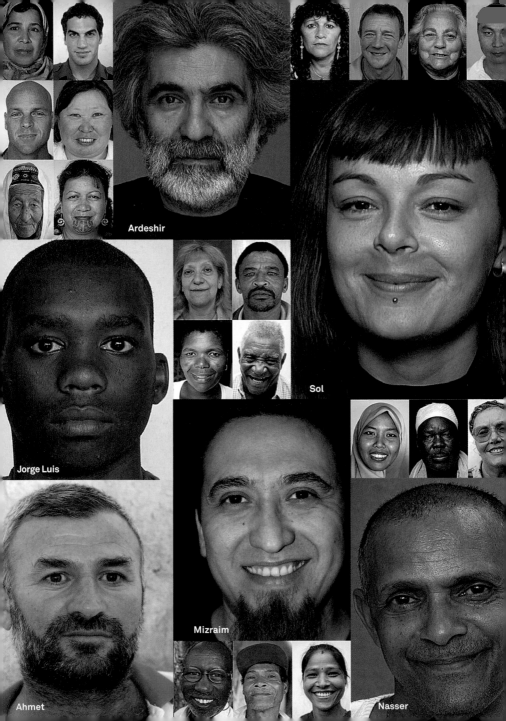

Ardeshir

Sol

Jorge Luis

Mizraim

Ahmet

Nasser

WHAT IS YOUR EARLIEST MEMORY?

Mizraim / *Lives in Mexico*
I remember a bed, and I remember being in my mom's arms. I don't remember her face well, but I remember her body, her chest, her arms, her white skin. I remember her smell well. That's my first memory of the world; that's my mother.

Sol / *Lives in Spain*
I remember a day when my father had told me off, though I don't know why, and I went to the kitchen so I could talk about it to the dog. I remember I was sitting on the floor with the dog in my arms, and I told him what had happened between me and my father. And I really felt that the dog was listening to me and taking an interest, and when I finished telling him, hey presto!, my problem had disappeared.

Jorge Luis / *Lives in Cuba*
My favorite memory, let me think ... ah yes! It was in elementary school, the first time a girl kissed me. I'd spent about two hours convincing her. Imagine: I was nine or ten. I said, "Come on, cutie, a little kiss!" She gave me a tiny kiss. I went home so happy! Oh my God! I went home so happy. A little kiss! It was a happy time.

Ardeshir / *Lives in Italy*
The memory that comes to mind was in a Turkish bath. I was a small boy surrounded by naked women, each with a different smell. I was two or three.

Nasser / *Lives in South Africa*
I remember something: I used to take off all my clothes and give them away. Then I'd go back home naked. I must've been about two then.

The first kiss I gave anyone in grade school.

Ahmet / *Lives in Turkey*
I always used to arrive late at school because I had to look after the animals. Every morning I told the teacher, "It's because of the animals." One day I knocked at the door, but there was no one there. Knowing I'd be late, the teacher wanted to play a trick on me and told the other pupils to hide in the next classroom to make me think that I was the first to arrive. I went in but there was nobody there. I sat down on a seat, and all of a sudden I saw the whole class enter behind the teacher, and they clapped for me for arriving first.

WHAT IS YOUR EARLIEST MEMORY?

Jasper / *Lives in The Netherlands*
I think that one of my earliest memories was when I began to skip nursery school—I didn't like it at all. As young as I was, I thought it was a complete waste of time. I always thought so. I began to skip the courses when I was about four or five. Is it possible? That's one of my earliest real memories. I was already searching for freedom; I didn't like being boxed in.

Ruihe / *Lives in Shanghai, China*
My first memory goes back to when I was four or five, when my dad was teaching me to write and draw. After each day's work, he would tell me what he'd spent the day doing through pictures, and it was from that moment that I began to like painting.

Octav / *Lives in Romania*
I remember very well the moment I started to write a diary. I saw my grandfather writing his diary in the evenings, so one day I jumped into a little pedal car and began to write a diary too. I wrote, "It's midday . . ." and then I didn't know what else to write. Then my grandmother called me to eat lunch, and I felt relieved because I didn't know what else to put down.

Ramashani / *Lives in Tanzania*
Once, when I was out hunting with my dog, I met a leopard. I took out my bow and aimed between his eyes; the leopard fell out of the tree. I called to one of my grandfathers and asked him what type of animal it was, and he said, "Stay away from that animal, child, it's dangerous!"

Mamadou / *Lives in Mali*
What was it like when we were kids? We had worked in the fields up until harvest time. And when that time came, the crickets ravaged the fields. These things didn't happen recently. We were young, you know. It's hard to forget something like that. You can't forget something that deprived you of food. You never forget it.

Bibi Fida / *Lives in Pakistan*
My father was in China for five or six years. I helped my mom. I worked hard. We had little flour for bread, and my mom used all we had. Every day, I'd put some aside so that when there was none left, I'd tell my mom we had a reserve, and she was very happy. I thought we'd be rich if we worked hard.

Mohammed / *Lives in Pakistan*
There is one thing that happened during my childhood that I've never forgotten. When I was very young my mother died. I remember when my mother was actually dying. She took me in her arms and said to me, "Oh God, I'm not afraid of dying, but I'm afraid that a stepmother will take my place and hit you." That's what I remember. She died as she took me in her arms.

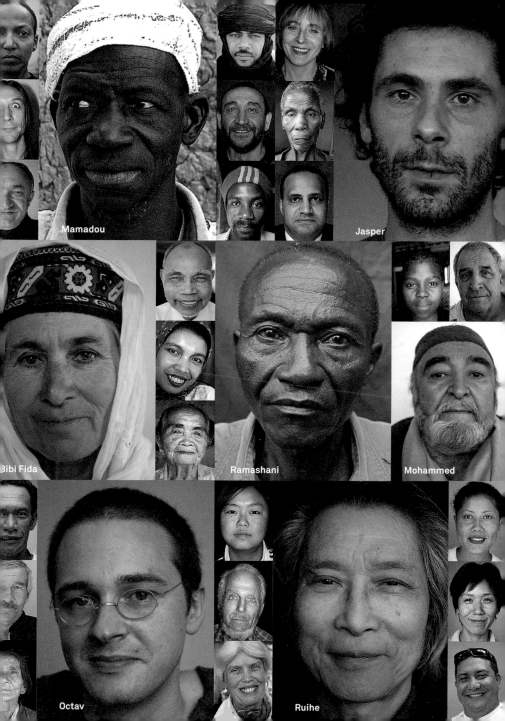

Mamadou

Jasper

Bibi Fida

Ramashani

Mohammed

Octav

Ruihe

Mian

José Bertrand

Ereman

Arvo

Carlos

Pierre-André

Mian / *Lives in France*
My mother was never very tender; I think it's also very common in the relationship between Chinese parents and children. We never used to say, "I love you" or "I'm thinking of you." And as for cuddling, it never happened. I remember when I was very little, I used to say to myself, "I want to be ill." Because when I was sick, maman would be very, very kind to me and tell me stories and give me cuddles.

José Bertrand / *Lives in Spain*
My first memory when I was little was the first thrashing I was given by my dad because I had "homosexual tendencies." He had given me a cardboard horse, which I exchanged for a doll. That's something I'll never forget.

Carlos / *Lives in Bolivia*
When I was four, I lived far from the town; there were almost no vehicles that passed that way. One day I saw a van. Inside there was a small fair-haired boy. He stuck his tongue out at me. I must've been three or four. He stuck his tongue out, and I just stood there and stared in surprise. Then I started to think, "Why is he sticking his tongue out at me? Is it because my clothes are dirty? Is it because my skin is brown, and he's white?" I don't know why he did it! I've never forgotten this childhood scene.

Ereman / *Lives in Papua New Guinea*
I remember the day I saw white men for the first time. They were Australians. I was a bit scared, to tell the truth! They looked so different! But after, I understood that they were just like us. Today I laugh when I think I was afraid of Australians.

Pierre-André / *Lives in France*
My oldest memory is absolutely horrible. It was a gun fight in a tram during the war. I was barely four years old, and that's when I saw what death was. A young girl spoke to me. Moments later, I heard gunfire. She fell beside me, a bullet through her temple. I really realized what violence was at barely four years old. That was a bad start to life.

Arvo / *Lives in Finland*
I was three-and-a-half when the war started in March 1939; that's my first childhood memory. I was seated on a sleigh pulled by a horse. Facing backward, I saw that our houses were being set on fire; we went a few miles to the railway station where we were supposed to leave on the train. It was a cold, starry night. Bodies of soldiers were grouped together all along the station wall, and that was the first time I saw dead bodies, dead soldiers—I saw their frozen faces. It was this event that made me a pacifist.

WHAT IS YOUR EARLIEST MEMORY?

Salah / *Lives in Egypt*
I was about six. As soon as we were able to go down and play in the road or at the club, we played at war, at soldiers and thieves. Our generation was raised with the memories of the 1973 war. That influenced us a lot.

Cris / *Lives in Romania*
My mother said that the stork brought babies. I wanted a little brother who I could torture. It's not that I wanted company. I needed my parent to channel their attention elsewhere. I wanted a sibling, and mom said it was the stork's duty. I went to the lake and talked to one. Then my mom surprised me; she granted my wish. And the stork came.

Bing / *Lives in China*
When I was five, I remember, one afternoon my father came back to the house with the tractor and there was a birth-control task force at the house. They wanted to abort my pregnant mother. I was very angry; they shouldn't have done that. There were a dozen or so controllers who wanted to take her away by force.

Hans / *Lives in Ohio*
When my younger brother was born, I remember my father coming back from the hospital and coming into the room, lifting me up above his head, and saying, "You have a baby brother!" He was so happy. It is a very physical memory of being lifted up.

Maria / *Lives in Moscow, Russia*
One of my earliest memories is of when my father carried me on his shoulders. I was wearing a dress with daisies on it, I was very small, and I had a ridiculous white hat on my head. There's nothing tangible in the memory, just the sensation of my father's shoulders, that I was higher than everything else, and that my dad was very proud of me.

Romina / *Lives in Buenos Aires, Argentina*
Yes, I remember that on Fridays and Saturdays I slept at my grandparents' house because I wanted to—I liked it. My grandmother would wake me up with a cup of milky coffee. It was very foamy; I've never tasted another like hers. You know, when someone does something, and no one else can do it as well. That's what I like most about my childhood. Drinking milky coffee on Saturday morning in bed with my grandfather, because we sent my grandmother to sleep in the living room, and I spent the night with him. And my grandmother would arrive every Saturday morning with the milky coffee, and my granddad, sitting beside me, reading his paper. And the taste of that coffee, it was . . . I don't know.

Salah

Romina

Bing

Maria

Cris

Hans

Nukhbat

Lives in Pakistan

People ask, where is your family, why are you living alone?

Background / My name is Nukhbat, and I am a Pakistani. I belong to Lahore, I was born and bred here. I completed my education in the same city, and I'm working here.

Work / I must say very clearly that my work is my first love. And I cannot live without it. I mean, I cannot be free, I cannot just sit at home and watch TV and, you know, just eat and sleep and go out with friends. No. That is always part of life, but my work is my first love. It's my worship. It's something which I really—I really survive with. And, it is the biggest survival element for me, I must say. When I was a child, I was studying in school, and even when I was in my college, I never even thought that I would step out and would do a job, and would be an independent woman. I never thought of it. The reason was, obviously, the upbringing in my family, because my father never liked practical women. He always used to abuse them, and he never let my mother work. When I completed my graduation, one day, my mother came to me and she said, "Because your father is not doing anything, he is completely jobless, we have to run the house, and you're the oldest one and you have completed your graduation now, so you have to step up and you have to do something. You have to work." So at that time I started working.

First memory / My first memory . . . the very first time when I was slapped by my father. Yeah. I never forget that.

Violence / I am the only daughter of my parents. I have three brothers, and I'm the eldest one. People normally think here that because you are the only daughter you get more care and love from your parents, but this was not the case. I was beaten by my father, several times, even when I was in my college—I was a grown-up girl. My father used to beat me, and I mean, he used to put me on a chair, tie my hands behind the

chair, and start slapping me continuously. And I had very long hair, and he always, you know, used to grab me by my hair, and then he used to throw me from one corner to another of the house, or sometimes even on the streets. So it was which made me more isolated. It was something which—which killed me from inside. I was not able to grow myself, I was not able to smile, I was not able to be happy. I never knew what happiness is. I was always a very, very depressive and aggressive person. But the interesting thing was that all the aggression was inside me, and I never, ever took it out in front of anybody, but whenever I was alone, in any corner of my house, I always used to harm myself. I always used to cut myself. I always used to cry a lot. But not in front of anybody, not even in front of my mother. So this is what violence did to me. I always wanted to kill myself.

Success in life / I remember, when I left the house, and I was standing in the office of that legal aid cell, my mother was also there and my father was also there. My mother asked me a question, and she said, "Are you sure you are going to live alone?" Because she knew that I am absolutely alone. I don't have any support behind me. I don't have any friends, or anybody who's going to support me. I never had any money at that time. I never had any job. I even never had any clothes, you know. The only thing I was wearing was with me, of my own. The only thing that I had at that time was my original document, my degrees—that's it. … I said very firmly that, yes, I am going to live alone and I am going to manage alone. I will study, I will work, I'll make my own life.

Tradition / If your family, if one of your family members—they're just, you know, trying to spoil you. This is what is actually happening in our society. This is something which is happening in every other house. Sometimes the father, sometimes the brother, sometimes the mother, everybody is doing something, which actually the new generation does not accept. And they tried to, you know, protest, or whenever they try to step up, they are no more—the family does not accept it. The family, they don't like. My father, he never, ever thought that his only daughter would do this to him. And what I did was simply that I just gave him my decision that I don't want to live under one roof with you, because of the way you are. This was something very, very difficult. This is something very taboo in our society. Nobody accepts this fact, whenever somebody gets to hear that I'm living alone. People ask, where is your family, why are you living alone? They really do not accept that I left my house because I had some clashes with my father. The way he was, the way he was treating my mother, the way he was treating me, the way he was treating my brothers—this was something which I did not accept. And I stepped up. And if you call it rebelling, yes, I'm a rebellious-natured person. And if you call it to live for your own self, or to recognize yourself, and to make your own self, yes, I did so. And I'm actually very satisfied on that.

Taboo / At that time, my father said, "She actually left the house because she had some affair with somebody, and she wanted to, you know, get married and she wanted to get some freedom. And that's why she left the house, because otherwise, alone, she cannot do this. She doesn't have the courage. I believe that she doesn't have the courage." So this is what not only my father thinks, but I think ninety percent of the people of the society. If they get to hear the news that, yes, I am living alone and I had some clashes with my father, they won't accept. They would definitively, automatically, you know, go to that aspect. That because in this society, the people can never accept that a woman can do this alone, on her own.

Happy / There are different moments. When I look back on my life, there are different moments, which were really happy. But … I must say that those moments came when I stood out of my house. Because inside, when I was living with my family, there was nothing, there was absolutely nothing. I mean, I don't have any pleasant memory of my childhood, of my young age, when I was getting an education. So I never knew what happiness was, to be very frank. But, when I started a life of my own and I started realizing my own self, and when I got my first achievement of getting admission into film school—which was very hard because the level was very high and the test was very tough, and there was a big number of people who appeared at the test, so that was something very difficult, and I achieved it on my own—that was something which I really remember, and it was the most happiest moment of my life.

God / God has brought in my life free will. The gift, which was given to me, being a human being, from God is free will, which I really enjoy. I possess and I'm really thankful to God for giving me this gift, this absolute gift, which actually makes me live every day.

Fear / The greatest one is not to make angry your God. Because I'm not a religious person—if I sound like this, no, I'm not, I'm not a religious person—I'm more spiritual, kind of. And, I don't offer prayers. I mean, the way … I am Muslim, I was born Muslim, but to me, my religion is humanity. Yes, I personally strongly believe in it. But, there is one God, which I really possess. I love Him. And He loves me, too. Yes. And I really fear that if He gets angry with me, everything will go wrong.

Family / And family, I must say, is not that important to me. I don't think I will be able to create my own family one day, because whenever I think of a relationship, I think of getting married with someone, creating my own family, it's something very hard to digest, yes, because of the experiences I had of my own family, the relationship experience with my own parents. It's something very, very hard for me.

Khedeyja Toua

Lives in Mali

For me, family is a tribe … like the branches of a tree.

Background / I'm Khedeyja. Toua is the first name I'm most commonly known by.

Memories / One day when I was small I was playing in the rain. I went outside the encampment. It was raining and raining. I went to sleep in the Ténéré far from the encampment. Everyone looked for me in the encampment. Something, a djinn, came and woke me from my sleep and "transported" me, led me close to the camp, pointing out the fire. This "thing" said to me, "There's the encampment." When I arrived there, someone picked me up in his arms and took me to my mother. It's a memory I shall never lose.

Family / For me, family is a tribe of people sharing blood, with whom I live, whether they're black or white. Mine are the branches of a tree. I'm here today (at the Desert Festival, Timbuktu) to be part of my era. If your kids and those close to you evolve in an era, you must do the same. A set of siblings is for me the sign of plenitude, happiness, and gratitude to life. When you're close to all those who love you, you lack nothing to be happy in this life. To be surrounded by one's people, all races mixed, to bring them together, that is what life in our time should focus on. We all have a moral obligation toward our sons, and the sons of our brothers are also our sons.

Handing on / A very good education in kindness so that children are at ease through their behavior, education, and patience, so that they are able to travel together with anyone they meet on their path. These are the values that, for me, are of the greatest worth: having the dignity required to make you the ideal companion. That is what I wish to pass on to my children. I could also bequeath something material to them, but I prefer to instill good manners in them. Because by teaching your children politeness, kindness, and dignity, they'll be able to be a good companion to anyone. A

person without good manners can only be linked to others through mutual interest. And, when tired, those others will end up abandoning the first. Because even when you demonstrate patience toward an unkind person—for one day, two days, or years—just for love, that patience will end up reaching its limits. By teaching your children politeness ... they'll be able to be a good companion to anyone.

Living better than your parents / I have noted there has been a change in times. There have been many changes. When I became an adult, with what that implies—like having an open mind—a young man could never look at someone older than him. But now, after all, "the end of time" has come. All these changes and upheavals are inevitable and a natural feature of life. Life will end with what it began; nobody can do anything about that. Nothing remains the same. But we give thanks to God, and we're satisfied with what He decides for us. For our only duty is to obey God and to accept.

Ordeal / What I find most painful today is the disunity between brothers. It's not like it used to be. That's what hurts most. Do you hear, my child? That's the complete truth! In the past every brother used to "live securely" in the heart of others. Today it's like sifting, and that really causes me pain.

Happiness / What makes me happy most of all is life, because I love life, and I know that it can only be built with life itself. I want to be rich, and I know that the greatest treasure is the strong bond of kinship that brothers preserve between them. That's what fills me with joy, because that's what I was born into.

Love / Love is unequalled. He whose gaze you met and whom you knew immediately that you loved, even if he is not of any use to you—you're certain that his heart is better than all others. You're certain that he will not compare your heart to anyone else's for anything in the world. And he'll also let you know that love can never be founded on anything material. It is God who created love, and it is He who sees to it that two people love one another.

Different from the others / I can't enter anybody else's thoughts. It sometimes happens to me that I don't know my own mind, let alone that of others. Sometimes my mind gets separated from my soul. My thinking changes all the time, by force of circumstance and due to divine grace. Given that, how do you expect me to enter into the soul of another to know what it contains?

Laughing / My thoughts and acts prevent me from enjoying a real belly laugh. Each time I have a thought and I laugh, the "Other World" comes to mind. But after all, when someone does something that does not dishonor him, he may enjoy a moderate laugh. There cannot be any other type of laugh for someone who thinks in his heart of hearts.

Freedom / There is no absurdity for God. I know that He is omnipotent because He created us, and in creating us, He made us evolve on this earth, and He has the power to give the possibility to each free human being to do what he wants, in this life and in the life to come; that simplifies His creation for Himself.

The meaning of life / Life means no more to me than the arrival and passing of a morning shadow. I see nothing more in it than the fact that God created it: The day He stops it, it will disappear. To my mind—I don't claim that it's the same for every-one—now that God has created it, He's left it to continue the way it wants.

I prefer to instill good manners in them. Because by teaching your children politeness, kindness, and dignity, they'll be able to be a good companion to anyone.

Laya

Inoussou Asséréou

Vladimir

Marina

WHAT DOES FAMILY MEAN TO YOU?

Laya / *Lives in Mali*
Family is everything here. Family is the union of people almost having the same parents, people of the same line, the same blood. The extended family is the grandparents, the aunt, the uncle, nephews. Family means union, solidarity, mutual respect; we all complement one another. That's what family represents here. That's why until now families have always remained together, but now I see that families are gradually becoming less united because individuals are tending to leave to form their own nuclear family: husband, wife, and children.

Vladimir / *Lives in Moscow, Russia*
Family is this place, this little love nest, where you come to rest. Man is made to develop his love for others, and family is the training ground. Living selfishly isn't interesting; you're like a black light bulb that illuminates no one.

Marina / *Lives in Moscow, Russia*
It is like a law of nature: You must marry, have a family. I did. If we're robots in the future, not needing a family, and if I'm reincarnated, I won't have one. It all depends on the social context.

Inoussou Asséréou / *Lives in Benin*
At a certain age, you need a family. It's fundamental. I defy every kind of authority: You need a family. He who has no family breeds the culture of individualism. If you don't deal with contradictions in your family, you can't help others bloom. Otherwise we'll be like objects. We'll coexist, but we won't exist. We mustn't just live together, we have to share our feelings, we have to share our joys.

> # Family means union, solidarity, mutual respect; we all complement one another.

Rachid / *Lives in Egypt*
Family is not only the father and mother. I think it is a large community. We spent our childhood in places where there was a huge mix of cousins, aunts, mothers, and the neighbors. When we were young, if a child cried, the first woman walking by would give it her breast. Milk or not, it was a pacifier. We suckled—it was reassuring. Women's love is important to us. We owe them the joy of being held and having tasted all possible breasts.

Aron / *Lives in Hong Kong, China*
There are eighty people in my family, and we all live in the same building. Family is very important! I grew up with my cousins, uncles and aunts, brothers and sisters. There were forty bedrooms in my house, and we used to go into them just as though they were ours. What a benefit! You get to have close connections with people outside of your immediate sphere, and that gives you a different outlook on life.

Leyla / *Lives in Turkey*
For me, family is harmony between the parents. Love isn't primordial, although it's better. They must be complementary; they must love each other; and at night in the house, the meals must take place with joy. They must be able to laugh together. Alas, with my parents, I didn't have that. As soon as he got home, my father dove into reading his newspapers. My sensible mother always, I learned after her death, wrote, "talk to me" in the margins, addressing her husband. The absence of communication caused her suffering. It really saddened me.

Ebba / *Lives in France*
My family is large and complex. My folks divorced when I was little. My father married a woman who had three children. My mom remarried and had a daughter. So I have six brothers and sisters: three are from different parents, one half-sister, and two brothers have the same parents as me. But I con-sider them to be my siblings. We are a family, a family chosen with the heart. Those who have no blood relation to me are introduced as siblings. We grew up together—that's important.

Ismet / *Lives in Turkey*
I'd like to change the members of my family. I would like to exchange my brothers for more tolerant ones. That's it. Actually, I'd like to exchange my entire family.

Penelope / *Lives in Australia*
Family has the capacity to influence you very deeply, very early, and perma-nently, for both good and bad. And I think … it does in fact influence you both well and badly. I know that the behavior of my father when he left my mother, when I was a teenager, and blamed me for it, has scarred me for life. I've never gotten over it—see, I can't even talk about it. I've never got-ten over it. My mother was falling apart. My mother did fall apart, and she died. But I'll never get over my father telling me, the day he told me he was leaving, that it was my fault. So I think family has the capacity to do very good things for you, but they have the capacity to hurt you in the most permanent way because it comes from someone … whom you love. Even if you don't like them, you love them, and what they say hurts deeply.

Aron

Leyla

Rachid

Ebba

Ismet

Nikolaï

Carolyn

Penelope

Carolyn / *Lives in Great Britain*
My own close family means love, affection, laughing, tolerance, kindness. I suppose a certain amount of stress, and learning a lot about myself. I think I see my children as my teacher—not maybe so much me as their teacher. And I think to be married is a really interesting journey, a really interesting journey in tolerance and acceptance. And healing, I think. For me, marriage has been a lot about healing. My extended family—I think that I have come to understand that one does not need to love one's brothers and sisters. One has them, and they will always be there, but you don't have to love them. And parents—I'm a parent myself. But my view of my own parents is . . . I believe I chose them. I believe I have things to still learn from them. And I think my life has been about coming to that place of completely accepting them, as they are—which lets me accept myself. So I think it's a very big learning curve, family.

Nikolaï / *Lives in Ukraine*
I don't scorn this notion, but I don't think it is vital. Everyone dies alone and lives according to their choices. Everyone lives their lives despite affection for our family or the love felt for someone. It is impossible to understand the feelings of a loved one like our own. We can base it on what we feel, but we remain alone. Man is alone. Who knows better than Sartre, whom I am paraphrasing, "Man lives alone whatever his family's place in his life."

One does not need to love one's brothers and sisters.

Nathalie / *Lives in Hong Kong, China*
What was I deprived of? I think I missed the joy of family gatherings. Families spend Sundays together, they take walks, they do things—but not my family. I've always lived with my dad. I rarely see my mom. So sometimes on Sundays, my mom takes me for a walk. Ever since I was five years old, my parents haven't been in the same place. When I graduated, we all posed for a photo. I was very happy. I have a photo with my parents. I finally have a family portrait. What I missed the most ever since I was very young, and until I got my diploma, was not having a single photo. Sorry.

Margie / *Lives in Texas*
I think that my husband and I were both so involved in our careers, and we always said, "Oh, we'll have children some day! We'll have children some day!" And then all of a sudden, it was like, "Well, I think we're too old to have children now." And we have so many friends that don't have children. I think that life in this country, in the United States, is very different from life in other countries, where you have a lot of help in the house and a lot of help raising the children. And you have a lot of relatives that live near you. My cousin's in Spain—they've got their grandparents that come and pick the children up after school. Well, that does not exist here. Here everybody fends for themselves, and you have to hire people to do that. So I think it's very difficult to have a very high-level career—both of you have a very high-level career—and also have a family. And we just made a choice, that there were too many other things in life that we want to do. We can't have everything!

Élisabeth / *Lives in Antarctica*
For me the family doesn't mean very much. I have an unusual family: I'm an only child, and I have no child myself. My husband is also an only child and he doesn't have a child either. In fact, it's not really very important because my friends are my family.

Having a child would be harmful to my lifestyle. That's a selfish thing to say, but I take full responsibility for it.

Cristina / *Lives in Italy*
I don't want to have children. First, it's an enormous responsibility, and it's a life-long commitment. That sort of thing scares me. It's forever. Second, because I'm a bit selfish. I am selfish to a certain point because of the little money I possess and global situations, international and national, that prevent me from starting a family. Enough with sacrifices! Having a child would be harmful to my lifestyle. That's a selfish thing to say, but I take full responsibility for it. Finally, the idea of all that responsibility is really frightening. It's not true to think that at thirty or forty a son is totally independent. If something happens to him—he dies in an accident or goes to prison—me, the mother, I'd feel responsible.

Nathalie

Cristina

Margie

Élisabeth

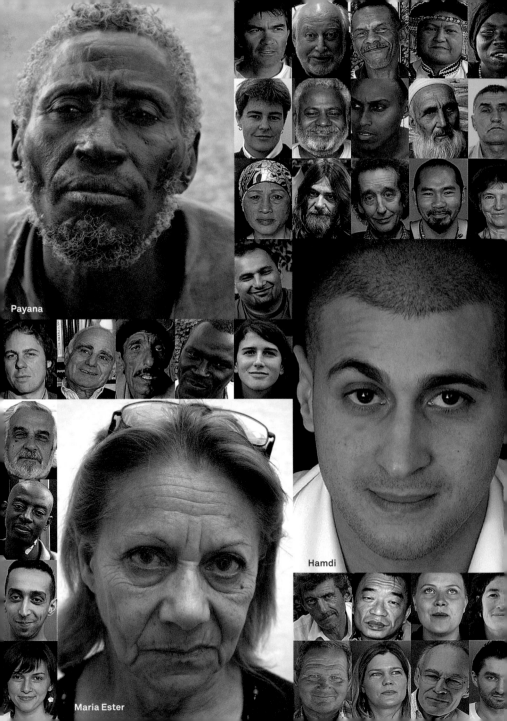

Payana

Hamdi

Maria Ester

Payana / *Lives in Ethiopia*

What made me so poor was having so many children. Life exhausted me. I'm old and sick; I will die soon. My children all left. Like I said, that's what caused all our problems. You drink, come home totally drunk, you don't know she is ovulating, and you get her pregnant due to a lack of education. That's where progress got us: Women buy contraceptive pills and get pregnant when they want to. They dress and live better. We were ignorant—that's why I'm so poor.

Maria Ester / *Lives in Buenos Aires, Argentina*

Family is everything. It gives rhythm to my life. They get angry because sometimes I'm demanding; I'm on their backs. I try to protect them. It's not good, but I can't help myself. I really can't. Even if they're adults, I must protect my fellow people, otherwise I don't feel useful.

I must protect my fellow people, otherwise I don't feel useful.

Hamdi / *Lives in France*

My parents supported me until I came of age. Then I left, and now I must help them. That's our way. We Arabs must give back what we got. You must. You mustn't go and slam the door shut. No way. That's how we were raised. Some are different. In my group some people think, "I'm eighteen, I'm an adult. I'll slam the door and forget it all." That's not our way. We like to come back to our roots.

Claude

Lives in France

People who know where they come from have no difficulty in knowing where they're going.

Background / I have an unusual background for Brittany. I have never known who my mother was. Thirteen days after my birth, I arrived here in the Arrée Hills. When I was younger I went round the world. By chance, I came here to work in the nuclear power station, and it was then that I discovered my roots. I'm coming on seventy years old.

Memories / My most important memories date back to when I was very young. I absorbed the values of nature. Culture, which I practice today, entered me from the ground. I didn't learn about it through my mind. It passed from my feet to my heart, before reaching my right-side brain, the brain that deals with emotions and imagination. Next comes the left-side brain, language and knowledge, that we have to put into practice. The right-side brain contains the stories I was told when I was young, with the forest, meadows, elements, nature, etc. The left-side brain is what you use at school. To me, school is about technique. Perhaps because of too much technique, one day I completely lost it. In trying to do too well, I found myself back at square one. When you fail, you use the right-side brain to get out of the situation. And that's what saved me. That's how I became a storyteller. I'd passed the age of being able to accumulate knowledge. My left-side brain was useless to me. All that was left were the stories and legendary characters I'd learned about in my childhood. Much later I made use of all that in my stories. And I realized that it was an exceptional means of communication.

Love / My wife. That all happened a bit strangely. I was a globetrotter; I wasn't cut out for marriage. I had lots of short-lived affairs, and I was happy with that. Then, when I arrived here, I fell in love with the countryside and environment. But very quickly I

understood there were rules to be obeyed. A local told me, "If you want to live here, you have to protect yourself." I replied, "Oh yeah?" He asked, "Are you married?" And I said, "No, why?" "It's rule number one here. Life here's so harsh that there have to be two of you to stand it." So I fixed that and started a family. It's not that simple for someone to accept to start a family with me because when you have a background like mine, you lug around all kinds of complexes. Now we've come a long way together. What brought us closest to one another was the hardship: getting back on our feet when we had lost everything. It wasn't so much a physical love as the defense of a cause, a way of life, a common faith.

Family / If it's not possible for families to live together, how do you expect society to manage? Tolerance begins at home. When you work the land as a family, people ask, "How do you manage it? Three generations!" It's become a way of renouncing the family, but today society can see what it's lacking. We're bound together, we're a bit of a clan, but perhaps clans are necessary. We deal with our misfortunes ourselves, we don't need a guru. Our solidarity prevents us from becoming dependent.

Occupation / It was the locals who told us, "But you're storytellers!" So we began to tell stories by drawing on what we'd heard as children. It wasn't difficult to find the material, we didn't need to do a whole lot of literary research, it was already inside us. One day the storyteller Alain Le Goff told me, "Listen, this place is just perfect for you: You're living in an area of legends." And it was true, we were fortunate enough to be right there in a region with a history of legends. So we began to talk to the locals, and we soon saw that in the process we were creating a special relationship with them. They started by saying, "Do you take us for country bumpkins, digging out those old Breton stories?" But in the end we were successful. Not only did it bring us closer to them, but we saw that the people actually needed it. It's a form of anchorage, roots. To begin with they're astonished, then they become enthusiastic, and finally they say it was something they really needed. When you're telling a story, it's not the story itself that's so important, it's the way you tell it. A story can't touch everyone at the same time. But, I'm pretty certain, by telling it, it awakens the capacity in the listener to dream. And dreaming is good for you. As soon as I help anyone to dream, I've succeeded.

Succeeding in life / "Legendotherapy"—this came out of a meeting held to discuss the future of tourism in the region. I was explaining my approach and saying that, when narrating legends, I was able to make people appreciate the rain that was falling on them, the mud they were walking through, I could make them drop their masks, let it all out! And one of the organizers cried out, "But that's legendotherapy!" And I answered, "Thank you, sir! Please allow me to use that word, I've been looking for it

for years." That's what it's all about: allowing people to loosen up, to communicate, talk to one another. Each person can respond to it the way they want.

Nature / I use dowsing to analyze sites, places of worship, and burial. Then I work on the perceptions it gives me. Sensations are essential. We've lost the habit of walking barefoot, of being in contact with the soil. We're no longer in contact. People in the past felt, in a rather physical manner, the quality of places. Today we've cut ourselves off from these perceptions because we're scared of our feet getting cold. We've surrounded ourselves with artifice to the point that we no longer have any natural means of contact. That's why, in our little group, we work around places of worship. We try to understand why a cult was in one place rather than another, and we note that any place there's a monument the place has strong vibes. It may not be inhabited, but it will be crossed by natural forces, converging waves, intersecting waves, etc. I don't read or write, I listen. I'd love to be able to read the great book of nature fluently because it contains everything. I can do without dusty libraries, just as long as I work with my intuitions and unconscious mind. I'm always receiving signals that allow me to say, "Something's going to happen." What we're missing is the code to understand it all. Our ancestors knew better than us how to read the book of nature—telluric, cosmic, lunar, and solar.

Joy / My greatest joy is this little kid here. The day my daughter told me, in tears, that she was pregnant, I said, "Listen, this baby is the best news in the world you could give me!" It was like an explosion of joy. My second joy was when he started to speak Breton. One day he took my hand to ask me to stand with him two abreast, like they do at school, and he said it in Breton: daw, daw. It was great. Breton, my mothertongue. Whatever people say, that it's going to die out, that it's a minority language, etc.—it's my language! The fact that this little kid said daw, daw to me as he took my hand is a sign that my language is not dead. Indeed, it's a sign of transition.

Handing on / The handing down of culture is essential. Someone who doesn't know where he comes from will have difficulty in knowing where he's going. It's within the family circle that values are transmitted best. When our ancestors were unable to do hard work, they looked after the children. It was them who handed on the knowledge and actions that were essential to life. A whole heritage was passed on, an intangible treasure trove. When things are passed down unconsciously, they're there for good. The task of the grandparents is to tell stories to their grandchildren. Not those lifeless stories you find in books, but our own histories. Why do so many people today research their, what do you call it, genealogy? They scour through archives to find out their backgrounds and traditions. People who know where they come from have no difficulty in knowing where they're going.

SilminabadepasPanga

Mohamed Elmehdi

Haoyu

Laurence

Olivier

WHAT HAVE YOU PASSED ON TO YOUR CHILDREN?

Olivier / *Lives in France*
You have to take upon yourself your children's education, what you want to pass on to and share with your children. It's easy to say but not easy to do because kids today are educated principally by society, not by us. I have Tibetan children who've become much more Western than I would've liked. I tried to make them absorb the values I had learned by living in the Himalayas for twenty years. We had to go through an adoption crisis, then a teenage crisis, before we could consider the matter from all sides, and for them to spend an entire year in their original community, where they lived until they were adopted at the age of three. To rediscover their culture and its values, they had to spend a year in the orphanage I found them in.

Mohamed Elmehdi / *Lives in Mali*
What I want for my children is that they consider their traditional family education and not sink into modernism. Fight the evil like others do, for you cannot be left behind. In a world that is evolving, you must absolutely evolve with modernism, keeping what is important to us: tradition, honor, prestige, and the Tuareg identity.

Haoyu / *Lives in Shanghai, China*
My parents and grandparents taught me nothing, and I find that there isn't much to learn from them. They're like all ordinary Chinese parents. You have to work hard at school, stay on the right path, become someone worthy, things like that. There's nothing to be learned from that. There's a great deal you can learn just in the society you grow up in. You get swindled, you get tricked: That's the kind of thing you learn from.

Laurence / *Lives in Great Britain*
Well, difficult question. What I learned from my parents is to unlearn. That is, I rebelled against all the bourgeois, old-fashioned principles that they instilled in me. My generation is one of the first to have rebelled. So it was hard for me.

Silminabadepas Panga / *Lives in Burkina Faso*
The past chiefs taught us of the chief's life. Today I advise my children. I teach them our customs: If they accept them, good; if not, too bad for them. I teach this to them since my ancestors taught me.

Jeannette / *Lives in Rwanda*

The negative side of what I retained from my parents' education is the lack of education they perpetuated with their children. They didn't have the means to raise them. It's the only negative point. Back then, it was good to have a lot of children. I later observed there were negative sides.

In the village the girls aren't taught anything. It's all for the boys.

Tomas / *Lives in Bolivia*

I'd like my children to move up in life. I work to give them a better future. My children study. They mustn't be like me. They must feel free. I don't want them to suffer as I did by working in the mine, or elsewhere, and obeying someone. I don't want that. They must count on and be responsible for themselves—depend on no one.

Naba Manega / *Lives in Burkina Faso*

When the white people came, school was a good thing—because thanks to it, they all drove cars, unlike our children. This is why I put my kids in school.

Baba / *Lives in Mali*

Children are rebels, they're rebels I tell you. When they go off to school, they stray away a little from family education, they learn the education of the school, the street, the education you Westerners give them—that's to say, Western civilization, television, radio, newspapers. They see all that in there, and they get interested, and bit by bit they stray away from us. That's the problem.

You Ze / *Lives in Yunnan, China*

In the village we don't leave anything to girls. Everything goes to the boys. The boys get the house and all the objects for daily life. When we leave the family, we have nothing.

Irina / *Lives in Tunisia*

As a mother, I'd like to pass something on to my daughter. She'll be twenty soon. I'd like to teach her to have the strength to do what she wants. Not to abandon her principles. I believe that you mustn't give up on yourself, your interests, your desires, or your dreams for someone else. I did that, and such sacrifices are pointless. As for my son, I tried to teach him kindness and to respect women. I think these are essential characteristics for a man to have.

Tomas

Naba Manege

You Ze

Irina

Jeannette

Baba

Duka

Borika

Ravshan

Zahra

Duka / *Lives in Ethiopia*
When I was little, my father wanted to teach me so many things. But I didn't listen. His advice was, "When you're married, clean the stable and the sheep-fold, make the coffee; clean the house, and work the land. If you do all that, your husband won't beat you." If I do all that my husband treats me well, and my children will help me when I get old. Otherwise he beats me. As I get older, I see that my father gave me good advice.

Carlos / *Lives in Bolivia*
Values. I believe that it's essential that they love life, more than anything in the world. And just as we encourage them to love life, we hope they will abhor death, violence, lying, and discrimination. We believe that life is to be shared, it's something communal.

Ravshan / *Lives in Kyrgyestan*
In our age, it's important to remain humane. It's a cruel age, to be sure—there are the rich and the poor. Our life is difficult, people are aggressive, there are lots of aggressive people. The most important thing is to stay humane.

Zahra / *Lives in the Palestinian Territories*
In these conditions it's just not possible. I educate my child to respect love and mankind. Every time that I arrive at a checkpoint in my town, I hear that a woman has been attacked and lost her twins, or that a young man has been killed at the checkpoint because they forbade him to pass through. When I try to teach them to love mankind and people, they reply, "How do you expect us to love people when they treat us differently?" I always tell my kids that there is a difference between man and his actions. Racist and excessive actions are something I refuse to teach. But I am not a prophet regarding what my kids see every day about the barrier on television, what they are subjected to.

Borika / *Serb refugee from Bosnia who lives in Serbia*
It's a mistake to raise your children like we were raised. You can't survive today being raised the traditional way, according to principles of hard work and honesty. It's everyone for himself. I'm trying not to reproduce that.

Alemluk / *Lives in the Kyrgyestan*
In my opinion, we humans don't raise our children as well as noble birds (eagles, falcons). They take so much care! When they bring their prey, first they pluck them perfectly. They divide it into two parts if there are two chicks. When they feed the first, the other doesn't move; it's marvelous! Whereas our children demand to eat even if they're not hungry. A bird would never do that!

Katarina / *Lives in the Czech Republic*
My mother's always denied the existence of innate maternal love. She pretends it doesn't exist, that it's a relationship that has to be nurtured like any other. I think I missed that enormously and that I've always searched desperately for that kind of love. But with my children, I'm sure that a maternal instinct exists, but perhaps it's a gift that not everyone has.

Peter / *Lives in California*
If you think about my mother in particular, I think she experienced the horror that is probably the worst that we could possibly imagine. You know, you can hardly imagine. I can't imagine what life in Auschwitz must have been like. And she lived a happy life after that. She did not let it destroy her life. She led a full and rich life. She had three children. She enjoyed life despite the fact that she died with a tattoo of a number on her arm. She never carried that bitterness from that terrible, and most terrible, of experiences into the rest of her life. And most of all, she didn't infect me with it. It didn't destroy my life. She didn't hold me back in living in fear. So she passed on that positive attitude toward the world, that ability to move forward without being trapped by the past.

Johan / *Lives in Sweden*
The most important thing to pass on is self-confidence—we're fine as we are, and we don't have to prove anything to be accepted. We're handsome and smart enough. We can always better ourselves without taking ourselves seriously. But good enough as we are, we often think that we're useless, that we're not handsome enough, that we don't do anything interesting, that we don't make enough money. A lack of self-confidence can cause negative actions toward yourselves and others. My children must learn to feel good about who they are.

The most important thing we can teach anyone is self-confidence and the belief that we're fine as we are.

Katarina

Peter

Johan

Alemuuki

Léonard

Lives in Gabon

It's through love that we build society, our family, the nation— it's how we build the world.

Background / My name's Léonard, I grew up in Mekambo in Gabon, in the northeast of the country; it's on the border with the Congo. I'm married to Jeanne Marthe, and we have several children: our own and some we've adopted. I'm a journalist and editor of the newspaper *Le Citoyen* in Libreville. I'm very involved with a movement called Mina Piga that champions the Pygmy indigenous minorities of Gabon and was created in 1997. This movement is the reason I travel so as to pass on the message of durable development of the Pygmy peoples in Gabon.

Occupation / Journalism is a profession that I like very much because I chose it when I was very young. At university I gave up studying philosophy to do journalism because in my life I had the choice between teaching to form others and journalism to inform others. I really love this job, and until I have passed information on, I feel I'm not alive. I began as a simple reporter with stories of dogs that had been run over, but later I became the editor of my own paper: *Le Citoyen, l'autre face de l'actualité.* But I don't just deal with journalism. Since 1997 I have been heavily involved with associations because I've always felt that I should be useful to others. I consider myself the ambassador of the Pygmies; I owe them a great deal. I have to fight so that the Pygmies can manage their own interests and development. Durable development, which begins with the schooling of Pygmy children—teaching them to read and write so that they are able to study properly. This is the only way that they'll be able to get out of the hostile society known as "civilization." But there's more: I also visit international institutions to convince them to equip the Pygmies with agricultural tools,

as these people need to be taught how to farm and breed animals so that they need no longer be dependent on the state, which treats them like objects. That's what I do, and I'm proud of it because it makes me feel alive.

Learned from your parents / My parents taught me love. My mother often told me to love. When I say love, I mean in a non-sexual way because it's through love that we build society, our family, the nation—it's how we build the world. I've understood that the greatest gift that I've received is that of loving others, whoever they are and regardless of their faults, because it isn't my place to change others or judge their worth. I love others, whatever their faults, because I believe that's how society is made, a society in which differences exist and where we have to tackle these differences. It's only with love that we will be able to succeed.

Love / Love, for me, is not simply the heart beating for one person. It's not that. It is fortune that leads me to love only one person, despite her flaws. It was thus with my dear wife in the month of July 1995. After a drink in a bar, I was struck by a woman's charm, and I said, "Madam, I am in love with you and want to marry you." Her spontaneous answer: "If you love me, make a decision." And today, we are in the eleventh year. I love my wife's sincerity. When I mess up, she must tell me, so I can stand tall, as I am a human being, made of flaws and qualities.

Joy / My greatest joy in life is living. It's knowing that I'm loved by one woman, one who has closed her eyes to other men. She only loves Léonard; she calls me Léo. My greatest joy is the two lovely children she's given me.

Fear / My greatest fear is of dying without having given her what she expects from me. I have to whisper my tender feelings into her ear when she's not expecting it: "Darling, you're the best, you're the most beautiful woman there is."

Loving your country / What I love about the Pygmies is that they have stayed the same. They haven't allowed themselves to be influenced by winds blowing from elsewhere. Even if they're said to be primitive and backward, I think that this is what being human is about: not changing to suit others, not following fashion.

Dreams today / My greatest dream is that the following will be written on my gravestone when I die at 120 years old: "Here lies Léonard, who championed the Pygmy people, starting from a simple concept, a reclaiming of their identity, and went on to achieve a program of durable development. This program has made Pygmies the authors and, therefore, the beneficiaries of durable development in Africa and their own world." That's my greatest dream. I don't want to live and disappear after my death. I want to leave something. As Martin Luther King said, "Be the best of whatever you are." That's my greatest dream.

Freedom / I won't talk about freedom as such: I don't feel free because, while there are blockages in the realization of certain thoughts and ideas, if you've really thought something out but you have to count on others to make something happen, there is a lack of freedom. I don't feel really free.

Nature / Nature is the haven in which God has placed us. Listen, God never does anything by chance. When the Bible talks about the Garden of Eden, well, I haven't seen it, but my Eden is the forest. If you destroy nature, you destroy yourself. And those countries that have allowed their natural habitat to be destroyed are places where now we hear talk of deserts and heat waves. When you pollute water. … The Pygmies have always lived in that environment. How can they preserve it when they use things that I cannot divulge here? I call that "the prohibitions." The laws of indigenous peoples are in their heads, and they call them "the prohibitions." If you want to protect the water, you won't do it through passing laws. All you need do is stick up a prohibition: "If you piss in the water, you'll be made impotent." Then they'll be scared, because no man wants to be made impotent.

Poverty / Poverty is when everyone is without, even without ideas. Poverty is when there are ideas, but they can't be developed. Poverty is when there are ideas, but they are not put at the service of the greatest number. Poverty is when the means exist, but you're not allowed to build your house. Poverty is when the means exist, but you're unable to dress correctly, or eat correctly, or see to the well-being of your spouse and children. Poverty is when you can't even pray to God the Creator, who sent us His son Jesus of Nazareth. Poverty is when you can't help others because you do not have the means. These are different definitions I give to poverty. I'm sorry if these are not satisfactory to you, but this is how I think of poverty.

Message / The message I'd like to give to the world is that we should understand we are a single family, and that the five continents are simply the five fingers on a single hand. It is God who has united us around this planet, the only planet where human beings must live, in peace and love.

Ranjana

Lives in New Delhi, India

So, given a choice, definitively, I would never, ever like to get married ever in my life.

Background / Hello friends! My name is Ranjana. I was born in Dehli and brought up in Dehli only. At present I am doing an MBA, pursuing an MBA, and my specialization is marketing and international business and shortly I'll be working with a corporate sector.

Family / If you are in trouble, then ultimately your family is the one whom you can rely on. Definitively your friends are there, but your first priority is your family and for me, more than a joined family, to me, a nuclear family is more important, wherein your parents are the ultimate decision maker. They don't have to consult others, the elders or other people, their relatives, for the decisions, for the important decisions in their lives, ultimately the decision maker is the father, or at max, mother. So for me, family is somebody, your mother, father, and at max your one or two elder brother or elder sister. That's it.

Childhood dream / Very famous person. A rich and a famous person—this was my dream always since childhood. Somebody who's very known, a very known face in the eyes of the public. You know, whom the public can think when you die, when you pass on, people can think, "OK. This was the person whom we can never forget." In a positive sense, not a in negative sense.

Fear / My marriage is the greatest fear I can think about as of now. Basically the family to which I belong is a very conservative, orthodox family, and as of now, I have somebody in my mind, so maybe these people might not accept. It's not might be, it's ninety-nine percent sure that these people might not accept. This is the biggest fear

I feel: What will happen if they say no. So that is the biggest fear, as of now. In India, the inter-caste thing is of great importance. And particularly the family to which I belong, this caste fact is definitively there. So he is not of our caste. So that is the thing.

Changing your life / I hope, as far as my life is concerned, I hope I would've been born and brought up in a more broad-minded family, wherein the father or the parents are much more understanding—even actually talking your heart out to your parents, very, very clearly. There should be no hustles, there should be no problem at all in discussing your problems, what you think about the life. There should be no problem discussing these kinds of issues with your parents. So I hope that this kind of thing could have been—or should vanish from my life or could be eliminated or deleted somehow from this thing. So this is the thing which I would like to change about my life.

Hard to say / The toughest thing to tell my parents is about this thing with me, about my seeing—about my going out with a guy who is not of the same caste.

Crying / When people don't listen to me, that is the thing that makes me cry. When I think about my future, that what will happen if my parents don't agree, that makes me cry. When I end up fighting with my friends, that makes me cry. When I hurt some very near and very dear ones, that makes me cry.

Work / As far as work and my personal life is concerned, definitively it'll be a very difficult reason, meaning I have to do work outside the home and I have to do work inside the home. But then, if you are financially strong, right, then there are servants who can take care of the stuff. What you have to do in your family, in your household work is basically cooking food, washing clothes, sweeping, and all these things, so these can be taken care of by these servants also if you are financially well. Once I get married, life will be tougher for me. As of now, I have my parents; I don't do anything. I simply go to my college, come back, I don't have to do anything. I have food prepared at my disposal. My clothes are ironed. They're washed. Everything is done. So I don't have to do anything, right. So life is very easy as of now.

Wish / Because I am living in a society, I'm put in a society with Indian culture, I have, at the end of the day, even if I like or don't like, I have to get married. Because I live in a society wherein you cannot afford to stay alone, you know. People will pinpoint and say, "There must be some problem with this girl. She might be going around with somebody." Or there might be many other things, you know, people will think this if you don't get married, with a guy or with a girl. Life is very tough as far as India is concerned. So, given a choice, definitively, I would never, ever like to get married ever in my life.

Changing your country / Tradition is important, sure. Tradition should not be imposed, right. As far as India is concerned, India is culturally a strong country. As far

as relationships are concerned, India is very strong in terms of relationships. There are still very few cases wherein you'll hear that a particular divorce is taking place, or people have thrown their parents or their grandparents out of the house. These things are very common abroad. As far as India is concerned, this is the most important factor: the value of relationship, which I never want to change about India.

Living better than your parents / So as far as my mother and my life goes, there is a lot of difference in the sense that when she got married, she got married at the age of sixteen, and that was thirty-five to forty years back. So at that time, during her time, working or education was not very important. But at present, working and education is definitively very important. So the difference lies in what I think about the society, about my knowledge level, about my education level; she cannot think in those terms, because she's been in the four corners of the house. She's never stepped out. So she is not aware of the fact of what is happening outside. I think I am aware of the fact of what is happening outside, and I think, definitively, she is much more experienced than I am, right, because she is older. She has an experience, I mean, of so many years, but as far as decision making is concerned, on important issues I think I can think better as compared to her, because of the knowledge level, because of the education level, and because I see people around. I have met different people, and I know what is the reaction of the people, what they feel, what they talk, which I think she is not aware of. So therein lies the difference.

Killing / Yes, many times. I've imagined if I could kill one person so he or she would be the person I imagine many times. When that particular person rants against me, at that time I imagined killing that person or when that particular person did something really, really very wrong, unlawful, at that time I imagined often killing that person. When ultimately it comes to killing, I won't kill.

God / As far as God is concerned, I don't directly believe in God. I definitively, whenever anything wrong happens, the first think that comes to my mind is, "Oh God, this should not happen!" But, because we were taught like that only, "Bhagwan." In Hindi, we call it Bhagwan, right. So we were taught like that but ultimately for me, I have faith only in my guruji and I treat him as my God. Otherwise, I don't idealize any God, like, in India, we have Gods with different names, like Shankar and Ramji and etc. So I don't believe in those Shankars and Ramjis, but I believe in only my guruji. I have faith only in him.

Giving love / I am the person who is not spreading so much love, reason being that I'm not satisfied with the society around. And if I'm satisfied, definitively I . . . I definitively pass on love, care to the maximum, to the fullest. But if I'm not satisfied—I think, to sum up, I would say that I am not able to give that much amount of love to the society as I should have given or should give.

Yona

Théodore

Misael

Karima

WHAT DOES LOVE MEAN TO YOU?

Yona / *Lives in Canada*
It's been a very long time since I was in love. I think that, when I was, I wasn't aware that I had chosen the person in question. But each one of us is like our own planet, our own country, with our own rules and history, and I think that what allows us to fall in love is when we meet someone who wants to explore our planet, and wants to learn how, in spite of its complexity, to climb to the top of its mountains and go to the bottom of the darkest caverns, and who will be able to appreciate the beauty of all the nooks and crannies that exist inside each of us.

Love … is something else. … It drives you crazy … ready to attack all the time.

Théodore / *Lives in Benin*
Love, you know, is something else. It drives you crazy. We become crazy. We're ready to attack all the time, and you watch everything that's going on around the girl. You need to be beside her all the time, to talk, to chat, and to joke.

Misael / *Lives in Cuba*
It's beautiful. Sometimes it's hard to describe because it's fascinating and completely blinds us. There may be something negative going on, but you don't see it because you've been blinded by love. When love hits you with that kind of force, it takes over completely. I don't know if it's the brain that is dominated by love, but when love is in control, the brain can no longer do anything.

Karima / *Lives in Egypt*
I'm madly in love with my man. I pray God he hears me, so I can say, "I love you" in every language. I love you, I love you, and I'll love you until I die! You are the love of my life, you are my path, it's you that I desire, I pray that you hear me; I'm sure that you feel it too. Because it's natural for you to feel what I feel and to understand me so well, to read in my eyes. Before, I used to hope to hear words of love from the person I used to go out with, but now, with my husband, I don't even try to hear these words because he gives me every sensation of love that exists.

Maria / *Lives in South Africa*
Love in my life is meeting that
person that is on the same page
with you in life, spiritually—and
everything. They just, you know. ...
Whenever you see them, your heart
just wants to burst whether you're
together for forty or fifty years, or
five days. When you see them, you
must just feel that flutter . . . that
you know that you're there. Yes,
love is very important to me, and
probably that's why I haven't really
found that special love, after being
a widow for twenty-five years.

Sofien / *Lives in France*
I don't know. I've never been in
love. I swear, never. Maybe when I
was young. Not since my incarcera-
tions. You know, I've been out very
little, like three months. Building
a relationship is complicated. I've
never known love. All I know is, um,
you know, it really hurts. It's cool,
but . . . it makes you suffer. I see
the state of my colleagues. In some
way it's not so bad because being
in jail and leaving your lover means
doubting all the time. You always
worry, you always wonder. Long live
singles!

Pandiammal / *Lives in Tamil Nadu,
India*
I didn't listen to my parents—I
married for love. Had I obeyed their
demands, they would have helped
us. As for my in-laws, they wanted
their son to marry well. They won-
der why it's me and still haven't
calmed down. Nor have my parents.

Remedios / *Lives in Bolivia*
We didn't know each other. We
weren't in love. We barely spoke.
Getting married in that way is not
good. These men consider us to be
objects. That's what I think. There
is still no love. I don't feel it. That's
why I have always heard that you
should marry for love and tender-
ness. Isn't that right?

Yevdokia / *Lives in Siberia, Russia*
Love is my first husband. I loved
him and had children. He died in
an accident. Then I met my second
husband, and I fell in love with him.
We had two children. Then my
third husband was a widower with
six kids. We fell in love. That's my
definition of love.

I've never been in love. I swear, never.

Maria

Pandiammal

Remedios

ofien

Yevdokia

Hajime

Jean de Dieu

Barbara

Zhen Xi

Maria Teresa

Keiko

Keiko / *Lives in Japan*
Compared to before the birth of my children, the love I have for my husband has diminished by half. . . . I give it all to my children, and I'm sorry for my husband, I really am, and I feel it every day. My husband, whose love for me hasn't changed, asks me to make love with him, but I can only do so unemotionally, and I don't think he's satisfied. In the evening, when he comes home, I'm already asleep with the children. I'm really very sorry for him; it doesn't mean I don't love him, but I do everything for the children every day. . . .

Zhen Xi / *Lives in Shanghai, China*
Now we don't care about each other anymore. We've been together for a long time, and we no longer talk about being loved or not, we just live together. We have to bring up the children, that's all.

We've been married for ten years. We no longer hold hands, but my love is stronger with each passing day.

Maria Teresa / *Lives in Italy*
These days love is like a pastime. That's something that would be good to change in the country and the entire world: The fact that it's turned into a pastime. It's no longer love: Love, when you get older, it's trying not to wake each other, when I get up early. That's love beyond sex. Sex matters. But it's not just that. It's a lot of other things.

Barbara / *Lives in Italy*
Love for me is something very physical. It's a sharing of interests and a need for physical contact, a need to feel someone. Love is less understanding than it is sharing. They're two different things. For me love isn't cerebral, it's more animal; it's more to do with action and gestures.

Jean de Dieu / *Lives in Madagascar*
I show my wife a smile first, to prove my love to her. I must make her smile, too. And when I see her smile, it means she is in peace. Well, then I am convinced that there is joy too. Her smile is proof of her joy.

Hajime / *Lives in Japan*
We've been married for ten years. We no longer hold hands, but my love is stronger with each passing day. In Japan we don't say "I love you" out loud. But "I love you" means that . . . if I'm told to die for my wife and children, I would. I think that's what loving someone means.

Alain / *Lives in France*

Love is a moment in your life, like a flash. Then it changes. It remains love, but less in the sense of fire. For me love is fire—it goes out, but there are embers. The problem is incubating it, keeping the embers alive.

Alvania / *Lives in Indonesia*

Love is like an egg . . . you must know how to hold it like an egg. If you squeeze it too tightly, it will break. But it you don't hold it firmly enough, it will roll and fall. If you know how to hold it, it will remain in place in the palm of your hand. And that goes for every type of love, not only erotic love. Love must be treated well. That's how it is!

Claire / *Lives in Moscow, Russia*

One day, during an argument with my husband, I screamed, "Look! We're too different! We have a different education, had different childhoods. We'll never get each other!" And suddenly I said, "We're even different genders!" We burst out laughing and fell into each other's arms. It's very, very funny. A couple must . . . you must reinvent it every day.

Darryl / *Lives in New Orleans*

My mother would always tell me, "You know, when you first meet a girl, you'd be like [smacks lips]. You just want to eat her up, because you're just all in love." She said, "About a year later, you wish you were spitting them out." But if you want your relationship to last, you have to do it day by day, moment by moment, minute by minute. Never,

ever, get too comfortable, because then you stand still. She said, "Always plan to build. Always plan to increase." Like, when you and she first get together, you have a one-bedroom house. Then you have kids, now you have a two-bedroom house. Then, you have grandkids, so you have a three-, four-bedroom house because you always have to have a guest-room. So you are building, you're growing. Do not stop, do not get comfortable. And then you always have . . . tomorrow. And that tomorrow we'll be together, because we work on it all day, today.

> Love is like an egg. . . . If you squeeze it too tightly, it will break. But if you don't hold it firmly enough, it will roll and fall.

Alain

Claire

Darryl

Alvania

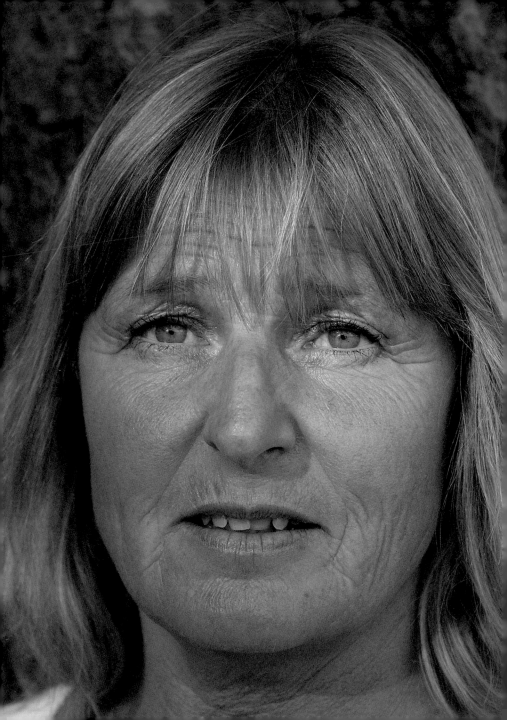

Lotta

Lives in Sweden

When I was young I had a dream that I've made come true. It was to live here.

Background / My name's Lotta. I'm fifty-one. I live in the forest, where the track ends and the lake begins. I've been married to my man for twenty-seven years. I have three adult children: Tove, twenty-five; Björn, twenty-three; and Thomas, twenty-two. They don't live at home, and that's good, but it's really nice when they come to visit us from time to time.

Work / I've worked full-time since the age of nineteen, but just now I'm working three-quarters of the time to enjoy life more and to do odd jobs around the house, which I love. I'm a prison warder.

Dreams as a child / When I was young I had a dream that I've made come true. It was to live here. This was my parents' holiday home. The house has belonged to our family for a long time; my grandparents bought it back in 1924. When I was a teenager and thought about my future, I used to say to myself, "Imagine! If I could just move here!" I've been here for the past four years: There's nothing else in life I want! It's just great!

Dreams today / You know, nothing comes to mind. I really don't have any big dreams. I've no desire to going parachuting or anything like that. I'm so happy to watch the sun go down with a beer in my hand, sitting beside the lake. There's nothing I want anymore. Good friends, of course. Family. But after that? I have no need to become anything else than what I am.

Family / Family? First of all, I have my own little family that I adore. We're very close and have a warm relationship. Then, there's the family I grew up in, which is still

very important to me. In my family association we carry out genealogical research and discovered a certain Mr. Stenfeldt who was ennobled in the eighteenth century. It's strange, because, once I found piles of papers and documents, I felt we can really make a link with the past. It's moving, even if I have never met these people.

Laughing / You can laugh at small things every day. For example, a green woodpecker on a tree stump throwing little bits of wood everywhere around. I could laugh at it simply because it's such a funny sight. I'm lucky—I laugh easily.

Crying / Sometimes I cry when I watch a film that touches me. And I can cry when I recall memories, even those from a long time back. For instance—there are tears in my eyes already—when I was little, we had small and large spades, and small and large buckets that we would swap every couple of days. One particular day, it was my turn to have the large ones. All the children arrived at the sandpit, but there was one child with his grandmother who didn't have either a bucket or spade. And he said, "Granny, I haven't got anything to take the sand with." He didn't have anything and it made me very sad.

Hardship / The hardest thing in my life? It was when my mother had her stroke, at the age of sixty-nine. She'd always been full of energy, but, all of a sudden, poof! she found herself in a wheelchair for nine years, nothing more than a human parcel. It was very hard for me because I felt guilty all the time: "I should visit her. . . . I should take care of her. . . ." It was a very difficult time. One day, a few months after it had happened, the doctors told us that she would die during the night because her condition had weakened so much. All her family was there around her. They told us she had very little time left, so we began to prepare ourselves psychologically for her death. But the doctors turned her over and she woke up a little. She looked at all seven of us and said, "Who are all these people? Right, now I want a cup of coffee!" We'd prepared ourselves for her to die but instead she lived for another eight and a half years. It was very strange, with a host of contradictory feelings. It was great but at the same time very hard. The years that followed were difficult ones: to see your dynamic mother stuck in her chair, needing someone to change her diaper, to feed her. It was a relief when she eventually passed on. I was happy to have been there when it happened, and the same when it was my dad's turn. That was good.

Death / We need to think about death and not try and ignore it. What happens when we die? I have no precise idea. I only know that I have no wish to lie in a grave. I'd prefer to be cremated and have my ashes sprinkled over the lake. On the other hand, I don't feel the need to visit my parents' graves, as I feel that they're here, in the house. They're with me every day. We had some fun at my dad's burial! He was a very down-to-earth type. So on the ribbons where you write your last message, we put, "See you

later, guys!" like he always used to say. We even had it carved on his gravestone! Death shouldn't be solemn; it's a natural event.

Freedom / I get a real sense of invigorating freedom when I go out on the frozen lake with my sled on a winter's night, under the moon and the stars. I go for rides on the ice, and I feel heady with freedom. I also get this feeling on a winter's night when we relax in the hot tub under the night sky. It makes me really happy, and I feel completely free.

Nature / I really like nature and often putter around outside. The bad thing about my work in the prison is that we're always very enclosed. I feel privileged in the fall when I go out searching for berries, mushrooms, potatoes in my field, peas, beans, the lettuce that I grow, and if we've caught a fish in the lake, we have a dinner produced entirely by ourselves . . . except for the beer, which isn't so good if you make it yourself! I buy it at the shop. Seeing the changes as the seasons change. When I wake up, each morning I take a little walk just to look. If I begin work a bit late, I take a walk around the house, just to look. Just for the pleasure I get out of nature.

Love / For me love is essential. We're a very happy couple. When we met in 1975, I was nineteen and he was twenty. We've been together ever since, and we've always been very happy. Sometimes we might go out for a walk, hand in hand, on the paths around here, and we'll say, "How happy we are!" I think that we've achieved this balance because both of us have always done our own things outside the marriage too. I go out with my girlfriends and take dance lessons, and he goes fishing with his friends. The important thing is to trust one another; that way, we know we're both there for the other and we're both faithful.

The meaning of life / There are so many things to say on that! First, to take pleasure, to enjoy each day, to have fun. Next, it's important to leave documents to future generations. I take lots of photographs of old objects, and I write down what I know about them; that way, the life of people and things continues. My father wrote a great deal about my grandfather and his family. I love it when they come alive again each time I read through or look at the photos.

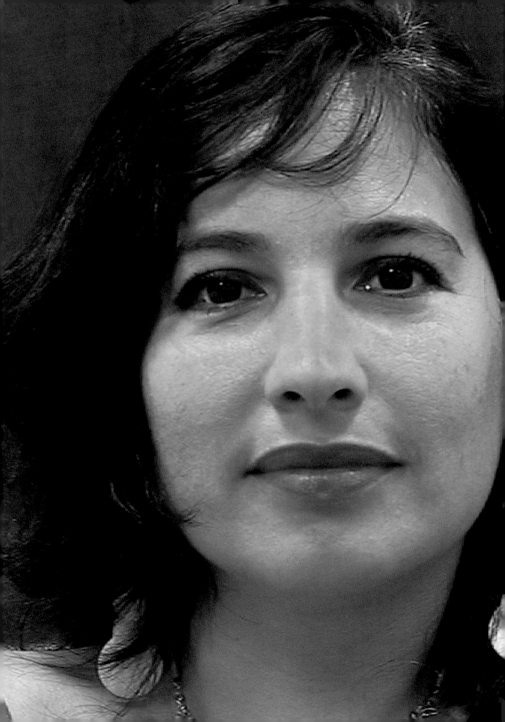

Christina

Lives in Los Angeles

So my dream is sincerely to learn how to live with what I have.

Background / My name is Christina. I'm from the United States. I am thirty-seven years old. And I am an actress and theater educator.

Memory / Whoa! My first memory—probably it reminds me of a time in preschool, so I must have been around three or four years old, and I had a best girlfriend. And her name was Felicia, and she was black. And the reason why it's interesting to me now is that I'm Mexican-American. So, you know, as you know in the United States there is a lot of segregation based on what ethnic group you belong to. And I gravitated toward her—she was the only black girl in the school. And I think I was probably one of the only Mexican-Americans, if not the only one. And I have a memory of us pushing a little baby carriage, like with our dolls inside, together. And that image always stuck with me. It's funny to think about that now.

Hard to say / It's difficult with my father to speak about politics because he fought in the Korean War. So he has a certain pride and patriotic feelings about being an American. And I respect that, but sometimes it's difficult because of what's going on right now, for example in Iraq. The rest of my family, we're much more, I guess, against the war, and it's difficult for my father to see it objectively. So we have a lot of passionate discussions that aren't always rational because he gets very angry and very defensive about being an American, in a way, and being this best country. And I think it comes from his personal experience fighting the war—the Korean War.

Happy / I'm not happy with my daily life. I'm probably going to get emotional right now, but because I think that in this culture, of being an American, it's difficult to be happy. And that may sound bizarre, but I think I'm realizing that . . . again, we are shown, I think, so much in this country, in the United States of America. We're told,

"You should look like this." We're told, "You should have this. You should have this job. You should be this kind of person. You should be beautiful. You should be sexy. You should have money. You should have five kids by the time you're twenty-five, even though you're poor." And I think I'm confronted with the reality that, well, I live in this society that in one way makes us very spoiled. It makes us want more, more, more, more, more because we think that's the only way we can be happy. And I know that it should be simpler; I know that I should be happy just being who I am. I should be happy with the fact that I am healthy, that I have a family, that I have friends. But it's very difficult on a daily level of basic survival to remember that the little I have is enough for most people in the world. But I really think it's a sickness of being an American, and it's something I'm really confronted with right now—in that, I am constantly, in a way, in a state of depression. Very recently I realized, like, why can't I be happy? And it's because I'm every day measuring my life based on a model that is sold to us every day, which is a model of, in a way, a capitalist society, you know. You turn on the TV right now, and it's ridiculous. It's sickening, all the reality shows and all of those things that are reminders that our life is not valid because we don't have what, you know, the television tells us we're supposed to have. And even though intellectually I understand it, emotionally and psychologically in a way I feel like I'm a victim, or a prisoner—it sounds very dramatic, but in a way I do feel that.

Love / Human love I think is what is most important, and I think sometimes we forget that in life because we're so busy fighting wars or fighting with each other or trying to find a job or trying to make a relationship work or, you know, there're so many distractions in life now. And sometimes for me it's very difficult because I know that it can be very simple, but my head gets very complicated. And it's really challenging to remember love is a simple thing.

Hardship / The most difficult moment in my life? I don't know if there's been one moment. I think I had a lot of difficult moments in my life. Probably in my case, it goes back to childhood, of living with a father who's an alcoholic, of the disappointment and the confusion and the conflict of living with somebody who loves you but then the next day may not be there. Or somebody who makes you a great breakfast on a Sunday morning and takes you camping, and all of those things, but then they don't show up for dinner the next day. I think starting life out with that kind of sadness and anxiety, for a child, is really heavy. And I would have to say that's probably the most difficult thing at this point in my life that I'm having to live with, because it still has its consequence for me now in the relationships that I'm involved in with myself, with boyfriends.

Current dream / To learn how to just be—I mean that's a dream on a real kind of an existential level, but I think it says a lot. I think I get caught up in the story too much, of what I have, what I don't have, what I should have. And it makes it difficult to be

happy now. So my dream is sincerely to learn how to live with what I have and trust that that's enough. And if more things are to come, then they'll come.

Fear / My greatest personal fear is that I give up. It's a fear of giving up on life. It's a fear of saying, "Fuck it, I can't do this anymore. It's too hard to be happy. It's too hard to live with what I have, or don't have, more likely." And it's a fear of just giving up, you know, because I think sometimes I suffer a lot because I'm so sensitive, in a way. I'm very sensitive to everything around me. I care a lot about the world. I'm very compassionate. And I think sometimes it's a lot. It's like a lot to be carrying. And I'm trying to figure out how can I channel all of that sensitivity in a positive way, you know. I'm afraid of my country, actually. I'm afraid of the power that it has. And I'm afraid of what we have done and what we will see because of it. And I know we deserve it. It's not like I want violence here. Well, 9/11 was obviously so violent, but I don't think anyone made the connection; I don't think most people understand there is a reason that happened. It wasn't just people deciding to bomb the most powerful country in the world. It's because we have gone into other countries, you know, and we have spread democracy, like we're the police of the world. We have gone in and destroyed whole cultures and communities, and antiquities, museums, because of things like oil, you know. But when they come over and—whoever they are, the evildoers, the terrorists—it's like, "Why would anyone hate the United States? Why would any one hate us? We're so wonderful! We're so rich! We have McDonald's and Mickey Mouse!" And, you know, it's a sick culture!

Woman / What needs to be done to stop making war is that women should rule the planet. I know there've been warrior-women, you know, but there is something about men governing countries that's not healthy for the planet. I think women, because maybe we give life, because we have a different value of what life is by giving it—it's like some sort of ancestral, intuitive energy-force we have—that there is a sensation of communal living that is more natural to us. As long as men are governing countries, I mean I know that sounds really extreme maybe, but maybe not! We've tried it one way, now let's try it another way. What about women taking positions of power? Let's see what sorts of changes can be made then.

Meaning of life / The meaning of life is love. What else is there? We all need it. We all want it. It makes us feel good if we're lucky enough to have it. Unfortunately, not everyone is. You know, there is this quote—Americans are very good at these very corny quotes—but it's one of these, like, "It's better to have loved and lost, than never to have loved at all." So it's worth the risk. It's worth the risk of saying, "OK. I'm going to love you. And that might mean I'm going to get hurt. It might mean that you might betray me or walk away from me, but guess what, it might mean that you'll love me back. And how amazing could that be."

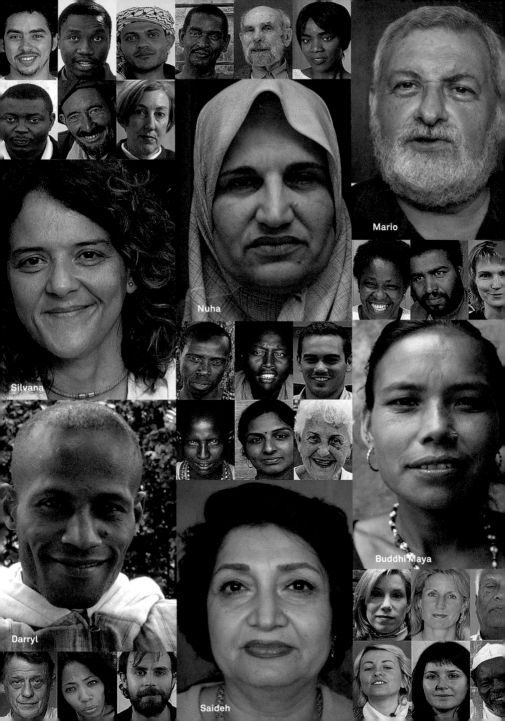

Mario

Nuha

Silvana

Buddhi Maya

Darryl

Saideh

WHAT IS HAPPINESS?
ARE YOU HAPPY?

Mario / *Lives in Buenos Aires, Argentina*
I've had several moments of happiness. Just being beside a mountain fills me with happiness. It's like making contact with infinity, with the vastness of nature and the world. Exchanging looks with my wife also brings me immense happiness. When your wife is not just your wife but also your friend, and you communicate well together, that brings moments of happiness. And even when there's suffering, or someone in the family dies, or there's a serious illness, a look like that is, was, and I hope will continue to be, a moment of great happiness.

Nuha / *Refugee from Iraq who lives in Syria*
My happiest day was the day the English department posted that I had passed. My love of English is incomparable. I love everything related to foreign languages, especially English, especially English. It's like traveling to the moon.

Silvana / *Lives in Argentina*
There has been no one happiest moment of my life. I've had lots of them. My most recent happy moments were only a short while ago, when I was making love.

Saideh / *Lives in Iran*
The first time a woman has a baby. And especially when the child moves in your womb. I had the strange feeling that there was another life inside me, and those feelings made me extremely happy.

Buddhi Maya / *Lives in Nepal*
When I was sick and couldn't work, my parents-in-law hated me, so I asked my husband to marry another woman who would work in the house. He said, "You came here, and you left your family. How could I marry another woman? I love you so much!" That was when I had a son. That was the happiest time of my life.

Darryl / *Lives in New Orleans*
When my son was born, my son Darryl, I was in the delivery room, and I was all nervous and scared, like—I don't know if I'm gonna to be able to stay in the room because, you know, a baby is gonna to come out, and I had just turned twenty years old. When I'd seen the head come out—and then I saw the shoulders come out—I just couldn't do anything but just smile and laugh, and I'd seen his face, even though it was covered. And I could see a little bitty me. And it just made me laugh because it was like, that's what my dad saw because he was in the room when I was born. And I look like my dad, and my son looks like me. So, it just made me really, really happy.

Anna / *Lives in Italy*
Can you be happy when you are alone? Tell me how. I was happy with my husband. Ever since he died, there is no more sun.

Carola / *Lives in Tanzania*
Oh my God! I don't know, because I don't know if—I don't believe there is a recipe for happiness. I think happiness comes when somebody has satisfaction, and satisfaction is really hard to achieve. I think I could easily get happy when I was young, because very small things could just make me forget everything. But as you grow older and you have more responsibilities, you have kids, you are waiting for school fees, you're not making so much money, and, you know, happiness becomes such a rare thing. Sometimes you find yourself smiling or laughing, but you're not really happy inside, you know, because all the time you have so much trouble. So I think for anybody to be totally happy, they have to be totally satisfied, which is a very, very difficult thing.

Norbert / *Lives in Madagascar*
I always have the impression that I'm not satisfied, that my life is incomplete. The result is that I always try to have more. If I have a franc, I want ten francs; if I have ten francs, I'd like to have one hundred; and if I had a hundred, I'd want a thousand. If I had a bicycle, I'd want a motorbike; if I had a motorbike, I'd want a car.

Akusawa / *Lives in Los Angeles*
Yes, I'm very happy because I've finally understood that happiness comes from inside. I remember, when I was young, that I used to look all around for happiness—in other people, other places, other things—but I finally understood that happiness resides inside us.

Jovan / *Lives in Bosnia-Herzegovina*
I've been married for forty-seven years and practically every morning since the first day, my wife has told me she has a headache, that she slept badly, or her shoulder aches. I, on the other hand, am happy to see a ray of sunshine, to live a new day.

> Oh my God! I don't believe there is a recipe for happiness. I think happiness comes when someone has satisfaction.

Yusuf / *Lives in Turkey*
When I go home every evening, I take a shower, change my clothes, sit on my balcony, and lean back on my cushions. If there's any fruit, I eat it. I call my children around me, and we talk and joke and drink tea. Is there any greater happiness than that?

Putali / *Lives in Nepal*
What do you need to be happy? You have to have a house, a field to sow corn, and an ox. If you can plant crops and grow everything you want, then you'll have happiness. If you can't grow anything, you're not happy, you're sad.

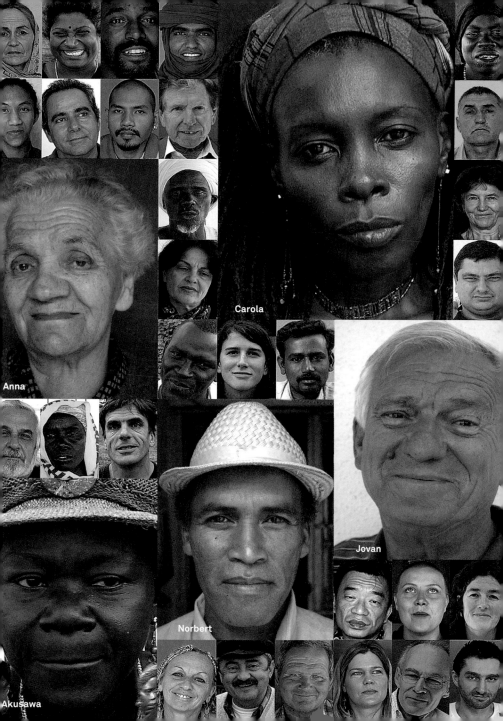

Anna

Carola

Jovan

Norbert

Akusawa

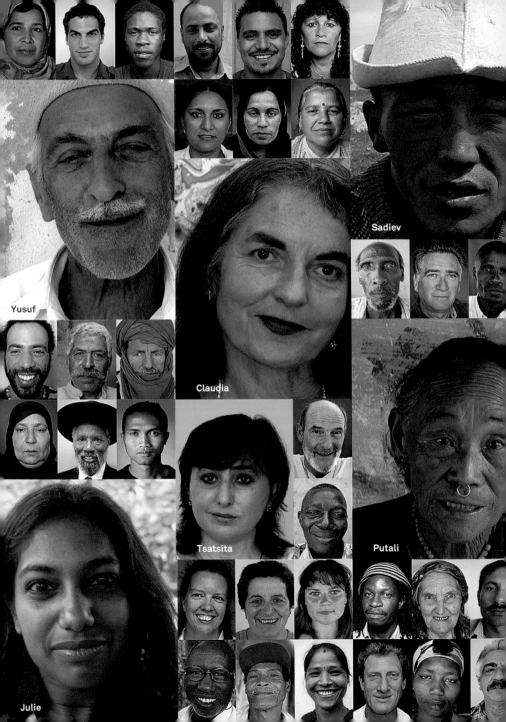

Yusuf

Sadiev

Claudia

Tsatsita

Putali

Julie

Sadiev / *Lives in Kyrgyzstan*
To be happy, you have to set yourself goals. If you achieve those goals, you'll be happy. As I'm a shepherd, my goal is to look after the whole herd well, to make them fat, and then to take them back to their owner. That's my happiness.

Claudia / *Lives in Germany*
I could try to explain it, but the French word is wonderful: bonheur—the good time, when great coincidences happen. That's happiness.

Tsatsita / *Lives in Chechnya*
It was January 15 or 16. I remember like it was yesterday. Suddenly, there was absolute silence—no more planes, no more explosions, you could hear again. I came up from the basement, and I found myself outside and I saw an enormous moon. It was a full moon. Along with the silence, it was really sublime. So I thought that if there is an eighth wonder of the world, this must be it: When silence comes after war. Whether it lasts one second, two seconds, or ten seconds, that silence is so beautiful.

Julie / *Lives in Tamil Nadu, India*
Recently I was ecstatically happy working at the orphanage. There was a little girl who was abandoned when she was eleven months old. She was still a little baby. She was abandoned on the street. The sisters adopted her—took her in—and this little girl, this baby who was just under one year old, she was full of sadness and she would sigh. I was deeply moved to see such a little baby already feel so much sadness. So I tried to see her every day, to make her laugh and even dance. And finally, after two weeks, she smiled beautifully. I think it was really pure happiness.

To be happy, you have to set yourself goals. If you achieve those goals, you'll be happy.

Isabelle / *Lives in France*
I was in a plane crash. I was the only survivor. Following that accident, in which I was literally broken from head to toe, I was shut-in for eight months and was a zombie for two years. I've always been thin, but then I weighed 83 pounds (38 kg). Then I remarried. I got pregnant. When I came back from the dead, I thought, "I'll never again be a normal woman." They'd shaven my head, I had eighteen stitches on my head and all that. The day that child was born, the moment I gave birth, was absolute happiness. But it was momentary. Happiness, for me, is momentary. We have moments of great happiness, quick flashes of great happiness in life. They're the reason for which we live.

Ruth / *Lives in Israel*
Happiness comes in flashes, in seconds, and perhaps in instants. You do something and suddenly have this feeling: "Wow! How great! I'm happy." But it does not last indefinitely. The word has such adrenaline. Happiness is flashes. You ask me if there are sparks—there are. Are there very many? Not many, but some.

B. / *Lives in France*
When my daughter hugs me and says, "Dad, I love you to the sky. As high as a mountain." It comes out of her, and no one taught her to say that. It's beautiful. We worry being in jail against prejudices, but kids are natural.

Gabriel / *Lives in Los Angeles*
I didn't use to be happy, but now I truly am, now that I've got out of prison and everything. Life is a beautiful thing because, you know, you don't stay young very long. So I just love life, you know, and with a bit of luck, life will love me too.

Sharon / *Lives in Los Angeles*
Happiness, happiness, happiness is. Happiness is the truth. Happiness is telling the truth and knowing that it's been heard. Happiness is seeing justice done. Happiness is watching a child connect with their imagination, and allowing it to be free. Happiness is dancing. Happiness is a mango. Happiness is … Oh! But happiness is in every moment, potentially. Happiness is so close—it's so close—it's just so close to us all the time. We can get a child to laugh so easily. And happiness tumbles out of that. Oh, happiness is everywhere, but it's not a big, loud thing. Happiness is not a big, expensive thing. Happiness is a little, quiet human connection.

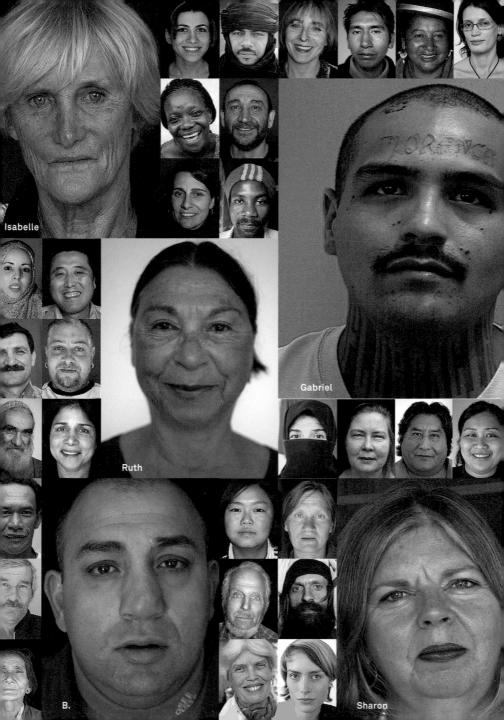

Isabelle

Gabriel

Ruth

B.

Sharon

Dushka

Lives in Kosovo

My hardest experience has been with drugs. I know that now because I've left them behind.

Background / My name's Dushka. I'm twenty-two. I was born and live in Pristina. I'm a student.

Dreams as a child / Like many others, I wanted to be an astronaut when I grew up. And then a painter. I loved to draw, and I dreamed of leaving for Paris with my best friend and of being a painter there. And an astronaut, of course! I used to fantasize about both. I wanted to be an astronaut because I was always thinking about the universe, the stars and planets. I always wondered what shape the universe was, what was behind the planets and the Earth, what lay outside the solar system. And as I never got any answers to these questions. What happened to this dream? I grew up. I studied geography, and I learned lots of things. I also learnt that some questions have no answers. And I read only yesterday that a Russian mathematician has found an answer to my question about the shape of the universe. So I wouldn't have discovered it even if I had been an astronaut. But I'd still like to, anyway!

Dreams today / My dreams today . . . I don't know. Owing to problems I've had recently, I haven't dreamed a lot. I haven't had the time. But I'd like to work in the theater: to be a costumier, paint the sets. In fact, that would be perfect. I haven't had any other dreams. I really haven't had the time to! I've been sick and, quite simply, I couldn't allow myself to dream away.

Handing on / Would I like to have children? I often think about it. Each time I do something really stupid at home, and stir up trouble for my parents, I tell myself I don't want children so as not to have to go through the same thing I make my parents suffer. I've learned a lot and had a lot of different experiences. I'd love to pass this experience on to my children, but I'd handle things differently from my parents: I'd be a little colder to them. I wouldn't pamper them like my parents did with me. I feel that they were wrong to do so, even if it was done for love. I'd like to teach them the reality of daily life—as a result of what I've been through: the good things and the bad things. But above all, contact with people—I'd teach them how to figure people out, and especially not to be naïve! I used to trust people because my parents taught me to be kind-hearted. But I've come to learn that you mustn't trust everybody. Perhaps the times have changed. When they grew up it was communism in Yugoslavia. Life was simple, so perhaps people could afford to be trusting. Of course, I'm not antisocial. I behave well with my friends. But I'm not nice to everyone!

Hardship / My hardest experience has been with drugs. I know that now because I've left them behind. Now I'm doing OK, and I know that it was my worst experience, the one that knocked me flat. I've had a lot of time to think about it. I think that the war was responsible. Sure, there are people who take drugs in places where there hasn't been any war for fifty years. But I think that, in my case, the war was the cause. It was the war that separated me from my parents. I was a very spoiled child, and I found myself alone in a large city. I went to school, my parents sent me money, I was looking after myself at fifteen. And then I took this other path. The bombardments began in Yugoslavia on March 24, 1999. Right at the beginning there was no electricity in Pristina, and the looting began ... food shops ... any shops—it was total anarchy. As I come from a mixed marriage—my dad's Serb and my mum Albanian—and these were the two sides fighting, a neighbor in the building, a Serb bastard, threatened my sister and me saying that all Albanian females were going to get raped: He was thinking of my mum, my sister, and me. We were young: I was fourteen and my sister sixteen. I was very scared and told my dad I didn't want to stay there anymore. So, with the help of friends, we snuck out of Kosovo in secret. We didn't take the bus because of our first names: My sister's name is Albanian, and she couldn't cross the border. So we went by car and managed to reach my grandmother's house in Serbia. That's how we got separated. It was heartbreaking. We cried all the time. We thought we'd never see our parents again because they had stayed here. An Albanian and a Serb together? Everyone would want to kill them! Both sides! It was so hard.

Lessons of life / My best memory? Doing drugs. That's the best memory of my life. It taught me a lot: I know that people who haven't taken drugs don't understand. "How can she think like that?" But I reckon that's my best memory: I also learned a lot about the bad side of people, and that helped me with regard to the good side. It's like the cross you have to bear. When I started high school, it was a very bad place; most of the kids there did drugs, and that's where I began. I thought, "Wow! We're doing what others don't do!" Totally stupid. For two years it was great: no sorrow, nothing but parties. And then it began to turn nasty. I was alone, without anybody. I was in bed all day. I thought, "The others go out in the morning and do things. I spend all day in bed and don't do anything. I feel dizzy." You'll do anything to get your hit … sell yourself, your soul, your body. For your shoot, for something worthless! That was the beginning of a very bad period with really nasty people—criminals. It was the worst; it was hell. Heroin is the Devil! The Devil! You're in love with the Devil. It's like you're in love with someone, and he's your obsession. Like a psychopath, you love someone, and you'll kill for him. You'll do anything. You love it and you do anything for it. And as it's the Devil—I'm certain it is—you begin to get into stupid things. It's like taking a knife and cutting yourself. It is just pain … pain! pain! You love pain, you adore pain. And the years go by. Like everyone who does drugs, I began to detest that life. If you're strong and intelligent, you get out of it. If you aren't, you remain trapped.

Happy / Yes, I'm happy. There are things I'd like to change to be happier, and I'm working on it. But I'm happy. I won't stop there. I think I can do better and that there's still lots for me to do. But compared to what life was like on drugs, I'm very happy now!

Happiness / What's makes me happiest is to wake up in the morning and have a cup of coffee. Not to have to worry anymore about finding money and drugs. Not saying to myself, "Oh, God, I feel bad! I'm sick! Oh my God! I've got pains all over my body!" Now I wake up like a princess, have some coffee, and think, "What shall I do today?" That's what makes me happiest: drinking coffee without feeling miserable!

Crying / I haven't cried for a long time. Music often makes me cry. When I hear a really beautiful song … I have to let it out; I cry for the music! Sure, I cry over sad things, but often I cry over music, and I like that feeling. Why? Because it's my inner feeling … I don't know how to explain it. I'm expressing my feelings. There are shy people who don't express what they feel and keep it all inside. That's bad because, sometimes, they explode with it all, and that's bad!

War / My experience of war—it's strange because it was nice! When the bombing started, I was fifteen. We used to sit outside all night on the bridge wearing "target T-shirts." We waited for the bombs. It was stupid, but it was fun: Everyone was there, and things would happen every evening. I had some good times. And the sirens at seven o'clock! That was the time of my first boyfriend, and when the sirens went off at seven, we began to kiss! My first experience ... it was a real love story! I had some really good times during the war. It's stupid, but that's how it was! I think of war as something simple, desperately simple. I think that it's totally stupid. I think that all people like me—normal, uncomplicated people—think that way. People who killed and stole were criminals. And it all stopped when some important guy in the background said, "OK, it's over!" We began to live together again, and that's not so easy! Even if you don't want to, you have to stay, because it's our land. Everyone stays on his land, and you start talking again to the others. Some people had all their family killed—they think differently about war. But from my point of view, not having been affected by it so much, I just think it's completely stupid!

Leaving your country / My mum, an Albanian, married a Serb. They have different cultures. When I'm with Serbs, I prefer the Albanians, and when I'm with Albanians, I prefer the Serbs! They can't understand what I feel because I'm half-and-half. I love being that way! Because I reckon that only people of mixed race are able to think objectively about the two sides. I'm lucky. So I don't think I'm going to stay here. When I left Pristina, I didn't think I was leaving my country. It wasn't to go traveling, it was a forced departure, it was like being a refugee. When you're a refugee, you leave your home because you must, not because you want to. And besides, I was separated from my father and mother: It was a really awful way to leave.

Anger / I feel Serb and will always feel that way. But it's very hard: I'm a girl, I'm pretty. Albanian men generally like Serb girls because they're freer. It's a different culture. When I go out with friends, they want me to be Albanian; they say, "Your mother's Albanian? So you're Albanian too!" They want to fix that in my head! I'm half Serb, half Albanian, but my father's Serb, and so I have his surname, so I feel Serb. But they also say the opposite! It's stupid! They say to others, "You're Albanian because your father's Albanian." And to me they say, "You're Albanian because your mother's Albanian." That makes me angry.

Nature / If you think about Kosovo before and after the war ... before, it was mostly countryside, but now, it's been built on. Every day, even overnight, new houses spring up like mushrooms—pop! pop! pop! Every day, when I wake up, there's a new house: It's continual change taking place under your eyes.

God / I believe in God. Yes, I believe in God. Religion is more a history of tradition than belief. I like to go to church because of the frescoes and the icons. I think that religion exists more to manipulate people than make them free. It's comforting to believe in something in life, but I prefer to believe in God in my own way rather than through religion.

Love / Love is that wonderful feeling that brings flowers into your life. When there are flowers, butterflies, and colors everywhere in your life, that's love! And then there's the other side of the coin: anger … those bad feelings that bring darkness into your life. But love brings beautiful colors.

Love / Oh yes! I remember! I was ten and I was in love like crazy. He was two years older than me, and we were together, boyfriend and girlfriend at ten and twelve! When I came home from school, I'd go into our apartment on the fourteenth floor. We were very high, and I'd look down to see where he was. I was crazy about him. I remember my first love very well, very handsome. I'd so love to be in love, but I'm not! Perhaps I expect too much. I love the theater. Well, maybe I play a role: I'm waiting for something, like in a film, and it's not reality. Or I lie to myself: "Oh! I'm in love!" I've told my parents hundreds of times, when we sit down to eat in the evening, "I'm in love today!" And they answer, "Well, we'll see." Every day it was someone new. I think I always expect too much. That's probably why I'm not in love.

Message / Everyone should enjoy every day of their life. It's because we talk about the next life or our previous life that we don't think enough about this life. But it's the key! It's so beautiful, so important! But we don't remember anything from our previous life, and we don't know anything about what's going to happen: all the more reason to live in the present. To really experience it … so that, when death comes, you'll have lived your whole life completely.

My experience of war—it's strange because it was nice!

Maria Rosa

Luis

Queen Ra

Thomas

Véronique

Gallina

WHAT WAS THE MOST DIFFICULT ORDEAL YOU'VE EVER HAD TO FACE?

Thomas / *Lives in France*
The hardest thing I had to face was facing my father, and his violence, and not ending up like him and not waste my life. It something that took me a long time, all alone.

Luis / *Lives in Portugal*
I had no mother. I had no tenderness. I couldn't come home and say, "Mom." I had no support. Not having had something that I could've had is a difficult memory that remains with me. That was my childhood, the bad part. I had no love.

Queen Ra / *Lives in Los Angeles*
My hardest time was ten years addicted to crack, living without a home, and having to prostitute myself. I quit it all in 1987–88. That was the hardest time of my life.

Maria Rosa / *Lives in Buenos Aires, Argentina*
The hardest time of my life were the three years I spent in jail, from twenty-one to twenty-four years old. The hardest thing was getting out and realizing that my friends and boyfriend weren't there. I learned to get over it, to pick myself up, and to want to be happy again.

Véronique / *Lives in France*
The hardest thing for me was—I don't tell many people this—was my elder daughter's incarceration in Italy, and the daily struggle to get her out of prison. What it taught me was that you'd die for you children, because at the time I wanted to take her place.

Gallina / *Lives in Ukraine*
When the nuclear power station blew up, it was like the Last Judgment. I lived here and the cows had to graze farther away. There were plenty of cars on the road, and it wasn't possible to cross the road with the cows. It was a really tough time. It was hard for everyone, both young and old. It was traumatic for us all. We survived, but why are we all sick? Sometimes it's pain in the stomach, sometimes in the head. We're already old, but what about the young? People have been sick since that nuclear disaster.

The toughest thing I had to deal with was not to have my mother anymore.

Darabe / *Lives in Tanzania*
The hardest thing is hunger, and
drought, like last year.

Nadia / *Lives in Turkey*
My hardest experience happened six
years ago: I got a brain tumor. The
day I found out—I'd had an MRI in
Istanbul—the doctor immediately
said, "You have a brain tumor."
I went out onto the street, there
was traffic—it was Istanbul—and I
thought, "What do I do now. I have a
brain tumor, and everyone is moving
around me. I'm going to die. That's
it." I called my husband, who was
working. There was a lot of noise.
He didn't hear what I said. I was all
alone, and I thought, "I'm going to
die. That's it." That experience was
the hardest and also the best in my
life. Both. Because the result was,
once they had my operation, my life
changed. I changed my lifestyle. I
began to do as I pleased. I didn't see
anyone I didn't want to see. I think
it was both the worst and the best
experience.

Angela / *Lives in Spain*
The most difficult time of my life
without any doubt was being a
mother. I'm not talking about rais-
ing my daughter, but the physical
experience of the pregnancy and the
labor. It's both brutal and marvelous.
I guess all mothers think the same,
but it's a brutal physical experience

nobody says anything bad about,
because that's not done. There's
social pressure on us mothers: We're
supposed to love and be thankful for
our capacity to have children, but it's
a brutal experience. Brutal. Having
another human being inside you
all of a sudden, it's something that
completely disrupts your chemical
system, your whole body, and your
spirit too.

The hardest thing in my life was to face the tsunami.

Risma / *Lives in Indonesia*
The hardest thing in my life was to
face the tsunami and losing every-
thing I have, like my beloved family.
So day after day, life becomes so
empty for me. But because I still have
my brother, I feel I have to live, for
him at least.

Nadia

Darabe

Angela

Risma

Ana

Ibrahim

Adria

Schie

Ana / *Lives in New Orleans*
Ricky came back immediately to
see the damage done to the house.
Everything was in ruins: We couldn't
go back to see our home for more
than a month. Right after Katrina,
Hurricane Rita arrived. Anyone there
had to leave again. The city was
flooded a second time. The water
reached a height of more than ten
feet. That was the worst week of my
life: We'd all moved out, and for close
on a week no mobile phone was work-
ing as all the transmitters were out
of order. It wasn't possible to contact
the people who were there: I couldn't
find out if Ricky was alive or not. I
had more or less accepted that we
might've lost our dog, Chewie. The
only information we had came from
the television news.

Ibrahim / *Sudanese refugee who lives
in Chad*
The war made me cry. They disembow-
eled my uncle and threw him in the
fire. They raped my two sisters and
took them away somewhere. I had a
six-month-old baby—they threw him
against the tree. And before me, there
was an imam, named Ali Ahmed,
preaching religion and friendship.
There was a fire, and they threw him
into it. It was terrible, and I cried
that day.

Adria / *Lives in Rwanda*
What frightens me most and haunts me
every day is the Interahamwe (horse-
back militia) who treated us badly in
1994. They injured me, cut me, caused
my handicap, raped me. In fact they
caused an "incurable handicap" that I
still suffer from; every night the wounds
give me pain in my head, arms, and
thighs, and everywhere they hurt me.
That causes me a lot of distress, and I
think about those who did it. Moreover,
they continue to persecute me by let-
ting me know that they can kill me at
any time.

Schie / *Lives in Mexico*
The most difficult thing? I've had many
totally desperate moments. But the
experience of losing my family in the
gas chamber. In the same chamber I
lost my mother—my father had already
been executed—my three sisters, and
my nephews. All I have left are my three
brothers. My family: dad, mum, three
sisters, three brothers. Us three broth-
ers were selected, set on the right side,
which meant "life," that's to say that
we were to be left alive. The others were
killed in a gas chamber like insects, as
though they were capable of commit-
ting murders or doing wickedness in
the world. Who condemned them to
death? Evil people. I don't believe that
my nephews of three and four years old
deserved to die for having done some-
thing evil.

111

Kosal / *Lives in Cambodia*
Pol Pot's regime made life difficult for everyone. I was fourteen or fifteen years old. I was part of a group that carried out the physical labor that was the hardest. I'll always remember when they killed my friend. He was ill. At the moment he decided to rest, he was dead. They came to beat him with sticks. He was hit five or six times. Then they saw he was dead—such cruelty toward the dead, torturing the dead. Imagine how they treated the living.

Kerstin / *Lives in Sweden*
I'd call the violence that I suffered torture. My father is probably the gentlest person I've ever known. As for us, we learned to listen at doors to find out the right moment to go. We knew that we said things that we shouldn't, and we knew that, when we said what we shouldn't. I'm not saying that they hit us, because hitting a child with a chain is not hitting—that's torture. But then there's another side to the violence that's psychological. She'd say, "If you don't do what you're told, I won't protect you from being beaten." It took me a long time before I understood that my father was using physical violence and my mother psychological violence.

Yavuz / *Lives in Turkey*
The worst thing in my life was the torture and time I spent in a military prison. They say that torture is a "crime against humanity." The word is easy to say, but you have to experience torture to understand what it means. I could only understand barbarity and inhumanity by living through it, and I still have yet to understand the damage it has done to my mental state and mind. But the words "barbarity" and "inhumanity" don't give an idea of what I had to go through at Diyarbakir military prison. There, I learned what suffering, cruelty, and desperation were. I learned just how far men can go, I learned about the absence of human rights, the cruelty caused by the absence of rights, and I learned what dictatorship is. I learned how innocent men can be transformed into violent people. The truth is that I learned what can generate evil, sorrow, and violence. And when I saw just how much harm it can cause humanity, I knew I shouldn't do it myself.

I'd call the violence that I suffered torture.

Kosal

Yavuz

Kerstin

Kanha

Malika

Concepcion

Oscar

Kanha / *Lives in Cambodia*
The hardest time for me was when I collected plastic and metal from the dump. It was the hardest thing to bear. It's hard to talk about it. "Hard" is the word. I was little. I didn't know anything. I didn't have enough to eat. I had none of the things that the rich kids have. Every day, I'd work early in the morning to late at night. I only knew garbage dumps, just gathering plastic and metal to make a bit of money to feed my family. I worked at night and at day in the heat. I didn't dare complain, even if I was hurt, cut by metal, or hungry. Sometimes a whole day would pass without anything to eat, but I had to put up with it. The big difficulty was the hunger, the thirst, and the heat, and I was only little. Living on the dump was very, very difficult. But it taught me to know about hunger, and I learned how to go without. It's burned in my memory. One day in the future, when I have a good life, I'll never forget that I achieved it thanks to the effort, struggle, and difficulties I went through.

Oscar / *Lives in Buenos Aires, Argentina*
The hardest thing was being unemployed for several months. That scarred me later in my life, when I had to fire or hire people. The impact by the lack of work is the most terrible thing in life.

Concepcion / *Lives in Mexico*
The hardest thing in my life was being married. It didn't work out. I learned one thing: I won't make that mistake again, not with him or anyone else. I won't make that mistake again, because he drank a lot. He beat me. That's why. No, I won't do it again.

Malika / *Lives in Pakistan*
I was studying for my diploma, and I had to hand in my homework. One day my uncle came and said to me, "Tomorrow's the day of your engagement." I had vaguely heard that I was to be engaged, and I was surprised by the fact that it had all taken place so quickly. There was no time to prepare. I wasn't ready to get engaged the next day! But my father and uncle came that evening, and the next day I was engaged!

The impact by the lack of work is the most terrible thing in life.

Nompucuko Gloria / *Lives in South Africa*
I was eighteen and studying in high school. My adoptive mother told me that she'd had enough and that she was going to marry me off. She "lent" me to some people. The fact that she'd never educated me was hurtful to me; then she defended her son when he raped me. She said that news of it should never get out of the house. And then, she never spoke to me of my real parents during my childhood. These were all negative experiences I had to suffer. One positive thing came out of them all: It gave me the strength and certainty that I would have my children educated. The dishonesty. I always want to be honest with my children. My kids have different fathers, but they know it, and I think that it's good for them to know. If I were to die, they'll know who their father is and will have a place to go.

Màrio / *Lives in Portugal*
The most difficult, the most complicated thing for me to deal with was the death of my mother. What did I learn? I learned that we can live without those we love around us, we can continue to smile and cry, and we can continue to be happy in spite of everything. But I will always miss her very much.

Marie / *Lives in La Réunion, France*
The greatest suffering I've known was the death of my husband. We were together, he was alive, we were talking, and all of a sudden he died. It was an aneurismal rupture. It happened very quickly, like snapping your fingers. One moment you're alive, the next you're dead. Before that, I had known death because in La Réunion we take part in funeral vigils, and we talk about it. It's part of life. There was a sort of logic to losing my father, but to lose my husband, when we were full of projects and we had a small child, that was a form of unspeakable violence.

Rachid / *Lives in Egypt*
The hardest thing, I've carried it since childhood: It's the loss of my big brother. He was a year and some months older. We lived like twins. This brother was taken by the sea. I wasn't there—my parents and one of my brothers were. His body was never found. Still today I dream of him. He died when I was fifteen. He was sixteen. Each time he comes to me in a dream, he tells me things, and I say, "Stop! First tell me where you've been!" So the wound is still open.

To lose my husband ... that was a form of unspeakable violence.

Rachid

Nompucuko Gloria

Marie

Màrio

John

Akusawa

Lynette

John / *Lives in New York*

The hardest thing in my life was when a person I loved very, very much, and who I think loved me very much, killed herself. It's something I think about every day. My family tells me incessantly that I wasn't responsible, but I can't get away from the idea. It's dreadful to be close to someone who kills himself. It's one of the mysteries of life that I don't think I've solved to this day. But in any case, I understood that the responsibility of every one of us, whether we're aware of it or not, is enormous. We must all judge ourselves and feel responsible for our actions. I've realized just how deep my relationship to this person was, and I feel that I'll always bear some of the responsibility for her death for the rest of my life. I'm afraid I'm always going to be marked by this experience.

Akusawa / *Lives in Los Angeles*

The most difficult time of my life was when I was told that my youngest son, who was twenty-five, had been brutally killed. That was very, very hard, and I learned about it from the coroner, which wasn't the best way at all. I remember that my heart was beating so fast I thought I'd have a heart attack, and I can see myself asking them, "Why? What happened? What've I ever done to deserve this?" The more I asked myself this, the more I wondered how many people have lost their lives, how many people die a violent death, how many mothers have suffered as much as I have. I learned that we have to face up to our trials, and that the strongest of us will learn a lesson

from them. There's a lesson in everything in life, and life has a sense that we have to discover. I keep looking for the sense in my son's murder because I believe even that has a meaning. I also know that the inner strength I've drawn from it I can share with others who maybe don't have the same force and energy to withstand the loss of a loved one. Not only losing a loved one, but at the hands of another person. That's the hardest thing I've had to bear in this life.

Lynette / *Lives in Australia*

Oh, look, I don't like to talk about all the bad things because I dislike them. If you dwell on them too much, they bite you. I just think that I've been here for two years in this job, and I've done nothing but cancel, and I haven't seen any positive outcomes in some areas. And it's sad that some people can't change, or choose not to change, because it's frightening to change, because you don't know if the family is going to support you with change. So for me, all my teachings, everything that's happened in bed, for me, is sexual abuse, incest, domestic violence, the mental anguish, the removal, my mother's death, been disowned, even my own daughter had been taken away. These things are lessons. I've looked at them as lessons. If I have to dwell on them as a victim, I would not survive today. But I choose to teach other people that you can change your life if you have those that are strong enough to support you, and you have the strength, and your values, beliefs, your identity, your spirituality—you can achieve anything.

Misbah

Lives in the Palestinian Territories

What scares me is that the future I'm trying to build for myself can easily be changed.

Background / My name's Misbah. I was born in Al-Brej refugee camp in Gaza in 1981. I'm twenty-seven. I studied math at Ramallah and later found a job. Right now I'm a web designer.

Memories / I remember certain places in Gaza. I used to love nature and animals a great deal. I had family in the area. We used to go bird-hunting, climb the trees, and play in the fields and small meadows. I really love the sea and often remember a day we went out as a family to the beach. For me it was like a holiday because we were going to have fun all day long and go swimming. Those are great memories. I lived in Brej camp, where there were a lot of people, a lot of movement. You might see five hundred children playing in the street! I thought I was lucky to have family living in the countryside, where there were trees and space to play.

Learned from your parents / My father taught me to be self-reliant. I remember once, or rather several times, he asked my opinion on something. For example, when I was ten, he was working in the house and he asked me, "What d'you think? Do you want me to do it like this or like that?" Of course, he knew the answer already, but he loved to make me a part of what he was doing. He wanted my opinion for me to get used to making decisions. I think that influenced my personality enormously.

Lessons of life / I have the impression that my childhood had an influence on my life today. As life was very hard, I used to work to help bring money in for the household. I have the feeling that it was forbidden, that I was not old enough to work, but I did anyway. Today that affects me two ways, one positively, the other negatively. On one

hand I spent my childhood working, with responsibilities that were way beyond my age. On the other, it allowed my personality to form, and it taught me to deal with problems and solve them all alone. There were plenty of situations that taught me things you don't learn at school, that you only acquire through experience. Another aspect of my childhood was negative. I love music, but when I was little I didn't have the right to listen because our family was very old-fashioned. Music was forbidden in most of the camp and considered a sin. So I never had the chance to listen. Today, I realize it was a shame to have missed all that and that there were lots of things I missed out on. If I could've listened at my leisure, today I would think differently and take more pleasure in life.

Ordeal / The greatest hardship I've known? Being arrested and put in Israeli prisons. In 2002 Ramallah was invaded when I was in the street. Anybody could be arrested anywhere. There were waves of arrests right across Cisjordania. Those were the hardest three months of my life. It was a crazy situation. Nobody could understand what was going on. They arrested people and put them in the Israeli jeeps, then they took them to a sorting station. For instance, "You, you've done wrong, so you stay here. You, you haven't done anything, so you can go home." They began by arresting everyone, then did the sorting out afterward. Through bad luck, I was in a very particular situation. According to what I was told, it was because of my brother who died a martyr in Gaza during the Intifada. It was said he was a member of a group of activists. For the Israelis, that was a good reason to arrest and interrogate me. That experience affected me even more than the shock of my brother's death. It might seem strange that the shock of being in prison was the hardest experience of my life rather than my brother's death. But the death of loved ones, it has to happen, it's natural. Whereas prison wasn't natural at all, especially for someone who hasn't done anything wrong. I'd heard plenty about prison and what happens in there, but I could never have imagined it would be so tough, above all when you're innocent and there's no reason for you to be there. Although my life today is also a "prison," a larger prison, life in a real prison is much harder. I spent twenty-six days in a cell measuring 3 feet by 6 feet. If you want to talk to anyone, it's to an inspector, and that's morally exhausting.

Joy / My greatest joy was when I came out of prison. I was very emotional. "I'm out, I'm out of prison!" I kept saying to myself. I couldn't believe it. I'd been shut up for a month without seeing the sun. When I came out there were people in the street and sunshine! It was the greatest moment of my life!

Anger / I arrived in Ramallah with a permit valid for only one day. Of course I knew I had to study for four years. Then there was the Intifada, and the situation became critical in Gaza. Besides, there's no work back in Gaza, but I managed to find a job here. I don't get the chance to see my parents. For eight years now I've lived an hour

away from them by car, but neither they nor I are able to visit. If I went to see them, that would change the course of my life. The situation here is very difficult. A lot of people ask for permits that are rejected by the Israelis because their son was in the resistance and died during the Intifada. As a result, they're forbidden from leaving. It's the same for me: If I go to Gaza, I have a chance of coming back free, but they might very well also arrest me a second time.

Fear / For the seven or eight years I've been in Ramallah, I haven't left the town. I'm scared of the slightest Israeli soldier—even one who doesn't even have a high school diploma can disrupt my life completely. What scares me is that the future I'm trying to build for myself can easily be changed. I can see myself getting married and buying a house here, but all it takes is one soldier to arrest me and send me to Gaza for my life to be ruined. So I can't build anything here.

Changing your life / If I could change something in my life, I'd alter it so that my childhood hadn't taken place in Gaza. I would've loved to live with my family in freedom and more in contact with nature. Who cares whether our financial situation is bad, or whether or not we have a beautiful house. It doesn't matter as long as we are anywhere but Gaza, free and safe. . . .

Love / My only contact with my parents at the moment is through the phone, but sometimes I hate using it. It filters out the tenderness and your emotions and leaves only your voice. My deepest feelings are transmitted through sight, hearing, and touch. I'd love to see my parents in person, to touch their hands; I'd love to be able to hug them. When I hear them on the telephone, I miss them less of course, but I only hear their voices: everything else is missing.

Religion / Religion was very important to me at a certain point in my life. My parents raised me in a way that religion influenced how I behave. I used to love religion, but later, I learned the difference between what's real and false without religion having any say in the matter. I know that God exists, but what I was taught does not have the same value today. Sometimes I tell myself that we're all free to have our own religion that governs what we say and do. I respect people who act with humanity regardless of color, race, or religion. As long as you lead your life humanely, religion is no longer of importance.

Ivica

Zhixi

Maria Teresa

Tava

Erick

Loïc

Ekaterina

Marthin

WHAT IS YOUR GREATEST FEAR?

Ivica / *Lives in Belgrade, Serbia*
What do I fear the most? Women. Beautiful women. And the lack of money in Serbia. That's what I fear the most. Otherwise, life is great.

My greatest fear is that God does not exist.

Maria Teresa / *Lives in Italy*
I can't tell you what my greatest fear is, I'm too ashamed. It's horrible, I don't know if I can tell you what it is. Shall I tell you? It's that I might be put in a coffin when I'm not really dead.

Zhixi / *Lives in Beijing, China*
My greatest fear is that my son will find a woman I don't like and who will come and live with us. And that after the wedding she'll decide how things are to be run, and we won't be a unified family anymore.

Tava / *Lives in Papua New Guinea*
I'm afraid of the volcano. I fear it will erupt again. I survived one ten years ago. And now I'm afraid of the volcano's power and hope it will never erupt again.

Ekaterina / *Lives in Siberia, Russia*
I was never scared. I was brave. I fear nothing and no one. It's better they'd be scared of me.

Marthin / *Lives in Papua New Guinea*
I'm afraid of Satan. I'm scared of going to hell—very scared of meeting Satan. So I try to be a good person.

Erick / *Lives in Cuba*
My greatest fear is that God does not exist.That we are alone in the universe—that is my greatest fear.

Loïc / *Lives in France*
That God exists: That would be my greatest fear. I think so, yes, my fear is knowing that God exists.

That would be my greatest fear ... that God exists.

WHAT IS YOUR GREATEST FEAR?

Bruno / *Lives in Indonesia*
The last time someone asked me about my biggest fear, I was sitting in a yacht, off Sumatra, and I told him that my biggest fear was losing my legs. Three months later, I had a car accident and broke my back and basically lost my legs. So, my biggest fear now is I've learned not to have a biggest fear, to let it go.

Penda / *Lives in Mali*
What scares me are the demons. Those we can't see. I know they exist, and it worries me. It worries me. It keeps me up at night.

Safyyeh / *Lives in the Palestinian Territories*
When a baby is born, there are mothers who never stop telling it, "Watch out! You're going to meet the jackal, you're going to meet El houmamé: a strange beast." These things shouldn't be said to a child. You have to let a child make his own way so that he isn't afraid, so that he grows and gets used to walking at night where he wants, unafraid.

It's fear itself that I fear. When you let it in, you lose control.

Anja / *Lives in Sweden*
If I may be philosophical, I think that it is fear itself that I fear. When you let it in, you lose control. Yes, once you let fear in, you have no more hope, you're bereft. Yes, I fear fear itself.

Meenakshi / *Lives in Tamil Nadu, India*
I'm afraid of my husband. When he drinks, he beats me. When he drinks, I'm afraid. I'm afraid he'll beat me to death.

Georgette / *Lives in Madagascar*
What I'm afraid of, as it would complicate my life, is having more children. Life is hard already. I have many children. The land with which I feed my children is small.

Willem / *Lives in South Africa*
The only thing that I would really be scared about is that I could possibly infect my wife. We've been always very careful in our love life. And it would be a very difficult thing for me to deal with if my wife had to become HIV-positive through me, because I love and care for her so much, and wouldn't want to hurt her in any way, and definitively would not want her to become HIV-positive.

Willem

Penda

Bruno

Anja

Safyyeh

Meenakshi

eorgette

Wenyuan

Evguenia

Miora

Mark

Kurfa

Maria

Mario

Esperanza

Wenyuan / *Lives in Yunnan, China*
My greatest fear is getting sick. Health problems are horrible for everyone but especially for us peasants. First, we have no insurance, and we don't have much money, so getting sick is catastrophic. I really fear for my mother. It's OK being poor, but you mustn't get sick.

Evguenia / *Lives in Siberia, Russia*
We haven't been paid in months. We scrape by. All Russians are afraid of tomorrow. We don't live, we survive—we fight for survival.

Mark / *Lives in Ireland*
One of my biggest fears, and worries, is the fact that I might lose my job—very straightforward, to be honest with you.

Kurfa / *Lives in Ethiopia*
What scares me the most is hunger. When my kids come home from school, they need something to eat. I teach them not to eat much and to save something for tomorrow because we don't have enough food.

Mario / *Lives in Bolivia*
They're saying it won't rain. And if not, there will be no crop—that's what we're afraid of. Rain is a blessing from God. And when it rains, there is a crop, and if we can sell it, and make money, the family has income.

Esperanza / *Lives in Cuba*
My greatest fear is being alone in the world, without friends or family. Solitude terrifies me—it really worries me.

Maria / *Lives in Argentina*
My biggest fear is a storm, a raging storm—that scares me. Something happening to my family.

Miora / *Lives in Romania*
I fear losing my mind, not remaining lucid until I die. We old folks fear mental illness, going crazy, or being vegetables. We'd prefer to die now, standing, than to stay alone with the caregiver. I'd rather die all at once, but you can't know that.

I'm afraid of death. I think of it often. Every time I go to bed I think about it.

Robin / *Lives in New York*
My first greatest fear is that I'm going to die before I do something really good for humanity. You know, I was so busy raising my kids, and now I'm working and I commute—it's such a long day, it's a twelve-hour day between commuting to New York and coming back—that I don't really have time to volunteer. And I just feel that I need to do that before I die. My second fear—believe it or not—is another terrorist attack, because I was in Manhattan when 9/11 happened. I was entering the tunnel as the plane came over. And in fact the person next to me—I was sleeping—woke me up and said, "Oh my God, that plane is flying low! It looks like it's going to crash!" And that was the first plane that hit the World Trade Center. So every day that I go through that tunnel, right before, I have the fear that it is going to come crashing down. My other fear's just that something is going to happen to my children. You know, my happiness, and everything, really depends on their happiness. That's when I feel good.

Birgit / *Lives in Sweden*
My most painful experience was losing my son. There's nothing worse for a mother than losing her child. After that, you fear nothing, the worst has already happened. I assure you.

Myriam / *Lives in Israel*
May god protect us! I don't even want to think of the day something happens to my children. I have two kids who are soldiers in combat units—I'm scared they'll be hurt. It's daily life in our country.

As a Holocaust survivor, I have no great fear. Nothing could be worse.

Norma / *Lives in Buenos Aires, Argentina*
Fear was always present. I remember, one day someone knocked on my door and called out, "It's the police!" I thought it was a joke, but no, it wasn't. OK, it wasn't anything important, they were just checking my address, but I had hidden the children anyway. I was calm because we didn't have any books anymore, we had burned or buried them all—anything that might have been suspicious … even the book of poems by Neruda was hidden. We were always afraid. Even as you were walking down the street, a car could pull up, and they could throw you on the ground, then search you for a weapon. It was terrifying.

Norma

Myriam

Birgit

Kouta

Robin

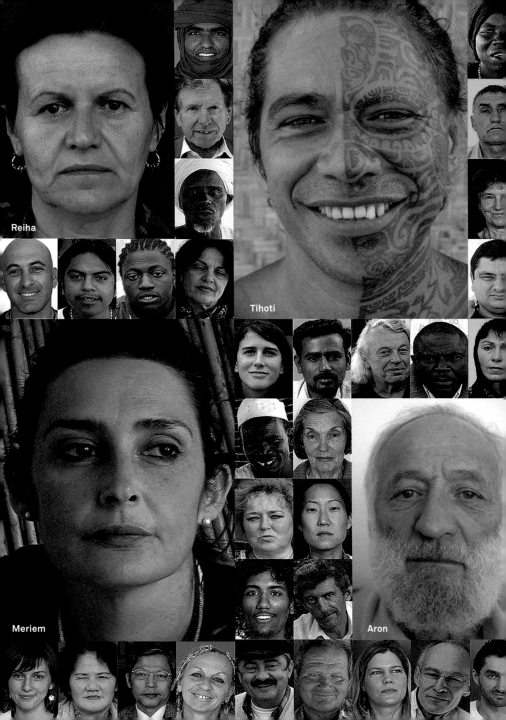

Reiha

Tihoti

Meriem

Aron

Kouta / *Lives in Japan*
What I fear the most is war. When I was a child, Americans would strike bomb attacks in the evening. Why in the evening? So we couldn't sleep. The noise of fighter planes is a vivid memory from my childhood. I'll never forget it. As soon as the siren sounded to warn people, the bombers came with this clamor in the sky. Then I'd see them fly away. You see, the city of Hiroshima is surrounded by three mountains. There was a giant projector on each summit to locate airplanes. And in my head, I see the image of a light, floating on the black sea. That scared me back then. Still today, that image remains in my head.

Tihoti / *Lives in Tahiti*
My greatest fear is that the great powers of the world will destroy us with their wars and politics, with all their nuclear bombs. That one day man will destroy the planet with his wars, his clash of mentalities. That's something I cannot understand. When you look around at the world today, there are lots of reasons for being afraid that the planet will be destroyed, as well as ourselves.

Aron / *Lives in Israel*
I think that as a Holocaust survivor, I have no great fear. Nothing could be worse. In relation to what I experienced as a child, everything else is trivial.

Meriem / *Lives in Tunisia*
I'm afraid of man, human unkindness. I'm afraid of the behavior of mobs, the cruelty in all of us. I'm really scared of all that, of mass phenomena, of human gregariousness.

Reiha / *Lives in Bosnia-Herzegovina*
I believe that we can all live together. We have to. We all lived together for many centuries, and we have to live together. Where I come from, there were Serbian and Muslim houses all together. There was no separation. We went to religious celebrations in each other's homes. This lasted for centuries. I don't see how you can live next to each other and not speak to or see each other. I wish it was as it used to be, going to religious celebrations at each other's homes, and birthdays, and baptisms … that we'd get along, that we'd live like normal people, without being afraid.

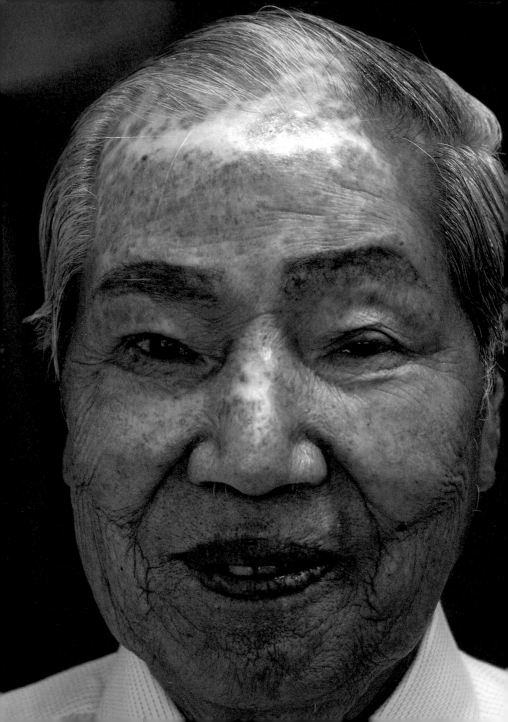

Sunao

Lives in Japan

I was twenty when I lived through the atomic bomb attack on Hiroshima.

Background / My name's Sunao. I'm eighty-one years old. I'm the president of an association of hibakushas [radiation victims of the atomic bomb].

Ordeal / I was twenty when I lived through the atomic bomb attack on Hiroshima and was just over half a mile from the epicenter. I was on my way to university when I was blown over. My body was hurled ten yards by the force. Of course I lost consciousness. When I came 'round, everything was black. I didn't understand anything. I didn't see the atomic mushroom cloud. Everything was so dark, I couldn't see a hundred yards. At first I was shocked, then I realized that my face was burned. My ears were torn, my lips swollen. Then I saw that my hands, too, were black and burnt. My shirt was in tatters, my pants too. Shortly after, I realized that I was running with my shirt in flames on my back. I ran for ten or fifteen minutes, but I was in such pain that I took off my shirt and put the flames out. I was bare-chested and wearing only my pants. Even today, sixty-one years later, I still have the scars of the burns. If I took off my socks, you would see how the skin on my feet is drawn tight. On my hips too. I have burn scars right across my body, or pretty much all. For a week I managed to stay aware of what was happening because I had to leave Hiroshima, as it was in flames. I spent several nights in the open. There was nothing in the streets, and even the houses had all burned down. Everything had been destroyed. It was a deserted wilderness. I spent a week like that, surviving on food given by generous individuals. It was later that I completely lost consciousness. I didn't even know that it was August 15 and that the war was over. In the end, I spent forty days unconscious. Then my mother found me and took me home. For five months, each time a doctor saw me, he told

me I was going to die. As for me, I couldn't really think straight or do anything; I was immobilized. In January the following year, I began to be able to move my arms and legs a little. A year later I was able to crawl. I was hospitalized ten times. But there's more to tell! During my ten stays in hospital, on three different occasions, they told me I would die during the night. They gave me transfusions—other people's blood. This morning I visited the hospital again.

Marriage / It's not only appearance that counts, even if my face was deformed by the radiation. And nor is appearance everything for women either. But everyone wants their wife or husband to be in good health. I could tell you a lot of women who remained unmarried. The rumor was that they wouldn't be able to have children, so the men steered clear of them. We've lived a long time with this discrimination. And at the time, as information didn't circulate well, people believed that radiation was contagious.

Love / When I fell in love with my wife and I wanted to marry her, her parents were against the idea. As a result we waited seven years. We said to ourselves, "As we can't marry in this world, we'll marry in the next one." Quite simply, we thought we would commit suicide together. We took pills that would kill us in our sleep, but not knowing enough about it, we got the dosages wrong … and we both woke up! So then we thought, "We can't live together in this world or in the other!" and both began to cry. Finally, when we eventually got married, our joy was immense, much greater than others'!

If a country gets the education it wants to pass down to its children wrong, the goodness humanity is capable of can't be attained.

Family / My family … I no longer have a wife; she died thirteen years ago. Now I live with my son. I have one son, two daughters, and seven grandchildren. For hibaku-shas, radiation victims, it was hard to have children. First of all, getting married was very hard. People thought that our life expectancy was very short, therefore no one wanted to marry us. It took me seven years to be able to get married, to be with my wife. Therefore, as a hibakusha, my marriage was a great joy. We had a first child, and then a second, and a third. That seemed miraculous for a hibakusha. I am very

happy to have a family. I never dreamed of fame for my children. I was just proud to see them born, to see them grow up, and to know that they were healthy. It was my wish for my family.

Work / The saddest and most painful time for us all was when the association of doctors of Hiroshima declared that the hibakushas couldn't get better. As it was the first atomic bomb in history, they thought we would all die in the next two or three years. Those hibakushas who had the strength to work had to hide their handicap so as to be hired. But as we were physically weak, we asked for more leave than the others. In the end the employers began to wonder if they were employing hibakushas, and, when that came out, some were fired. When I was at university, I was in an industrial section, as I'd planned to work in industry, but because of my physical weakness, I chose to teach instead, in order to benefit from the holidays in spring, summer, and winter. So I taught for forty years. I even became principal of a school of 1,500 pupils with 72 teachers. Over the years, I often had to go into the hospital. As a result, I really only taught for thirty years.

Fear / What frightens me most are human beings. Human intelligence discovered atomic energy, which is a marvelous benefit. But man has also invented the atom bomb. Scientists and politicians who exploit this energy for military purposes are the most dangerous people in the world. In just one second, they can cause the deaths of tens of thousands of people.

Message / If a country gets the education it wants to pass down to its children wrong, the goodness humanity is capable of can't be attained. Teaching begins in early childhood. I, for example, was given a military education that restricted my mind more than opened it. With that type of education, the Japanese couldn't be happy. Besides, they threw themselves into a war of invasion. When I think about it, I say that education is of major importance. Thanks to a solid education, the ideal I spoke of can be realized.

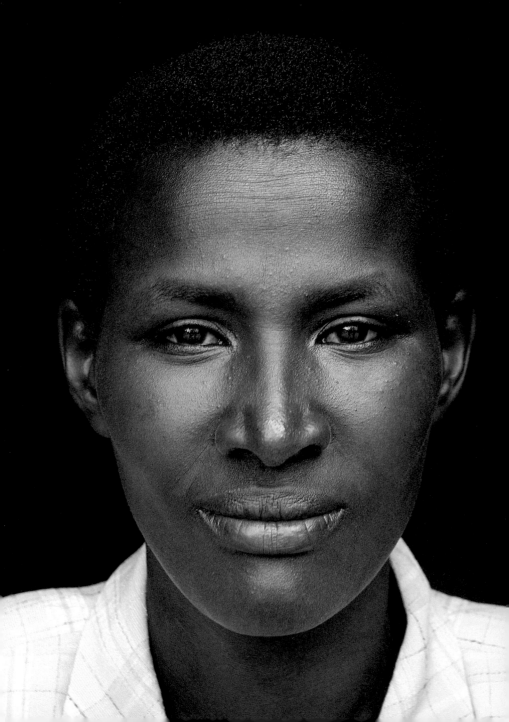

Ernestine

Lives in Rwanda

Of all those I grew up with, I am the only one still alive.

Background / My name's Ernestine. I was born near Mwogo in the district of Bugesera. It's still called Bugesera today. Of all my family, of all those I grew up with, I am the only one still alive. Before the genocide I was in the second year at school, but since then I haven't been able to continue as I'm always ill. In 1997 or 1996, I got married.

War / During the war the first thing I saw was the death of my brothers. I saw it with my own eyes. They killed my two brothers right in front of me. They cut their heads off, their bodies were on one side, their heads on the other, and threw them in the river. They killed another brother before my eyes. They trapped me and beat me. But before beating me, they raped me, and I still suffer the consequences. When they had finished raping me, they wanted to make me drink poison, but some of them prevented the others from killing me so nastily. So they hit me with a hammer. My handicap is the result of that treatment. They crushed my breasts and my lower stomach, saying, "We want to see how Tutsis behave when they give birth." And from that I still suffer the consequences. They hit my head with hammers and nail-filled clubs … now my head no longer functions like it should. In the end they tied me up with my arms behind my back and stamped on my chest. And then they threw me in the river Nyabarongo, the one over there. They said, "You Tutsis, go back to Ethiopia! That's where you come from." They made fun of me because they thought they'd killed me. The water was very deep because in April it rains a lot. The river pushed me onto the bank; I spent three days there, lying in the water. In the end I saw others who were coming out of their hiding places. When they saw me bound up, they untied me. But before doing so, they saw that I had ants all over my body, which was covered in cuts, even around my pelvis. I was in a very bad state. They saw that I was still breathing, but they left me, saying they couldn't do anything else for me because they too

were exhausted. They went to look for the Inkotanyi [the soldiers of the Rwandan Patriotic Front, the RPF] on Gatare bridge. They couldn't take me with them because I was dying, but they left me some water to drink. I spent about five days lying on the ground. That meant five days lying in my own excrement, and my stomach was swollen with water. I can't tell you how I managed to survive, but perhaps it was thanks to that water. Later, I heard people walking through the swamp. It was the RPF soldiers. As the ants were still biting me, I continued to move. The soldiers carried me on their backs to a village in the direction of Rebero refugee camp. Nearby, at Kicukiro, a lot of people had been killed. They carried me there from the side of the river. Some of those who had untied me found out that I was still alive. They recognized me and took me into a tent in Ndera camp. There they handed me over to the refugees. When I saw that it seemed to have quieted down a bit, I told them I wanted to go home to Nyata, where I had escaped death. A military van took me there. I came across people with whom I had hidden, one of whom was the mama here a moment ago, the one with the amputated arm. They all recognized me: Each time they cried out, "Here's Ernestine!" My morale began to return, and I was able to smile. A man arrived in Nyamata, who later became my boyfriend. He was still a soldier. I was going to be treated. He saw that my life was very difficult. He asked me if I would always lead this life. He said, "Come, let's live together." He proposed that I should go with him to Kigali. I said that I didn't want to, but he insisted, saying it would make my life easier. That's how we came to live together, without being married. I never told any of the surviving members of my family. That's how I ended up with him.

Ordeal / At a certain moment, you begin to think that your handicap is the will of God, but it was men that did it! There are moments when I suffer a relapse and fall seriously ill. I tell myself that if my mother were still alive, at least her. When I am in the hospital I see others with their mothers, and I say to myself that if I had mine with me then life would be less hard. If I still had all my family. Even then, being handicapped. But if I had my family it'd be easier. When you're alone, when you've got no family, that's very hard. But you go on living. The doctors try to calm us, to heal us. They ask us to be strong and hold on, and we live with this pain on a permanent basis. Even if you see me as I am today. In Kigali I'm not rich, but it's because I don't do anything in life. I just live. But because I believe in God I'm able to stand all this misfortune.

Death / Nobody can reconcile himself to his own death. It's too frightening. When I have a crisis, I get very scared and think, "This time I'm going to die." They give me a probe and it all calms down. I get my breath back but I don't know anymore where I am. Each time I'm scared of dying. As far as the postwar period is concerned, I've been very scared of dying. I'm frightened of leaving my children alone.

God / The fact that I survived among all those dead—for that I'm grateful to Him. Other people are completely handicapped and die of it. Some girls were raped and infected by AIDS. I know one who lives with the disease. Every time I bump into her, I think of how she caught it, and as she suffered the same thing as me, I suffer for her. As a result, I thank God I was not infected by this sickness.

Words / In the Kinyarwanda language, we say: "Well-raised people hold their heads high despite their inner problems." I may not have enough to eat, but I wash myself and make myself look good so that the people who killed me do not see that I suffer. So that they see that I am in good health. Moreover, when I'm sick, my husband worries a lot over me, and I often wonder how long I can stand this life. Sometimes, when a friend sees me at the hospital, I ask him or her to telephone my husband and to tell him to come and see me for the last time because I'm going to die.

Forgiveness / When someone who's done you wrong comes to confess it sincerely, you say to yourself, "Right, it's all in the past now. I can't bring back my family. I have to be content with that." You tell him, "At least you have the courage to tell me," and that's a good thing. You say to yourself, "There's no problem, he's telling me the truth." He's better than the ones who don't confess. At least you can forgive him better than the others.

Loving your country / I love my country very much, especially now, after seeing the Inkotanyi who fought the killers. While they were carrying me, I was practically dead. They told me, "Don't worry, those people who harmed you won't come back." I didn't believe that could be true. But for the moment, when I see that no one is coming after me, that nobody wants to attack me . . . when I talk about my problems, even if I know that they can't be put right, I find it comforting. Another reason why I love my country is because Rwanda manages to pardon its criminals.

Fear / What I am frightened of above all is the idea that everything that happened in Rwanda could repeat itself. Especially for us, those who have lived through it. I think about it at night, above all during commemoration ceremonies. When they read out the names of the dead, then I fall back into my memories and say to myself, "What if it started again, tonight!" The genocide, that's what I fear.

Relinquished / I have lost my confidence in others. The people who killed us were neighbors to whom my father had given a cow. We used to share everything. They were invited to weddings. And then, all of a sudden, they turned against us for no reason. I'll never trust anyone again one hundred percent. That's fixed deep inside of me.

Denis

Nura

Fatima

Aghsam

IN YOUR EXPERIENCE, WHAT IS WAR?

Nura / *Lives in Bosnia-Herzegovina*
All the consequences of the war are still inside me. It became clear to me that everything can change in just twenty-four hours, and that the madmen, criminals, and dictators of this world can do anything they want. That's what I learned from the war. And I no longer think anything is impossible. Absolutely anything can be done in this world. That's the lesson of this war. Up until the war life was so beautiful! It was the twentieth century, and we all lived well. I couldn't imagine such things could happen, and that we could be plunged into a time that was almost prehistoric, where life has no value.

Aghsam / *Lives in the Palestinian Territories*
War is savagery. It's hate that creates fear, and all the bad things in war. Everything that is good disappears— childhood and innocence come to an end and beauty fades. All that is good in us diminishes to give space for evil to grow. A good Man becomes transformed into someone evil, who loves to hate. War turns us into criminals and executioners.

Denis / *Lives in Rwanda*
I can't believe it because ever since I was a child the Rwandan people lived together happily. I don't know where the demon came from that sowed the hatred. Knowing the people from before, I can't explain how the genocide happened that killed all those innocent people.

Fatima / *Lives in Chechnya*
I remember, in a village, I saw young people who were burned. They lay dead in the rubble, and I remember this mother who went up to one of the bodies. There were many of them, but they were carbonized. She held one of their heads. She was in a state of shock. She was looking for a scar on that head, on that skull. As she was looking, she said, "You had a scar here, my son." She looked around and added, "You weren't so skinny." All around her, a mountain of bodies. She looked at them all, then yelled, crying, "You aren't my son, you are all my sons!" She couldn't find her son's body.

Zijada / *Lives in Bosnia-Herzegovina*
It was very hard. I was pregnant with my youngest. Every day, I would run when they told me that help had arrived, to get two potatoes to bring to my children. I would keep one for my son, who was on the front line, to make him a better meal. For these two potatoes, I was willing to stand and wait for five or six hours. I would go to the places where they handed out potatoes or a cup of oil. Shells were thrown and, in my mind, these shells that were thrown around me were thrown at me. I lived in caves, I ran away with my children. Every day, I would worry when my son left for the front line. I wondered if I'd see him again. But I was always brave. I never shed a tear. I prayed for him to come back. But my prayer wasn't granted. He went to Mount Igman on December 4, 1992, and he never came back.

There they told me to kill the people, and I killed them. There were fourteen of them.

Emmanuel / *Lives in Rwanda*
I killed those people because the régime in power was coming down harder and harder on us. It sent us soldiers and policemen. They told me that they were going to show me where there were riches to be had. So we went there where the first family I told you about was living. And there they told me to kill the people, and I killed them. There were fourteen of them. We continued, and we arrived at another family's house, where I killed three people. We continued, and we went to another family, and there I killed one person. There, that's what I did during the genocide.

Seu / *Lives in Cambodia*
They forced us to become soldiers so as to shoot at the Khmer Rouge. As they couldn't defeat the Khmer, we decided to enter the ranks of the Khmer Rouge to avoid being enrolled by force. I don't like going to war, but anyway I became a soldier for the Khmer because ordinary citizens were despised. The poor were despised. In fact, we're all the same—Khmer and soldiers—and when we find ourselves face to face, we fire on one another.

Zijada

Emmanuel

rahamad

Seu

Rick

Umekishi

Sabil

Nadji

Chirahamad / *Lives in Afghanistan*
Today, on the news, they said two commanding officers, from different groups, were fighting. In a short span of time, they fought three times. On both sides, they are Afghans, but in the name of a party, they're fighting. Because of those people, a lot of people are being killed, losing their parents, becoming orphans. The leaders, the parties' heads, feel obligated to create these wars. What do we want? There is peace. The whole world wants peace, to help us rebuild. But it's all appearances. These commanding officers are pressured by everyone and fight each other. They don't think of our country, of the twenty-five years of war. What have we gained? And people like me—poor people—they give us rifles and five or six hundred Afghanis to fight a war. If I don't have work, I have no choice but to go. I'm going. But those Afghans sending me to war have to understand that they are brothers, too. Why would I kill another man? He is a poor man, like me, who doesn't have work either, who has a family like I do.

Rick / *Lives in Los Angeles*
My father is very insecure and so he tries to make himself feel stronger than he is. And he wants … he wants me to pretend like I'm very physically strong or whatever. So when I talk about experiences like when I was in Iraq and I had to take care of people and I was getting sick from these experiences, he said,

"Don't tell anybody this. They don't want to hear that. They want to hear a soldier is strong and can stand tall and protect everybody. They don't want to see the emotion or the crying or anything like that."

Sabil / *Kosovan asylum seeker who lives in France*
I was mobilized at the start of the war in Kosovo, at the start of 1999, and I fought until the bombs stopped, so up till the time the Serbs left Kosovo—I mean the Serb police and army. How did I survive the war? I don't know how to tell you, it's a strange feeling, because I'm neither Serb nor Albanian [Goranak-Slav-Muslim minority], and I personally have nothing against either the Serbs or Albanians. I went to war simply because I was obliged to. And the only task I set myself was to stay alive, and if possible to protect my family. I had no ideals in this war. I was just waiting for it to end.

Umekishi / *Lives in Japan*
The mobilization order was issued. Then a stamp used to cost one sen, you know, the old Japanese currency. One sen, that's how we were all drafted. The red envelope was an order from the emperor. That's how I got involved in the defeat.

Nadji / *Lives in Bosnia-Herzegovina*
Fire at people? I can't say I didn't do it. I did it. I only fired ten shots. But when I was there, no one forced me. No one. I chose to go. Like I said, they attacked me in my house, and I put on my uniform. When I understood the situation, I took off the uniform, I gave back the rifle—goodbye.

Safi / *Lives in Afghanistan*
When there's war, you show no mercy. The enemy is 15 miles away. How can you know whether you hit their heads or their stomachs? Whether the injured are adults or children? Whether it's me that killed them or someone else?

Yehuda / *Lives in Israel*
Yes, I think about what I did when I was a soldier. We were 600,000 Jews in Israel facing an invasion by five Arab countries. We were trigger-happy; that doesn't mean we put people up against a wall and shot them, but sometimes you'd fire when it wasn't necessary to. Today I wake up in the night and find myself on the battle-field. It really torments me: Should I have pulled the trigger or not?

I never ask myself if I am afraid. I'm not scared of anything.

Jovan / *Lives in Bosnia-Herzegovina*
During the war I did stupid things, and when I think back today, I wonder why I did them. Sometimes, to boost the morale of the troops, I'd do a headstand or a cartwheel one hundred yards from the front line, or run from one street to another within sniper range to show the inhabitants that they needn't be frightened and so that they'd say, "If Jovan can do it, so can I." Really, I never ask myself if I am afraid. I'm not scared of anything.

Hans / *Lives in France*
I remember very, very well at the start of the new school year—it was a real shock for me, quite terrible! We came into school for the first time, and we were obliged to greet one another by saying Heil Hitler! I'd never learned this at home, nobody had ever said it. At my house we used to say Guten Tag [Good day]. And there we had to say Heil Hitler! As I refused to say it, I was sent home on the first day.

Safi

Hans

Yehuda

Jovan

Schie

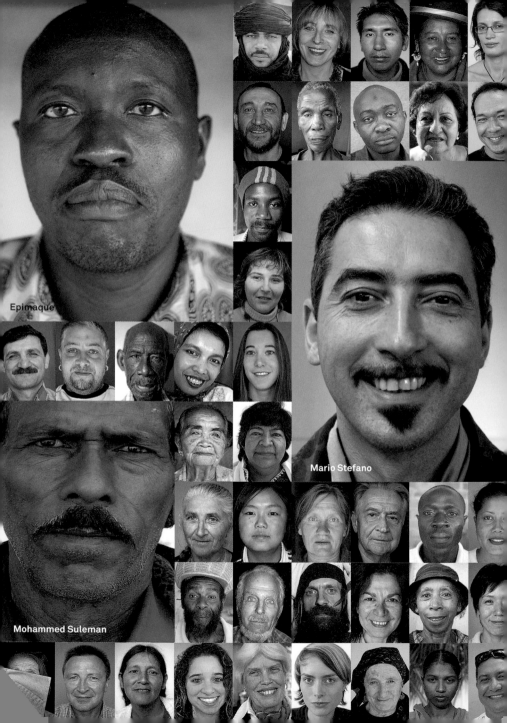

Epimaque

Mario Stefano

Mohammed Suleman

Schie / *Lives in Mexico*
It was the time of Auschwitz. I arrived there by train, I was among the first Jews in Europe as Poland was the first country to fall. We continued to organize ourselves so we could defend ourselves, and we succeeded at something, something very unimportant because in fact we weren't able to do very much. But, on thinking back, I realize it really was something important because we were ready to sacrifice our lives. We managed to blow up one of the four gas chambers at Auschwitz. There were four of them, and in each one two thousand people were killed each day. Eight thousand people a day. In such circumstances, it was very difficult to succeed, but we managed to blow one of them up.

Mohammed Suleman / *Lives in India*
There were plenty of wars around us, so I said to myself that I had to do something. I'm an old soldier; I spent nine years in the army. I wanted to be known for something in my country, so I set off on a tour of India with a sign that said, "Hindus, Muslims, Sikhs, Christians, we are all brothers."

We managed to blow up one of the four gas chambers at Auschwitz.

Epimaque / *Lives in Rwanda*
The reason I decided to hide those Tutsis who were being hunted down is because I love people, because I was brought up properly, and because I am a Christian. I thought that these people who were about to die were also men. There was therefore no reason that could justify their death and not my own. I was fully ready to die at their side. I thought that they were also human beings, that they hadn't committed any crime, and besides, as I got on very well with my Tutsi wife, my brothers-in-law, and everyone, I thought that to die was more courageous than to get involved in these massacres.

Mario Stefano / *Lives in Italy*
When I was in Kosovo, right after the signing of the Treaty, the air smelled strongly of death. That stayed with me. The other example that I give to explain how war affects you is just a quick memory, a fragment. I was on patrol with colleagues in a village that was completely abandoned. There was nobody there, only that very strong smell of death. And in that nothingness, inside a hair salon, there was a horse grazing by himself—almost as if to underline the complete disappearance of mankind in this village, and the return to nature and the animal kingdom.

Jasna / *Lives in Bosnia-Herzegovina*
This hatred that we all feel—how can I explain it? It will stay with us. We'll pass it on to our children. Maybe because, as children, we heard what was going on. When we got older, we saw it. We saw images and understood what had happened. We didn't see it as children. When you see all that, you feel hatred for the war, for the people who made you suffer. That will never go away. I know it's a part of me. I won't forget it. It won't go away. I'll pass it on to my children.

Tom / *Lives in Germany*
My father never talked about the war. He alluded to it. But everything I know about what he went through I learned fifteen years ago from his brother. He couldn't talk about it. Sometimes he would just say, "If only you knew. . . ."

Jean-Marc / *Lives in France*
When my parents came back from the war, my father remained very quiet. My mother was terribly affected by it. I went to look for her at the Lutetia hotel in Paris, where the deportees used to arrive. I remember that it was summer, and the weather very beautiful. It was 1945, probably May or June. I saw my mother come out—I recognized her. I was against the barriers, and I saw her come out. She was wearing the prisoners' uniform, that gray-and-white robe that you know. On the side it had the red triangle to signify she was a political prisoner. And, quite astonishingly, in her hand she was carrying the French flag. It was a flag that she had made herself in Germany. We went back home on foot. My mother gave me the flag, I held her hand, and we walked home. Later, she was consumed by what she had seen and experienced at Ravensbrück and Buchenwald, and she turned it over in her mind incessantly. She was very weak, both physically and psychologically—a severely disabled war invalid. And I have to confess that, from a certain moment, I was no longer able to put up with what she was saying. It was only recently that I finally made the journey in the other direction, that I became interested in my father's life and my mother's life, and that I was able to see once again that I really had amazing parents. Every time I ask myself—it's a dreadful question—if I'd been in their place, how would I have coped?

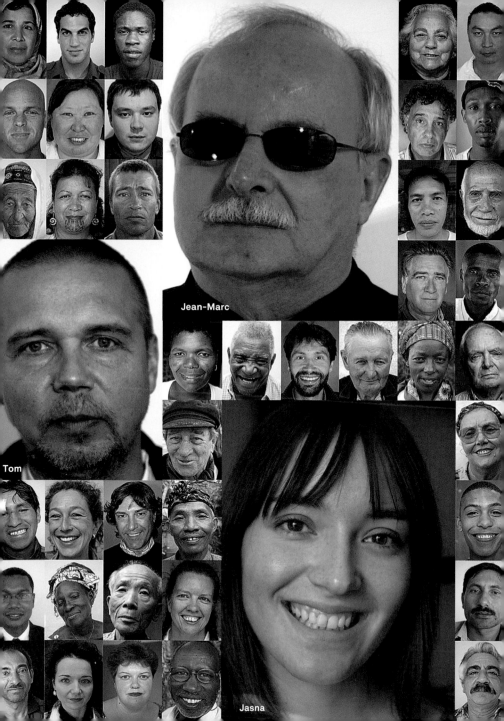

Jean-Marc

Tom

Jasna

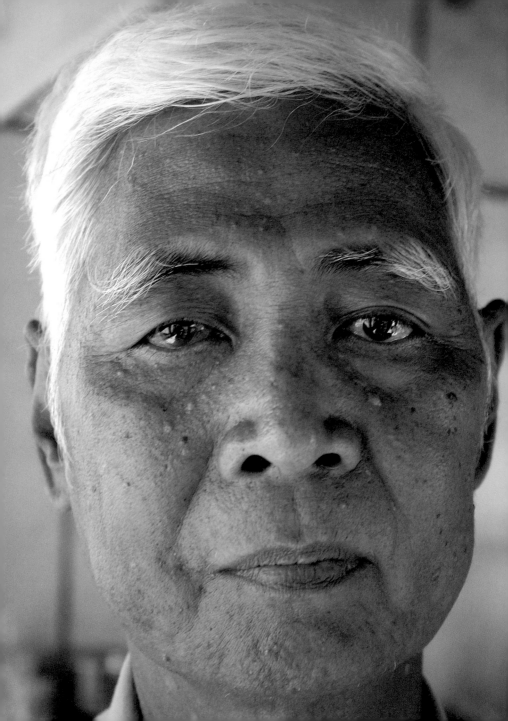

Vann

Lives in Cambodia

How is it possible to forgive if the criminals don't recognize they've done wrong?

Background / I'm Vann. I was born in 1946. I'm married and have had six children. Three died during the régime of the Khmer Rouge, the three others were born afterward, in 1980, 1984, and 1990, a boy and two girls. Currently, my wife runs a small restaurant that provides for our needs. Me, I'm a painter. I paint when I'm not sick. We live reasonably well and with dignity: We're a modest family.

Difficult to say / It's very difficult to explain what we've gone through. Not all of it can be told. We tell what we can. It's not that we don't want to, but the words don't exist to describe the extent of the horror, the suffering, and the fear. For example, when we had our eyes bandaged and our arms bound, when we knew they were going to execute us, it's impossible to find the words to tell you how frightened we were. All I can say is that at that moment I was very scared. I remember what I experienced with my parents, my wife, and my children. I remember it all, but I can't explain just how terrified I was, nor how much I suffered. No, it's not possible.

Ordeal / The most difficult period was the three years, eight months, and twenty days of the Pol Pot regime. But one month in particular was horrifying: between January 1 and February 3, 1978. During that month I very nearly died in Centre S 21. It is unimaginable that anyone could live in that fashion because we had placed total faith in this new regime. It was supposed to be a pure society that would liberate us from an oppressive and corrupt society. We thought that the Khmer Rouge were going to put in place a just and honest society, a patriotic society devoted to the reconstruction of Cambodia. But from the time of the Liberation in 1975, it became the opposite.

We experienced every kind of suffering possible. Firstly, there were no longer any medicines or doctors to care for the sick. Secondly, we were deprived of food, and it was forbidden to eat. Thirdly, we were forced to do work that was beyond our physical strength. Fourthly, we were accused of treason and other grievances. Whereas, in fact, I and my friends who died at Centre S 21 worked as well as possible for them without interruption. We still don't understand why they destroyed everything. The country had an organized government. Why did they murder us methodically? We hadn't done any wrong. We respected their laws and work hours. They shattered family ties, the love that exists between members of the family, between brothers and sisters. Why didn't they just let us live? It's not as though it were only me, my village, or my province—it was the whole country. I do not understand. They arrested me and took me to Centre S 21. I was very lucky because I survived. I survived thanks to my job as an illustrator, which I've always loved. Lots of other artists died. It's a mystery why I survived. They asked me to draw something. I'm an honest person. So when they asked me to reproduce a photograph, I answered that I couldn't make an exact copy, that I would do my best to please the party. They liked my work and kept me working for them until January 7, 1979, when the Vietnamese army arrived. I ran away. I'm happy with my destiny and to have survived all that. If you ask me why life was difficult at that time, I can't answer. All I know is that I was arrested and imprisoned. For what reason? I still don't know.

Justice / Justice and injustice walk side by side, they're like day and night. Whichever side you are on, you are in opposition to the other. People say that those who committed crimes are unjust. It's said today that we are searching out the innumerable injustices committed during the Pol Pot regime. It's true, we are looking. But how useful is it that justice is served when everyone is already dead? It's not that we're going to be given back what we've lost, but we want those who committed the crimes and are still alive to recognize their misdeeds. There, that's all I wish for.

Violence / The violence of that period has left deep marks. Today those people who still dare kill, disembowel, or decapitate others are men of thirty or forty who were Khmer Rouge guards when they were twelve, thirteen, or fourteen years old. They led the people to their death, they tied them up and shot them: For them it has become normal. We who have never killed anyone, we're frightened; they're used to it and aren't scared. That's what remains from the earlier period. Those for whom violence was commonplace continue as though it were normal today. They have not understood that the laws have changed and society too. They themselves have not changed.

Anger / In the past, some people have made me very angry, but not to the point of wanting to kill them. I don't know about anyone else, but I don't bear grudges. I have never wanted to take revenge by killing someone. I only have one wish: that

the person in question would recognize the problems they cause and the mistakes they've made. That's what I'd like. Today the person who arrested me and put me in Centre S 21 is still alive. I went to see him. I met him, but it was to try and get an idea of those things that I had never understood. He didn't dare meet me. He ran away and hid because he was so scared I wanted revenge. But in fact I never wanted to pay him back in any way.

Torture / When I was interrogated, I told them I didn't understand anything of what they were telling me. I didn't know what CIA meant. I lived in Battambang. It's all in the file I have here: "You are a member of the new people, you are a painter in the enemy zone, and therefore you are a member of the CIA." Where do you expect me to live? My parents and my grandparents have always lived in the city. I couldn't live all alone in the rice paddies. Just think about it! The fact that they accused me wrongly and that I had nothing to say made me a real suspect, because they forced me to say things about myself that were not true. But if I didn't tell them what they wanted to hear, they beat me—electrocuted me—until I lost consciousness. That happened to me three or four times because I didn't want to talk. In the end, I said, "Yes, it's true." It was very hard to confess to things I had never done. You can lie to other people, and they will believe you. But there you had to lie to yourself and accept things that you had never done. We were obliged to invent stories and to write them down. We lied to ourselves, to others, to the whole world ... just so the pain of their beatings would stop.

Forgiveness / How is it possible to forgive if the criminals don't recognize they've done wrong? That's something very important. Those who massacred thousands of people don't even recognize their actions as faults. How is it possible to pardon them? Those who gave the orders and pretend they didn't know what was going on—how can they be forgiven? I find their behavior astounding. Who should I forgive? At the moment there is a lot of talk of "reconciliation." We have to "be reconciled" so we can rebuild the country. But who should I be reconciled with? Who is going to stand up and show himself so he can be reconciled with me? What's his name? Who is he? I wish he'd come out into the open so a press conference or something like that can be organized. I'd like us to sit down face-to-face and confront one another so I can ask him questions. So he can answer me and give his reasons. Because I'd really like to know them.

Mamadou

Majji

Noosuri

Khalef

Corinne

Michel

DO YOU FORGIVE OTHERS EASILY?

Majji / *Lives in Tanzania*
I've forgiven many people. I forgave the man who came to steal my shoes, I forgave the man who hit my children, I forgave the one who gave me poor-quality products to sell in my business. I pardoned them all! I can say that I have no enemies.

Khalef / *Lives in Algeria*
Oh yes! If someone does me wrong, I forgive him the first time. But I explain to him that he did me wrong so that he won't do it again. But if he did it on purpose, if he starts again, then I won't pardon him.

Michel / *Lives in France*
There's someone I haven't forgiven. Why? Disloyalty. He was a guy that I helped and who smashed up my work-shop. I followed him. I wanted to kill him, yeah, I followed him in the street at night with a pickax handle. I saw him again afterward, and I've never forgiven him. On that I won't budge at all. I trust people to start with, but if they deceive me, if they betray me, there's no way back. I don't have anything to do with them anymore.

Mamadou / *Lives in Mali*
How is it possible to make up a quarrel? In our society there are elders whose job it is to reconcile people and make them forgive one another. When people fight, even if there are twenty or a thousand of them, if the elders get involved, they reconcile themselves with one another, they ask for pardon and forgive one another.

Corinne / *Lives in La Réunion, France*
No, I don't forgive others, or very little. I learned only a short while ago that I had Sicilian blood, so I understand a bit better now why. If someone plays a trick on me, I don't forget; I tend to hold grudges. And though I don't try to get my own back, I don't forget. I don't go with this idea of the Catholic pardon. Not at all. I don't forgive. Probably I'm wrong because, in the end, I know there are people around me who I have something against, who I don't forgive but who continue their lives because it's of no importance to them. Deep down I'm more unhappy than them because I've always got a gripe against someone, whereas they've moved on.

Noosuri / *Lives in Kenya*
I forgive easily because I too want to be forgiven.

I pardoned them all! I can say that I have no enemies.

Nicholas / *Lives in Los Angeles*
I've done things in my life I'm not proud of. I've hurt people real bad in the past. I hurt my family, I hurt people who loved me, and they forgave me. Because of this experience, there's always a chance of forgiveness with me.

Yvonne / *Lives in France*
It's very nice to say "I forgive you" when it comes to little things—then it's easy. But when you've really been made to suffer . . . I think that it's like a wound. You have to wait for it to heal.

Peter / *Lives in California*
Forgive? It's not possible to forgive. Oh no. My mother could hear the noise of the incinerators her mother was burned in. However, she didn't have anything against modern Germany. She and my father traveled across Europe as tourists, then they went to visit Germany. But forgive? No. I doubt that she'll forgive them all her life.

When someone really does you wrong, write it in the sand. When someone does you something really good, carve it in stone.

Patrick/ *Lives in Tanzania*
I try to do what I can to forgive, but it's difficult to forget. However, this is what I keep telling myself: When someone really does you wrong, write it in the sand. When someone does you something really good, carve it in stone. And when the sun and the rain come, what's written in the sand will disappear, and what is carved in stone will also end up by disappearing, but only after a very long time.

Sachiko / *Lives in Japan*
The people I can't forgive are those who do things that make life difficult for others. Here's a real example. One of our geishas came to me to borrow money, giving reasons and crying. Even though I didn't have much money, I lent it to her because she said, "I promise I will pay you back next year. . . ." I lent her ten million yen! [about $95,000]. The fact that she has not paid it back means I cannot forgive her. It was the first year of the Heisei era, so that makes it almost eighteen years now. Despite that, her face doesn't betray anything. When I speak to her of it, she says, "Wait just a little bit!" I find it hard to forgive her.

Peter

Sachiko

Nicholas

Patrick

Yvonne

Alicia

Javier

Christian

Norma

Javier / *Lives in Mexico*
What I really regret even to this day
is. My father worked hard to be able
to build our house, to build the dif-
ferent floors and the bedrooms. Me,
who used to drink and party, I stole
all the money he had saved to build
the house. And I stole lots of money
from my sister too. My brothers, who
are older than me—I'm the youngest
in the family—worked as well. Well, I
watched where they put their money,
and I stole that too. I stole their jew-
elry so I could drink and buy drugs.
Today I feel really sorry for what I did.
I feel I can't even ask their pardon
because. ... They have already forgot-
ten it but not me. I'm full of regret.
They worked hard to earn their
money, and I just stole it from them.
I feel bad about it.

Alicia / *Lives in France*
Is there anyone I haven't forgiven?
The only one might be my mother,
whom I never knew. But when all's
said and done, I pardoned her too.
I forgive everyone. Even her. Why?
Because she gave me a life in France,
and even if it's not always so wonder-
ful, she gave me a good family, and
that's enough for me! That's what's
important, and for that I forgive her.

Christian / *Lives in New York*
If I think about forgiveness, then my
thoughts turn to my parents, to know
if I've forgiven them or not—but
what should I forgive them for? The
need I feel to see them as perfect,
my wish to have had an easier life, a
better upbringing. Maybe I'm just
an idiot who watches too much TV,
thinking that I'm owed a perfect life.
In fact I'm sorry I haven't forgiven
them. I'm sorry that I haven't been
strong enough to do it, because they
deserve it.

Norma / *Lives in Buenos Aires,
Argentina*
I can't forgive my mother ... her
authoritarian attitude when I was
a teenager and a child. Even now, I
can't forgive her! She's always given
me the impression of being envi-
ous of the successes of others. She
has never shown joy, not even at
the birth of her children. She's very
distant and cold. The other thing
that I can't pardon, and I believe I
never will, is when the father of my
children left, the day that he walked
out leaving me with two babies. I will
never forgive him! Never!

Nirmala / *Lives in Nepal*
Who has really wronged me? No one.
Ah yes! My husband! Him, yes, and I will
never forgive him. Never! Even if he dies,
I don't want to see his face, because
of what I had to suffer on his account.
When we were living together, he found
nothing better to do than marry other
women. He married two or three times.
It was so hard to live with him! It was so
hard to bring up my children! I washed
dishes at people's houses, I looked after
the kids, I educated them, I fed them.

Eike / *Lives in Germany*
What I couldn't forgive is being deceived.
The fact that someone lied to me about
fundamental matters of life, that's very
hard to forgive. If someone told me he
loved me and behind my back he said,
"Ha! You're really stupid, I don't love
you!" It's very difficult to forgive that.

Miriam / *Lives in Bolivia*
I had to live with that for a long time, the
horror of living in a very violent atmo-
sphere because of alcohol. At that time
there were many things I didn't under-
stand, but I forgave them. Now I'm try-
ing to change the person who made me
suffer. It's very difficult but not impos-
sible. I'm a person who has to under-
stand others and thus find the peace to
which we all aspire. And, well, we have
to understand the faults of others.

Megan / *Lives in Ohio*
I'd say that I haven't forgiven the man
who raped me. It was very difficult to
deal with the fact that I haven't been
able to pardon him. My faith in God is

very important to me, and I had the feel-
ing that I had to forgive this man. Until
the day that one of my best friends told
me that the reason that God existed, or
one of the reasons, is that we needn't
forgive people because God will do it,
that it is for Him to handle that kind
of thing. It's not up to us, we're only
human—it's too difficult for us to deal
with. So I haven't forgiven him, but I
don't find that a problem anymore.

It was very difficult to deal with the fact that I haven't been able to pardon him.

Fatiha / *Lives in Algeria*
This government that talks about for-
giveness, what has it done for us, the
victims, so that it can ask for pardon?
My husband disappeared eleven years
ago, and I've never received news of
him! I wish they'd come and see how
we are, how we live, our situation in life,
and after that they can talk of forgive-
ness! Those terrorists who have cut our
throats, killed, who have committed all
those atrocities, now they've become
the good guys, and we are left, the vic-
tims of terrorism.

Eike

Nirmala

Fatiha

Megan

Miriam

Ljilja

Musa

Alija

Seum

Hajrija

Musa / *Sudanese refugee who lives in Chad*
I would offer my forgiveness if they would compensate for the injustice they have inflicted on us. If someone comes to your house, takes your things, kills your loved ones—you can't live with him in the absence of laws, because it is very possible he will begin again and that nobody will judge him.

I'll never forgive all the war criminals, never.

Ljilja / *Lives in Serbia*
I cannot forgive the politicians for choosing to go to war, and that's that. Because it should never have happened. If someone needs some land, it can be gained peacefully, without necessitating the death of the innocent nor reducing them to a state of poverty and wretchedness. It was of no use, all wars are useless. Everyone loses, no one wins. It was the innocent who paid. What was my child guilty of that everything is taken from him and that now he has nothing?

Seum / *Lives in Cambodia*
I will never forgive the Khmer Rouge because they tyrannized all my family and caused the death of my children by giving us nothing to eat. They tied my arms and left me in the mountains. Every single one of them, without exception, should have his head cut off.

Hajrija / *Lives in Bosnia-Herzegovina*
I'll never forgive all the war criminals, never. I'll never pardon them. What crime are innocent children guilty of? My boy was in the first year of junior high when he died. What sense is there in that? Those responsible didn't have one iota of humanity in them [those responsible for the Srebrenica massacre].

Alija / *Lives in Bosnia-Herzegovina*
It is very interesting to see that I and my colleague and neighbor Zrinko Pulic were best friends before. While we were both here, in the same Croat army, we were both officers, and then, all of a sudden, we found ourselves on opposing sides. Now when we see one another, what are we supposed to do? We have to continue to live, we have to forgive. We can't keep on with that wartime mentality.

Edison / *Lives in Rwanda*
To be able to leave prison I had to acknowledge my misdeeds. I asked for pardon from the survivors, their families, the Rwandan state, and God.

Jean-Pierre / *Lives in Rwanda*
I think I'd be able to forgive if some-
one came to me to ask for forgiveness,
but I cannot say today, "Listen, I for-
give you," as no one has asked for my
pardon! Let's talk about the genocide
here in Rwanda. The state frees lots of
people, and these people say, "Listen,
we asked the state for a pardon." As
though they had killed the state! They
ask for pardon from the president,
as though they had killed the presi-
dent of the republic! And from all the
Rwandan people and humanity. But
I'm not all humanity! I'm Jean-Pierre,
I'm not a State, I am an individual, nor
am I the president of the republic. So,
for me to forgive the murderer of my
family, he has to come to me to ask for
pardon. I will never go to his house to
say to him, "Listen, I forgive you." He
has to come to me and tell me exactly
how he killed my family, and then I
will pardon him.

Adria / *Lives in Rwanda*
When they come to me to talk to me
about the members of my family that
they killed, to tell me the place where
they threw their bodies, and to help
me dig the bodies from where they
threw them, then they can ask my for-
giveness. And I will forgive them.

François / *Lives in Rwanda*
I used to feel hate. It's an uncontrol-
lable human feeling, one you cannot
escape. When someone harms you,
you cannot do otherwise than hate
them. I'm no saint; I'm a man like
everyone else. When someone does
something evil to you, you hate him.
I can't tell you that I love them, and
there are still some that I do not like;
I still cannot manage to love them
today. The only one of them that I
recognize the value of is the one who
asked my forgiveness. As for the oth-
ers, I still don't love them because I
am afraid of them. When you don't
like someone, you are afraid of him.
We live together because the law tells
us we have to, but I'm afraid of him.
And I think that he is also afraid of me
because if he tries to harm me, the
law is there! This human nature will
always exist.

To be able to forgive, someone has to come and ask for forgiveness.

Edison

Jean-Pierre

François

Adria

Renata

Lives in Romania

Look at the gypsy girl! We don't play with them because they're gypsies.

Background / My name is Renata. I live in Craidorolt but I was born in Timişoara. I look after my children at home. For the moment I don't work. I hope that I'll find a job one day, I don't know where, but I hope so, so that I can bring a little money into the household, because for my husband alone it's very hard. That's all!

Handing on / What do I hand on to my children? I teach them to obey their parents because we cannot want harm to come to them in any way. Also that they have to learn at school because, thanks to education, they'll go farther. Without it they'll end up in the street, among the riffraff or I don't know what. Schooling is essential.

Family / I don't get on well with my mother or brothers, but with my new family—my in-laws—it's just great. With them I can talk about anything. If I have problems, I go to their house. How could I go to Timişoara? And what would I do there at my parents' house? Nothing. I'd come back in the same state as I left. I'd go for nothing. I have two children: if they saw me with two children, they'd throw me out. My parents are really, really bad. See what I mean? I've been married for fifteen years, and we hardly speak to one another. In fifteen years I must've talked to them ten times. I don't have any real attachment to them, but I love my new parents very much. New parents! That's just what they are!

In love / I met Bobby here in Craidorolt. I had come to visit my grandparents. When we met, we played like children; we were twelve when it happened. And out of play and childhood, love was born! Five years later he asked me to be his wife. My parents were against it. I don't know ... they didn't like him. I said that I was going to run away with him if they didn't allow me to choose for myself, and one day we decided to leave because they'd beaten me, all because of Bobby. My mother was drunk: She hit

me very hard. Well, I said that I was leaving right away, that it was finished between us: "You don't want me to stay with him? You want to hurt me?" A week later we were married, and I've been very happy ever since. The wedding day was a time of immense happiness for me, of great joy.

Love / We love one another very, very much. Very much! Often I get scared that we might separate. As a result, when I go to bed at night, a whole load of crazy things pass through my mind. I ask my husband, "What would you do if we were separated? Could we keep on living? ... like others live, with their children separated, some in one house, some in the other. ..." And I cry at night when we talk about things like that. And he cries too. I don't know, we're very attached to one another.

Poverty / My husband didn't yet work at the Dressmaier factory. It was very difficult. We lived on social security and the allowance we received for Bobby, our eldest son. At the time we had 60,000 leis (about $2.60) per day. I'm not ashamed to say it, we were very, very poor. There wasn't a crust of bread in the house, not even a crust! And the children cried with hunger. We were so poor. We took what clothes we had that were in good condition to the village to sell them. I can't say that they were splendid, but they were in a pretty good state. We sold them for between 10,000 and 15,000 leis apiece, enough for us to buy some bread. That period was extremely difficult. You understand? We went to dig the ground, and when we came home we bought bread, a packet of cigarettes, some oil, and five or six pounds of potatoes, and that's all! That was all the money gone! Every day it was the same. Often there was nowhere to work because there's not much work available in the village. Elsewhere there is, but here you can die of hunger. And I thank God for having let us get this far. I can't say that we're rich, even now, but we no longer live like we used to. We have food to eat every day, and for that I thank God.

Money / My husband Bobby earns 5 million leis a month (about $260), but that isn't enough to pay our debts. It's very little money, very little. And when he gets paid, we give it back to the factory to pay our debts. My youngest needs milk every evening. I buy it for him, but it costs 7,500 leis a pint. So I spend 2 million each month just for the milk when my husband earns 5 million! What can I do? Pretty much nothing. Certainly not buy them a pair of shoes, or trousers, or a T-shirt, or anything else. I don't know, the money just isn't enough: 5 million is very, very little. Moneys doesn't buy much.

The meaning of life / The meaning of my life? What can I say? I have become all that I wanted, all that I wished for. Except that I'm not rich. My wealth, now, is love; I'm rich in love. I have a big family; I love my children and my husband. The meaning of my life is my love, my family.

Joy / It's usually in the morning, on Sunday or Saturday, when Bobby doesn't go to work. We wake up and the baby wakes up laughing. Baby Nicolas comes to Bobby and gives him a little tap, and Bobby wakes up. He throws a pillow at us, and that's how it starts. We play all day: We wake up, we eat, we go out or go swimming at Crasna . . . it's great when we don't have any problems. It's rare that we're in a really good mood, but for the children's sake we try not to show them our worries, so that they don't suffer too. It's enough that we, the parents, have to suffer.

Fear / What am I afraid of? That something will happen to my children. I'm always afraid of that. Even when I wake up at night, I get scared that there might be a serious flood, and I get frightened because they don't know how to swim. My greatest fear is that something might happen to my kids.

Discrimination / Yes, when I was a girl there was racism. We used to play in front of the building, and the children who weren't gypsies used to say to me and my brothers, "Look at the gypsy girl! We don't play with them because they're gypsies!" I don't know . . . we put a distance between us. Still today, when I go somewhere with people, I feel like a gypsy. I don't know how to say it—when those children said that to me, they put it in my head that I was a gypsy, that nobody would pay attention to me or would want to go anywhere with me. I was a child like them, and I took it badly because they treated me like that when I was a clean child, dressed normally, like them. It was just that my face was a little darker.

Future of the world / I don't know how the world will be in twenty years. I have no idea. I can't predict. I hope that it will be better than now. I hope that it will be more civilized. Of course it's civilized today, but I don't like the way of it. Let's say that I'm a gypsy, that's the way it is. A Romanian woman comes and says, "Look! A gypsy!" I don't like that because I'm also a human being, just like her, or a Hungarian. I'm a person. I'm a gypsy, but I'm a clean gypsy! I love cleanliness. I'd like to have a good life, but we don't have any money. If we had money, then I too could say, "Look who I am: a lady!" But no, that's how we are: We've stayed at the bottom of the ladder.

Hannah

Lilu

Yeter

HAVE YOU SUFFERED FROM DISCRIMINATION?

Hannah / *Lives in South Africa*

The blacks are a race apart. Their values are different, their dreams and ambitions are different, they want to reach the top, but they don't yet have what it takes to get there. I think that schooling and ... studying will help. But whether or not they will be able to run a country properly or not, I don't know, because when I look at the rest of Africa, there isn't a single country that can do it properly. There are always struggles, fighting, and all sorts of unpleasant things going on. So I don't know, I don't have much hope that blacks will manage to run the country.

Lilu / *Lives in Nepal*

I began to go to school at the age of eleven. I had to walk for two hours to get to the school in Bahun Danda, the village of the Brahmins [caste]. There was no school in my village of Gurungs [caste]. As the school was at Bahun Danda, some friends sometimes asked me if I'd like to stay at their house, and I accepted. But for the meals they made me sit all alone downstairs. In a Brahmin house, a meal cannot be served to a Gurung woman except from above ,like Moroccan tea is served. They were all upstairs in the kitchen, and I was put downstairs all alone. Among the Gurungs, guests are not made to wash their dishes, we do it for them. But in the Brahmin house, I had to wash my plate myself. I don't get it at all! I slept with their daughter, I studied with her at school, I ate biscuits with her, we shared our ideas and thoughts, but when I went to their house, they always made me sit very far away.

Yeter / *Lives in Turkey*

My family was from the Black Sea, so very nationalist. Their way of looking at the races of the world was very different. For example, with hindsight I see that my family does not view Kurds positively and does not even consider them as human beings. They never make their opinions known when the rights of Kurds are discussed, or whether the Kurds should be helped or not. They are a family that supports Turkish nationalism. When I came here and thought about it, I understood that they had passed all that onto me.

We shared our ideas and thoughts, but when I went to their house, they always made me sit very far away.

Rina / *Lives in South Africa*
When we used to go to the beach—the largest beaches—there were never any Africans. And when I asked my mother where they were, she answered, "They have their own beaches because they don't want to be with us." We were brought up like that, thinking that they didn't want to live with us. Also, even if it staggers me to say it today, the blacks were thought of as unintelligent beings. And so, when whites spoke to an African, they spoke slowly because they thought he wasn't intelligent. When we were small, the Africans were supposed to not be interested in education; they were just a lower class of people. They weren't interested in the same things as us—that's how we were brought up.

Florentino / *Lives in Cuba*
I remember once when the woman who was my mother-in-law said to me very seriously: "Florentino, I used to have something against you because you were black, but the problem was that I didn't know you, because the only characteristic you have of a black man is your color." And I replied, "You mean, to be black I need something more than the color of my skin?" "No, because you speak like a white man!" she answered. "No madam, I don't speak like a white man, I speak like me. I completed my studies right to the end and, to my knowledge, unless anybody lied to me, the only thing you need to be black or

white is the color of your skin." She was left open-mouthed. Our marriage didn't last just two days, it lasted eighteen years, so they ended up getting used to the situation.

Pachaiamma / *Lives in southern India*
Such things can't be changed! Since the dawn of time, since the times of the kings, the caste system has been perpetuated from generation to generation. When a father works in a place, if his son wants to study and leave his condition behind him, nobody close to him will let him do it. They'll say to him, "This has been your father's work, and you will do the same!" So no progress can be made. This is passed on in an almost natural manner, and nothing can change or alter the course of things.

Chafiqa / *Lives in Afghanistan*
When girls and boys are little, their parents tell them that they are not equal. And unfortunately the mothers say it too—above all the illiterate women. Our society is run by men, so the women prefer to have sons than daughters. As boys are given preference as they grow up, they feel superior to girls. The girls do nothing except work in the house, while the boys can have a job outside, trade, sell sheep ... and so they can earn money. That's why mothers prefer to have sons.

Rina

Florentino

Chafiqa

Pachaiamma

Isabelle

Amine Bouzarine

Rahmatou

Cecilia

Rahmatou / *Lives in Mali*
In our society, women don't suffer any discrimination; it's them who are the boss. They are the ones who make the decisions. We have even had women chiefs, women spiritual guides, women war advisors, women counselors. … When a woman gets noticed for her qualities, she is respected.

Isabelle / *Lives in France*
When I was younger, I used to say to myself, "Feminism is a struggle from my parents' generation. Thanks for having fought it, but it's no longer relevant to my era." Wrong! Even today, when you look at our government, the people at the head of the country, you see that they are nearly all men among the deputies [congressmen] and the ministerial cabinets, not to mention the ministers themselves. They're practically all men! Imagine if the situation were the other way around. Imagine that the president was a woman, that the prime minister was a woman, that the minister of the interior was a woman, and the finance minister was a woman … the French would say, "But what's going on? We're being held hostage by women!" However, the fact that they're all men doesn't shock us. That proves that we're still a thousand miles from equality between men and women.

Amine Bouzarine / *Lives in Algeria*
The situation of women in Algeria has improved enormously. Only a few years ago it was like the Middle Ages: It wasn't clear if a woman was a human being, a demon, an object, or I don't know what else. She didn't have the right to speak or to go out—she simply didn't have the right. She knew by heart the expression "not the right." And she respected that state of affairs. But today they are beginning to take their place in society, to look outward, to see, talk, express themselves, and to take responsibilities. I just love that!

Cecilia / *Lives in Texas*
When I got my engineering diploma in Venezuela, I looked for a job. I answered a job ad. I had all the qualifications of the applicant they wanted, but when I visited them to present my application, they told me they were not looking for a woman but an engineer. I told them, "But I'm an engineer!" "But you're a woman! We're not looking for a woman!" I found it very hard to put up with that. Nevertheless, I found a job in a branch dominated 100 percent by men. It was in the oil industry. It just goes to show that anything can happen!

In our society, women don't suffer any discrimination; it's them who are the boss.

179

Abdel Aziz / *Lives in France*
I once went to see an employer—everything I'm going to tell you is true! I park my car and walk into the factory. Everyone was saying, "They really want people to work in that factory." I was twenty-three. So I go there and see the guy, I was smartly dressed, "Good morning," "Good morning to you." "I'm here to see if you are looking for anyone to work here." "Well, you're very lucky, we are looking for someone! Do you have a CV?" "Yes, yes, it's in my car, I'll go and get it." I run to my car and get the CV. He takes it. He sees my name, Abdel Aziz. He reads my name and says, "Right, I'll let you know. I have your phone number here. I'll call you. It should work out if there's work to do. ..." You guessed it! He didn't call back. I know that if I had a French name, I would've been given a job straightaway. To my face he said, "fine," but after seeing my name, he thought to himself, "not so fine after all."

Bora / *Lives in Cambodia*
Before, a lot of people looked down on me because they found me very dark, small, and not pretty. No one liked me; they used to say I wasn't a good woman. When I began at university, I wasn't liked because I had told people that when I was a child I had collected plastic and iron at the dump. They didn't want to speak to me, and they said it was disgusting to do that sort of work. When I spoke of it to someone, he began to avoid me. I was unhappy and wanted to kill myself. I wondered why I had been born different, and why, when I spoke to others, they didn't want to reply. They said that I was poor and that they didn't want anything to do with me.

Jean-Marc / *Lives in France*
There are lots of people who don't look at you when they pass in the street because they don't want to think that one day they might end up in the same situation. You understand? "You mustn't look at the homeless." Or, when they see you, they turn their eyes away. "I didn't see him. I'll just pass by." They feel ill at ease. They'd like to help you, but they say to themselves, "Would it be right? Shall I give him something? No! If I do, I'll encourage him to stay like that!" If you want to give, give. If you don't want to give, smile! But don't pass by without looking. What hurts most is indifference, the people who pass by and don't want to see you.

Mohamed / *Lives in France*
My face makes me stand out from the others: I'm a bit brown, I'm a bit swarthy, I have a strong squint, I have a broken nose, as for my teeth, it's not obvious if they're really teeth. Ever since I was very young people have looked at me completely astonished, you know? And then it's also a way of dealing with life. I refuse to accept monotony!

ean-Marc

Abdel Aziz

Bora

Mohamed

Stéphanie

Roberto

Carmen

Carmen / *Lives in Spain*
I think discrimination is the pits! That's because when I was younger I had to live through it myself, and badly. My parents are a bit different in the way they look. My father is a tattooist; my mother does piercings. They dress differently because they're into heavy metal, and I turned out a bit of a Goth. Well, a thirteen-year-old girl in Jérez, a town near Cádiz ... I wasn't exactly looked upon gladly! People told me I was a witch and would say nasty things to me. The people here are pretty closed. That's something we should all be aware of, and be more open-minded, and not judge people by their physical appearance. Because when you see a man dressed in a suit and tie, and carrying a briefcase to go to work, he might be nastier than someone wearing a spike necklace or whose fingernails are painted black.

Stéphanie / *Lives in Israel*
When I lived in France I never suffered discrimination. Nobody checked my ID in the street, if you see what I mean. But I know very well that if I were dark-skinned, if I were a man with a dark skin, and if I lived in certain areas, I wouldn't have the right to the same treatment. Unfortunately, I have to say that I suffer that here, and it's a bit tragic for me. I love Israel and am happy to live here, I wanted to come, but it's true that it isn't easy. I mean to say that here you really have to spell out your identity: your age, whether you're married or not, where you come from, your nationality. When I begin to say that my father is Jewish and my mother is a non-Jew, their eyes almost pop out of their heads. They just don't understand! "Ah, so you're not Jewish! What are you doing here then?"

Roberto / *Lives in Cuba*
I have a friend who's black, and every time we walk down Calle Obispo, the police turn up and ask him for his ID, just because he's black. Here, in Cuba, in Calle Obispo! I hold out my ID to the police too, but they say to me, "No, not you. We only asked him." But why? We're together, we've just come out of work! Sure, they don't tell you it's because he's black, but if it happens four times a day, with four different policemen, any day of the week, there has to be a reason. . . ."

When you see a man dressed in a suit and tie, and carrying a briefcase to go to work, he might be nastier than someone wearing a spike necklace ...

Maxime / *Lives in the Palestinian Territories*

I have a Palestinian passport, a green passport. I say "green" because there are different color passports in Palestine. This was imposed on us by the Israelis. A green passport means that I am an Arab who lives on the West Bank. Some people have blue passports: They are Palestinians who live in East Jerusalem. Then there are others who have red passports: They are Palestinians who live in Gaza. The colors are important because they correspond to different degrees of "lack of rights"—not "rights," "lack of rights." There are certain things that I am not allowed to do, which are different to those of blue passport holders. In the end, it all boils down to lack of rights, not rights. What do the colors mean for Israeli soldiers? It means they can abuse this Palestinian because he is of an inferior race, and even more so because his passport is green. It's a little like in South Africa: the Africans were divided into seventeen different degrees of color, and the whites gave them different rights, or rather lack of rights, on the basis of this code. It simply means that I have no right, that I am a human being deprived of all his rights. That means that I can get myself killed at any moment without my family having the right to make a formal complaint. I can be hit at the checkpoint, I can be arrested, interrogated, harassed, I can be denounced, humiliated, and I don't know what else. And that's what people like me have to suffer here on a daily basis.

Fatima / *Lives in France*

My children were born here, thanks be to God! My children were born here, and there's no problem. They're called Daniel, Emmanuel, Isabelle, and Catherine, and that's good. They're not called Fatima, like me.

Shazia / *Lives in Ohio*

Before September 11 I was never discriminated against. When I wore my veil in public, people smiled, greeted me, and asked me how things were going. We had a very friendly interaction, though a little strange because most people didn't know what a Muslim was or what it means to cover oneself. After September 11 that relationship changed: It became more hostile. People don't smile at me anymore. They stare at me or look daggers at me, and make sly comments as they pass. And I always have to explain to them how it is that I speak English so well. People cannot associate wearing a veil with having American nationality.

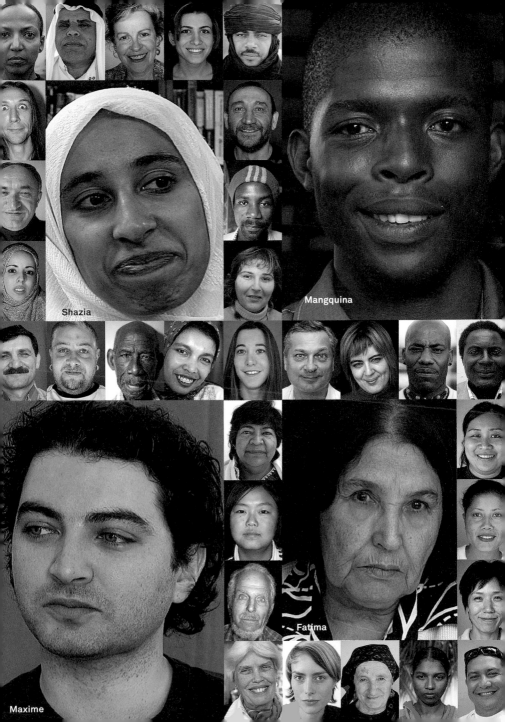

Shazia

Mangquina

Maxime

Fatima

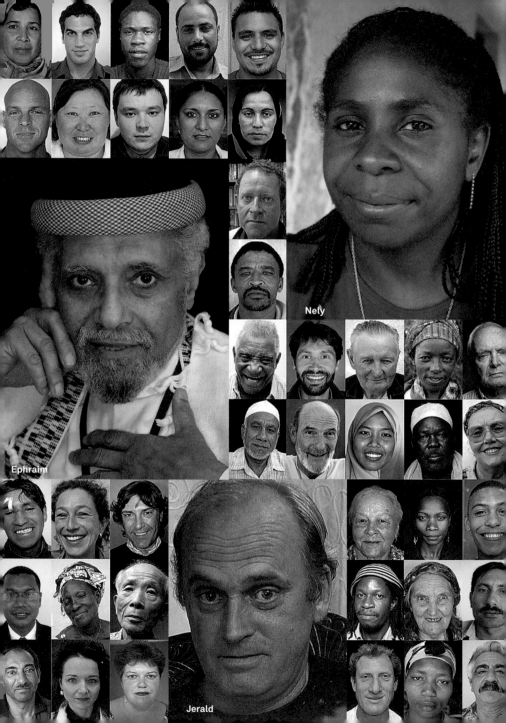

Nely

Ephraim

Jerald

Mangquina / *Lives in South Africa*
How did apartheid affect us? At one time I played rugby and was captain of the team. One day, as we were losing a match, I got the team together and, as captain, said to them, "We've got to do it! You have to give more, we have to improve our game!" I said it in a pretty strong way. That day my grandfather and father were in the stands. After the match I walked across the pitch to join them and suddenly my grandfather gave me a slap. I was dumbfounded, I didn't understand why he'd done it! It was because of the way I had talked to them. "You don't talk to whites like that, you don't shout at them!" So, when I talk about being a victim of racism or of the struggle against it, it can appear in different guises, and what I just told you is simply another form of being a victim of racism. Apartheid was abolished in 1994, but now it takes a new form, one that is no longer physical but mental. This victimization is the sort of baggage that I don't want to carry around with me for the rest of my life.

I grew up in Ethiopia, a country where the people look down on Europeans, on whites.

Ephraim / *Lives in the United States*
I grew up in Ethiopia, a country where the people look down on Europeans, on whites. The people there think that they are superior, and that Europeans are white because they've suffered from leprosy. We're not supposed to touch Europeans because we're afraid of getting ill. So I grew up with this feeling of being superior to Europeans, and when I came to America and there was discrimination against us, it didn't bother me—I even found it amusing!

Jerald / *Lives in Canada*
I'm of mixed race, and that's made me suffer for a long time. "You're not Indian. You're not white. You're between the bark and the tree." I suffered because I couldn't think of myself as either an Indian or a white. The government told me that I didn't exist. Amazing, isn't it? Just because I'm of mixed race! When you grow up like that, where's your sense of membership? I no longer had one. In fact, it's only been a short while that I've had a feeling of belonging, that I've begun to accept myself: I am Hindu, a human being.

Nely / *Lives in Bolivia*
I'm very happy to be African-Bolivian. I sometimes have the impression of being a sort of beauty spot where I live. I love it, being a beauty spot! It's also wonderful to feel different, when you have the feeling that all the world is the same. That's really nice! No, I am very happy to be African, I don't regret it at all.

187

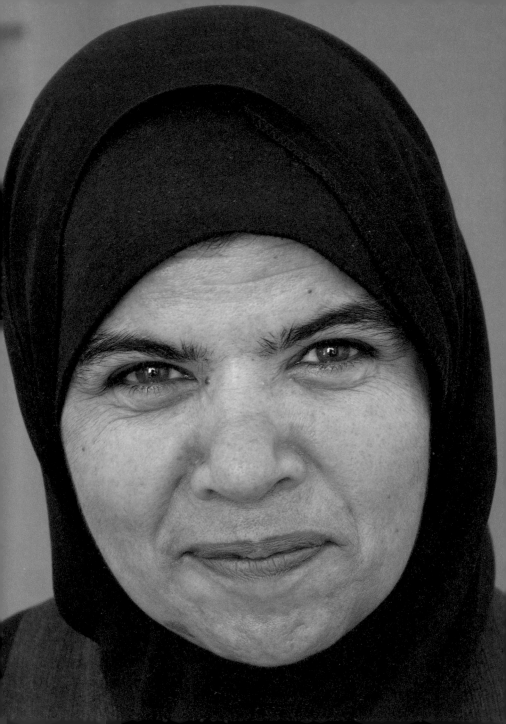

Ahlam

Iraqi refugee who lives in Syria

I've never envisaged returning to Iraq, because my children stand no chance there.

Background / My name is Ahlam; I'm forty-two and I come from Baghdad.

Memories / There were seven of us: four girls and three boys. My father worked in the fields with my mother. We used to go there too, and if fruit was falling from the trees we'd pick it up. We took our breakfast with us; we drank tea. During the summer holidays, we'd go home as night was falling, but we always passed by the swimming pool! Every evening we'd go for a swim. My father had diverted the irrigation water from the Tigris River with a large pump. Those were wonderful childhood moments. Our parents joined us in the pool, and we all played together like kids. But when we got dressed again, my parents went back to their parental roles.

Dreams as a child / I tried to make my pop's dream come true: to be different. He gave me everything he could when he was just a simple farmer. It was very hard for a girl to enter university or learn to drive, but thanks to him, I studied languages and computer science. He also taught me to use a gun to defend myself: In the country-side you can get attacked by stray animals. Perhaps I realized his dream: that of being different.

Learned from your education / Raised like a boy, I learned how to drive, swim, use a gun, and fight. It's a little as though my father had had four sons instead of three. He used to say to me, "You're a go-getter. You're a girl but a fighter. You're not like your sisters." I've never been afraid of birds or animals. I think I have a daring spirit. The boys were always away, doing military service, enrolled in the army ... so much so that I was the boy in the household. I carried a gun to protect the house. At that time

189

my sisters, who were brought up as girls, kept their distance from boys and young men. They learned to cook, make bread, and do the housework, but I never learned to do the things the lady of the house has to do once she marries.

Ordeal / Once I nearly drowned; another time I had a car accident. A third time, when I was working, I was kidnapped for eight days and seven nights. At every moment, each minute, each second of those eight days I lived with death. In a way it became a companion. When a kidnapper came to interrogate me or fired a gun close to my ear to intimidate me or to alter my perception of noise, I was never frightened. I was only scared of one thing: that my little girl would learn later on that her mother had been killed. I also thought about my elderly mother. Following my marriage and the death of my father, she had more need of me. It was those two I thought of: my mom, to whom I was getting closer and closer, and my daughter, who might have believed her mother was a spy. At that time I used to work in a humanitarian organization. Thank God I managed to escape from the kidnappers. But the worst thing I've known is to see my son die in front of me without being able to do anything about it.

Crying / I cry nearly every day alone, unknown to my children or my husband. I lost my eldest son, who I had managed to make a friend. He was almost as tall as me. When we went out together, everyone thought he was sixteen rather than twelve. I cry because he has left us. I know that death is in the hands of God, but you miss the person. When that happens, you cry. You cry for the person you miss, for the child you gave birth to, whom you brought up, who grew up with you, whom you tried to protect even if he witnessed serious events because he was the eldest. He was there when I was kidnapped and when I made the journey from Baghdad to Damascus, via Amman and Egypt. He took on the responsibilities of an adult. I cry for him every day, sometimes without tears. I often used to sit beside him and we'd spend a lot of time talking. I have no other reason to cry. None at all.

Leaving your country / When I left Iraq I didn't have any choice. I worked for the Iraqi Aid Center. What I liked doing was helping disaster victims. But because I was dealing with American doctors and civil engineers, the militia decided that I was a spy working for the Americans. The fact that I speak English fluently and that I didn't need an interpreter confirmed their suspicions. They abducted me in front of my house at eight o'clock one morning when I was going to work. Four cars surrounded me. Two armed men came toward me. I pushed the first away but not the second. They got their guns out and fired between my legs. They made me suffer a lot while they held me. Torture. Gunshots. They made me believe that they had abducted Abdallah, my youngest son. They made me listen to the voices of children crying out for their mothers to put me under pressure. When my parents tried to obtain my freedom, the kidnappers demanded a ransom of 50,000 dollars and exile with my children. The

day after I got away, I had a heart attack. They had stolen my passport, so I had to get a new one. That, and the medical treatment, took about two months. Finally, I left Baghdad on September 2, 2005. I stayed for a month and a half in Amman, where I couldn't live. From there I went to Egypt, where I didn't have any ties either. I have more connections with Damascus: It's the same land, the same environment as here in Iraq. Here the people are very easy to live with, much more than you can imagine, provided you know how to deal with them. It was their modesty above all that attracted me. I've been here in Syria now for almost three years, and I'll never leave. They keep begging me, "Come back to Baghdad!" but I answer, "No, I'm staying here."

Being at home / Syria, that's my home! This country took us in, my children and me. It allowed us to have our own home and to live here. My neighbors, Iraqis and Syrians, supported me during the worst of my hardships. When I lost my son, you should've seen all the women and men who were crying around me. They refused to eat unless I ate with them. They came to take me to their houses to have morning coffee with them. Today they continue, but by telephone! The way they greet me when we meet in the street, the way they worry over my children, whom they watch over as though they were their own! Yes, Damascus is really my home.

The future of your country / Really, I've never envisaged returning to Iraq because my children stand no chance there. And I think that the situation isn't going to improve. The only thing I could do is to make people useful to society, so that they contribute to building their country rather than destroying it. But probably I'll never see the results of my work, unlike my children, who are of the next generation. I think that one day Abdallah and Roqaya will return to Iraq, but without me, unfortunately.

Family / Family means love, intimacy, and the feeling that you're not alone despite the distance between you. My mother, who's seventy years old, comes to see me two or three times a year. When I send my sisters a text message, they call me immediately and ask me what I need, despite having their own problems. My brother and my nephew come to visit me, stay about ten days to be sure that I'm doing ok, then go back to Iraq. I never feel alone. I always have a member of my family around me— right now there are two of my brothers and one of my sisters. They come to visit, and we spend time together. When my mother asked me to go and see her in Baghdad, I told her that it was impossible: As soon as I see the sign indicating the Iraqi border, I turn around and go back. One day I organized a taxi to take me to Baghdad, but when I saw the border I asked the driver to turn around. I couldn't help it.

Forgiveness / Yes, I pardon my kidnappers. Straight after my abduction I forgave them. I can't judge people. I pardoned them at the start of my abduction, whatever was going to happen. I wasn't alone, I was with my cousin and my husband ... but it was the first time they saw a woman in this situation, doing that kind of work.

Rubbing shoulders with foreigners, dealing with them and helping them to move around. Above all, when the American troops showed themselves capable of rape, murder, injury, and destruction, we were authorized to bring the American army to justice and to demand compensation for the victims. That was something completely new in Iraqi society—working with humanitarian organizations and handling problems that arose between Iraqi civilians and American soldiers. In very closed minorities, the uneducated rural population was at the mercy of unverifiable rumors. Everyone in battledress was considered an enemy, and all foreigners too. That was the kind of background we had to deal with. When you're caught up in such a setting, you have to accept the consequences. That's why I forgave them almost as soon as they abducted me.

Love / My husband is a cousin ten years older than me. At the start I played the go-between! Devoting myself to my studies, I tried to find him a wife. But every time I spoke to him of a particular girl, he invented an excuse: That one's too tall, this one's too short. There was always something that wasn't right. Then one fine day he burst out with, "You're looking for a wife for me but it's you that I love!" I was taken aback. I had never thought he could be interested in me, when I was spending most of my time hunting down a wife for him! And that's the way it is!

Joy / My greatest joy is to be with my children. To raise them. I dream of seeing Abdallah and Roqaya get their university diplomas. When that happens, my mission will have been accomplished, and they can continue alone.

God / God exists. He shows us the right path. You only have to listen to your heart. God exists. He watches us, puts us to the test. If you pass, you're the happiest person in the world. If you fail, you can only be angry with yourself. Thanks to God, faith is set in our hearts from our earliest childhood. We were taught the true Islam, not the one you hear about today. Islam is the religion of love, it speaks to everyone, from children to the elderly. It illuminates us at every stage of life. If you follow these stages, you will live happy. On the other hand, you become embittered if you wonder, "Why has God done that to me and not to the others?" Let's not look at those who have better lives than us, but those who have more difficult lives. In my very modest apartment I never have the feeling that God is unfair to me. Lots of people live in much worse conditions! I am lucky: a roof, children, family, a husband, I don't ask for anything more.

War / War is destruction. Wartime has filled twenty-five years of my life. Born during the Iran-Iraq war, I lost much of my youth. Even if we suffered less in Baghdad, except for the first year with the air raids, that war had an impact. Children lost their fathers. To feed four or five children, mothers exhausted themselves working at sewing machines or in orchards. People lost their parents, relatives, and friends. Entire families were destroyed. War is destruction. God didn't create man to destroy himself

but so we could love one another. War not only devastates the environment and society, but also the human soul itself.

War/Ordeal / When the Americans dumped their bombs on us, I saw children die. It was then that I took a lot of risks. It didn't last long, just forty-eight hours, if you count such things in hours. But every moment of those forty-eight hours was intense. I risked my life for those young men, aged between eighteen and twenty, burned and killed by the bombs before my eyes. We were responsible for them. The army set up bases in the orchards. The soldiers were principally from the south of Iraq, from Basra or Amarah. Their families were looking for them. The worst thing was to give parents who asked for it the identity card of their son and to bury the body with a simple sign on the grave.

War/Discrimination / I've stopped watching the news. I've learned not to differentiate between Sunnis and Shiites. The only time in my life that my father hit me was the day I told him I had a Shiite friend at school. He forbade us to distinguish Sunnis from Shiites. The war today is not destroying Sunnis or Shiites but all of Iraq. The young generation is growing up learning about violence and losing their dear ones. What kind of community are we building? Boys and girls, they'll all be marked when they come to creating a family. How will those who've been taught violence bring up their children? If we wanted to destroy an entire society, we'd start a conflict of that kind, a conflict between sects. In fact, this distinction disappears as soon as you cross the border out of Iraq: It doesn't matter whether you are Sunni or Shiite. If you ask an exile what sect he is, all he'll answer is "I'm Muslim, period. I didn't escape from Iraq to answer that sort of question in Damascus."

Message / I'd like to address the Iraqi people to say: "You are a good people. You've learned love and goodness. Stop killing one another. Look at your ruined streets and buildings. How much effort did it take to build them? Compare your life to that of your sons and your younger brothers: Raise your children as you were raised yourselves, in the understanding that there are neither Shiites nor Sunnis, nor Christians, nor Sabaists, but only human beings that you must treat as such. That is the requirement to prepare for the future."

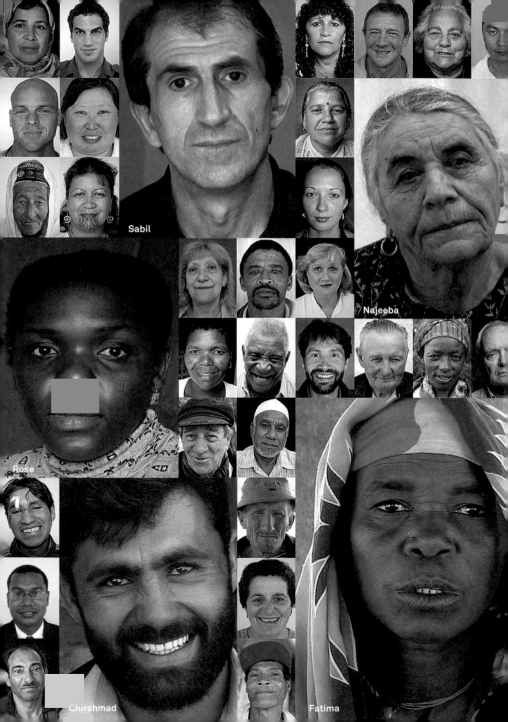

Sabil

Najeeba

Rose

Chirahmad

Fatima

WHY DID YOU LEAVE YOUR COUNTRY?

I left Cameroon because I didn't have a job. . . . I was obliged to go and look elsewhere. And today my battle is almost won.

Sabil / *Kosovan asylum seeker who lives in France*
Nobody leaves his country just to go and look at someone else's. It's adversity, suffering, and war that make you do it. Today the Lebanese we see on television don't flee because they want to but because they're forced to! Believe me, when I go to bed I dream of my country, but of how it used to be: as Yugoslavia under Tito. That was my country. That's my dream—a utopia that can never become reality.

Najeeba / *Iraqi refugee who lives in Syria*
I left Iraq because of the atrocities—killings, thefts, and threats. Do you think it's easy to leave your country? No. But there's nothing for us there now. As Christians, we're threatened. With my own eyes, I saw someone get killed. It's not one or two people, it's thousands, and above all in our region of Dora. Why would I want to continue to live like that? Not only is there all that, but they threaten us as well. Me, a woman of seventy years old, I was threatened! That's not done, to someone my age. Islam says that it's forbidden. I'm a woman who's raised a generation, and they came wearing masks and carrying machine guns to threaten me!

Rose / *Congolese asylum seeker who lives in France*
I just left without asking myself what would happen in France. When I saw that the children's lives were in danger, I preferred to go. I told myself that my children shouldn't suffer as I did.

Fatima / *Sudanese refugee who lives in Chad*
What happened to us? At dawn on the first day of the attack, planes, trucks, camels, horses. . . . When they attacked, they killed. They dropped fire down on us from above. We traveled by night and by day hid among the people. Owing to all that yalla, yalla, yalla [move it, move it, move it], we left. We left to get out of Sudan. They exterminated the people, they took the girls, killed the old, they burned everything.

Chirahmad / *Lives in Afghanistan*
In Logar [Afghanistan], at the begin-
ning of the revolution, our villages and
houses were bombed and everything
burned. We went to other villages. After
a while, three or four years, we'd had
enough of these financial and security
difficulties and took refuge in Pakistan.

Magdelein / *Lives in Qatar*
I always knew that I could never stay.
One day, I'll have to leave here, too.
Wherever I go, whatever happens, I live
in insecurity, in the inability to orga-
nize my life, even short-term—all this
because the world is unstable. It influ-
ences what we are.

Yaya / *Sudanese refugee who lives
in Chad*
Over there, there's the country—goods,
properties, land, gardens. It was a
peaceful, joyous world. Here there is no
joy, nothing nice, just the luck of being
alive. Everyone's family is safe and
sound. The only joy is being there with
your family, alive and safe.

Jalil / *Lives in Afghanistan*
I had a lot of difficulties in Afghanistan.
The Taliban murdered my father and
hunted me too. I couldn't live there—I
had to leave, go abroad. France is the
only country I took refuge in, but they
wouldn't give me any papers.

Zedjiga / *Algerian asylum seeker who
lives in France*
I feel more at home here than back
there, in Algeria. Because a country
where you're not relaxed, where you
have problems, where the people

196

don't accept you, is not your country.
Consequently I never felt it was my
home, I feel better here. To me, this is
my home, even if I still face problems
... I don't have papers. But it's better
here! At least there is no threat, there's
nothing.

Soupian / *Azerbaijani asylum seeker who
lives in France*
We live in the hope of returning one day
to our homeland, once it's been freed
of its occupiers, of all those scum who
won't allow our fathers, our grandfa-
thers, and us, the young generation,
to live. We don't see a future while
those people won't leave us alone and
in peace. Of course we believe, and
strongly hope, that one day that will
happen, that we'll be able to go back to
our homeland.

Aseeya / *Lives in Afghanistan*
When I was a child I thought of
Afghanistan; now I've found it again
and I want to keep it. If Afghanistan has
problems, I want to try to change, but I
don't want to leave the country. I'm free
here, I can say "I'm an Afghan," I can do
what other Afghans do. So I want to stay
in Afghanistan.

Here there is no
joy, nothing nice,
just the luck of
being alive.

agdelein

Aseeya

Soupian

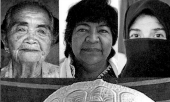

Zedjiga

Jalil

Yaya

Otto

Cameroonian asylum seeker who lives in Melilla, Spain

My greatest joy was … the first day I set foot in Spain. I was the happiest man in the world!

Background / I come from Cameroon, my name's Otto. I'm thirty-seven years old.

Dreams as a child / When I was young I dreamed of becoming the president of the republic.

Learned from your parents / My parents taught me to help people. In Cameroon sociability is essential—you have to help your neighbor, you have to love and help your neighbor, that's the most important thing.

Family / For me family is something splendid, something special. Yes, there is something sacred about family. Unfortunately I'm single, and at my age that's undignified for an African. It's all because of the economic conditions of the countries in Africa, which prevent someone of my age from being married.

Dreams today / Today my dream is to create a family, to marry, to raise my own children, and to love them more than anything.

Ordeal / The most difficult thing for me has been the death of my father. Twenty-five years ago my father died of the results of a road accident. Today, when I sum up my life, I tell myself that if he had been beside me, maybe it wouldn't have been so hard for me, perhaps he would've helped me to get on in life. When I see my life today, frankly, I miss my pop. When I see other people's fathers, I wonder what mine would've been like.

Leaving your country / I left Cameroon because I didn't have a job, and that wasn't because I didn't make applications to several local companies! I studied enough to

get a job: I finished high school, and that was enough to get at least a small job, but I didn't have that chance. Fifteen years after leaving school, I was obliged to go and look elsewhere. And today my battle is almost won.

Account of the journey / To leave Cameroon, I did a little job that earned me about 200,000 Central African francs, and I set off. From Cameroon I went to Nigeria, then to Benin by car, and from Benin I went to Togo. After that, Burkina Faso, Mali, then Algeria, and from there to Morocco. After Morocco came the country of my dreams: Spain. All that took several months. In all it's been three years of sacrifices, three years of hard labor. I crossed the desert, was attacked … oh yes, that was hard! For three years, I lived in the forest [in Morocco, just outside the Spanish border], I stayed wherever I fell asleep. They were three very difficult years. Well! You can imagine what it was like for someone who left an equatorial climate and found himself in January in such a cold climate! It was very, very hard but, with the strength of the Lord, the Almighty, the Most High, I overcame this trial. In the forest we woke up in the morning, we'd fool around, tell each other everything, talk about our dreams, of what we were going to do in Europe, we'd say we'd be prepared to sweep the streets, to do little jobs, anything to achieve success. Because at least there, in Europe, the possibility exists to get on. Oh sure! The desert—at times you cross it on foot, at times in a vehicle … and the vehicle, for me, was pure chance because I was never sure of having it. I'm happy today, I tell you that sincerely. Some died, those who couldn't walk in the desert, and were left buried—there were several. Their dream ended right there. They had a dream like mine, but they weren't up to it. They just couldn't manage it.

Happiness / I'm not happy yet, not yet. But I'm on track to be happy because I'm really going to work hard. The West gives me the chance to do that, something that's impossible in Africa. To be happy, first you have to have a good little job, you have to be able to work. That's how I define happiness.

Europe / Europe? I imagine Europe as the Garden of Eden. Eden, have you heard of it? When God created the Earth, for him the Garden of Eden was up there, it was almost Paradise, you see? There were beautiful trees, a wonderful climate, where you lived well, where there was no suffering. Oh yes! To me Europe is the Garden of Eden! Here there is the chance to get on, you can eat as much as you need, there are jobs. That's what Europe is to me. I know that there are millions of unemployed in Europe, but maybe those people would like to have fine jobs, they'd like to work in offices. Today I'm ready to sweep the streets because even if you sweep the streets in Europe, you get paid. And well paid! I can do it! At home in Cameroon there's nothing to do and yet everything needs to be redone. You understand? That's all.

Joy / My greatest joy was arriving here of course! The first day I set foot in Spain. I was the happiest man in the world because I told myself that now my dream could come true! God is at my side; that was my greatest joy.

Fear / My greatest fear is to be forced to return to Africa without making my dream come true: without having married, without having a house. You understand?

Poverty / There is poverty in the world because men have created it. And those men know who they are. Africa is not a poor continent, as far as I am aware. Africa abounds in minerals and has a very rich soil. All that's needed is to run Africa well. When a road has to be built, the budget is voted, but sometimes the money is embezzled—who knows where it goes. I've had the time to see how things work in this small town of Melilla: to build a road there's no need to lay out a budget. It's enough that the mayor decides that this portion of road isn't good enough, and it's redone. It's not like that back home, you have to have a budget, and a vote has to be taken. It's so slow!

Enemy of mankind / The enemy of mankind is man himself, because man is a wolf to man: Man eats man. Oh yeah!

Message / What has Africa done to deserve all that? That's my question.

I'm not happy yet, not yet. But I'm on track to be happy because I'm really going to work hard.

Hector

Wilfredo

Filomeno

Claudia

Ben Ali

Hector / *Lives in Ecuador*
We'd all like to go to another country to work. We poor would like to go to where there's a source of money. There are some people who, even if they have work, go elsewhere, that's for sure. For us, it's even worse. We live in the water, in the mangrove swamp, and we don't eat three meals a day. We want someone to come and help us. If you asked me to go to another country to earn money—to work—I'd go straightaway.

Filomeno / *Lives in Mexico*
We were so poor that I always wanted to have something to be able to help my parents and brothers. Time passed, and I had to leave for the United States, given the conditions my family were living in. Thanks to God, I found two jobs there. I worked in the morning and finished about 2 or 3 in the afternoon. I just had time to freshen up a bit, to take a shower, then I started another job at 5 that lasted till 2 in the morning. I did all that, made all those sacrifices, because I wanted a better future for my family. At that time I was already married, and I didn't want my children to have to do what I was doing.

Claudia / *Lives in Bolivia*
My children aren't here. They're in Argentina. Life is hard here. They left. They call me. It's nice. I think of them. It makes me cry.

Ben Ali / *Algerian, lives in France*
The most difficult thing is leaving your family—your children of course, but above all your parents. Because your parents suffered for you and, when you leave them, you cry because you love them, that's the hardest thing.

Wilfredo / *Lives in Mexico*
I never imagined this voyage. I was young when my daughter, who's now twelve, was born. I have five children in Honduras. Leaving was inconceivable. I thought of it later, when I was thirty-two. I wanted to ensure my family's wellbeing. As I'd seen many people try and succeed, I thought about leaving. Suddenly, I had a chance to go. With hope and volition, I left my people and my country. That's why I left.

If you asked me to go to another country to earn money—to work—I'd go straightaway!

Yves Clement / *Cameroonian asylum seeker who lives in Melilla, Spain*
The hardest part was crossing the desert. It was very hard, I don't even like to think of it! I thank God because it was the Lord who saw to it that I managed to arrive where I am. I lost many friends while crossing the desert. I lost friends—three companions from Nigeria who died. After spending seven days in the desert, without water or food, abandoned there in the sand, we had to walk nine miles without a vehicle, nothing. As God does good deeds, all of a sudden we came across another group of illegal immigrants, who stopped and helped us. We'd already lost three of our companions. It was the hardest thing we had to do ... I don't like to think about it.

Andres / *Lives in Mexico*
I was between two wagons, always hidden, fearing the police would come. That's why we hid—so we wouldn't get caught. Sometimes we were hungry and we had to get off. That's why we decided to get off, and we did so despite our fear. Right then, we could've lost everything. I fell and my foot was cut off. I fell under the wheels of the train and my foot was cut off.

Philemon / *Cameroonian asylum seeker who lives in Melilla, Spain*
I was obliged to live in the forest close to the Spanish border. From time to time we went to the fence with the hope of being able to enter Europe. It wasn't easy; the Moroccan police caught us and beat us hard, as well as the Spanish Civil Guard. And that was very hard. They tortured me and threatened me. I spent three and a half years in the forest—three and a half years! It was really time wasted, but I was hopeful, I was always in good spirits, because I knew that without that, I was nothing. Yes, without that, really, I was nothing! It was the hardest thing in the world to get in here, but I made it!

Evangelina / *Lives in Mexico*
I don't know how I'm going to cross the border because I don't have anyone to guide me. I'd so much love to have the courage to take a bus or climb in a taxi and tell him, "Take me to the border!" Seeing so many people passing, I'd like to mix in with them and pass through on foot, and to have the courage to pass without fear. May God protect me and allow me to reach Los Angeles and be out of danger, because I don't want the border police to catch me, because I don't want to go back home.

Daouda / *Malian asylum seeker who lives in Melilla, Spain*
My greatest fear is expulsion, that's all. That's my greatest fear. If I don't get thrown out, it's certain that I'll find work. My greatest fear is expulsion.

Zombra / *Burkinabé asylum seeker who lives in Melilla, Spain*
As a child, my dream was to go to Europe. Today, I thank God I made it. Now, it's up to me to do ... everything.

Yves Clement

Evangelina

Andres

Daouda

Philemon

Mirta

Hamlet

Zombra

Martha

Sohari

Martha / *Bolivian, lives in Great Britain*
My eldest son couldn't study because of a lack of money. The others wanted to study, and I told them they had to find themselves a profession, they had to study. I had to leave for England. If I hadn't come to England, I would've gone to Spain, and if not Spain, then Italy. Yes, I had to get into one of these three countries to work. When I arrived in England, I couldn't speak English. For three months it was really hard, I almost slept in the street. And then I met these people, and through them I heard of this house, after three months without work, without anything.

Mirta / *Lives in Buenos Aires, Argentina*
I was sad to leave my country, but curious to discover a new place and new things. They said Argentina was grandiose. I'd imagined it to be more … I was a kid then, and I thought it was different from Paraguay. When I got here with my mother, who was poor, we had to live in a shantytown. When I saw that, I was very disappointed, as I had imagined something else.

Sohari / *Madagascan refugee who lives in France*
My dream as a child was, like everyone, to come to France. For us France is the shining destination! Everyone wants to leave for France! Now I'm here, but I don't have the same vision as when I was young: a France where everything is beautiful and good, where life is beautiful. I've noticed that when people who come to France go back home again, they try to give a false image of

the country. They work very hard, and I understand that when they go back, when they arrive home, they want to show that they're rolling in money, that life in France is great, that everything is fine. But here, to succeed as a foreigner, you really have to work hard! You can forget about holidays, you can forget about outings, you can forget about life in general!

Hamlet / *Lives in Moscow, Russia*
You know, life is tough in the countries of the CIS [Commonwealth of Independent States], the former Soviet Union. It's the same where we live—life is tough! I came here to work and help my family. Of course I miss my wife, and she misses me! And the children. Each time I phone, my little daughter tells me, "Come home, daddy, come home!" So far it hasn't been wonderful, but it's essential that the situation at home stabilizes and that my children find work there.

Kader / *Algerian who lives in France*
My family is back home. I live here. At times it's difficult. Sometimes I've spent the day crying … because my parents are back home, and I'm here. It's nearly four years since I last saw them. The last time, both my brother and sister got married, but … I wasn't there. That's the problem! When I saw the video, I cried all night.

207

Marissa / *Philippine who lives in Hong Kong, China*
I've worked in Hong Kong for sixteen years, and everything I earn I send to my family. For example, I bought a Plastoplan to build the house, and I allowed my brother and sister to study at university. I've been here for sixteen years, and I haven't saved anything for myself. Once I was chucked out of my job, and I had to return home without any money, and in their opinion it was as though I was begging. That was the biggest mistake I've ever made! I don't think of myself, I do everything for them!

Camilo / *Lives in Mexico*
I think that yes, it's been worth the effort. You see my little house, I built it by making sacrifices, by saving. That's the result of my work, and what I've done with my comings and goings to the United States. If I'd stayed here, I would've had nothing, because there's no work here. It's not a town where there's much work.

Pedro / *Lives in Bolivia*
The last time I cried was five years ago. I was in Argentina, I was working, I didn't come home, I hadn't seen my parents—my mother—for a long time . . . I was seized by a feeling of sadness and powerlessness, and I cried, you see? I cried! I cried a lot, until I said to myself, "Why don't you go home so you can be happy?" And now I'm here and for the moment I'm happy!

My family is back home. I live here. At times it's difficult. Sometimes I've spent the day crying . . . because my parents are back home and I'm here.

Kader

Pedro

Marissa

Camilo

Katiba

Lives in Algeria

Before independence I was a "native," and afterward I became an Algerian.

Background / I'm Katiba. Very often people ask me, "Why are you called Katiba?" It's simply because my father wanted to pay tribute the regiment of Salah Eddin El Ayoubi at the time of the Crusades, and he gave me this name which was taken up by the NLA, the National Liberation Army. So I'm called Katiba, I'm fifty-five, and I've lived in Tipaza for about twenty years. I'm actually from Alger, that district ... the district of history, a history of a district. I'm originally from the Casbah, the heights of the Casbah, which is called Bab Edj'did.

Memories / If only you knew what being Algerian means! When we were bullied and insulted, when we were called bicots, melons, and ratons [derogatory terms meaning North African Arab], when we only existed in relation to the others—if the others weren't around you didn't exist. If you knew the feelings we had in the month of July 1962. I know I never shut up about it! Very often my children say, "We know!" ... and they say it for me. It's very simple, I have the feeling I'm ninety years old! If you knew the joy I felt when I was a child! First, the notion of being Algerian was a dream that came true for me in 1962. My father had said, "Do you know what independence is?" For me independence was abstract, something that didn't really mean anything. It was just a different stage. And when my father told me, "Do you know what independence is? You'll have a passport and a seat in the United Nations." When I was twelve or thirteen years old, a seat at the United Nations ... it meant nothing to me, even if I was involved in it all. But a passport! I'll exist when independence comes! That's my most beautiful memory!

Country / Before independence I was a "native," and afterward I became an Algerian. Before independence we were members of the community with Jews, Christians . . . in other words, respecting the others and accepting them for what they were. In the old district of the Casbah there were not only Algerians, or Arabs, or natives as we were pejoratively called at the time, there were Jews and Christians. We all celebrated our own festivals, like Christmas and Aïd. Among Muslims, Aïd sghir is the big festival that celebrates the end of Ramadan! And then there was Yom Kippur for the Jews. By inviting each other to our celebrations, we shared our happiness.

Ordeal / The curfew was a very sad time, it was very difficult. I would never have thought it possible that in this independent Algeria I could live through those same things again! The deathly silence, the silence on the other side of the door! It was atrocious! You had the impression of being safe, but safe in relation to what? For me the curfew was a time of hearing the footsteps of the French army, the footsteps of the soldiers, grrrrh! The rangers! I thought it was finished, that it was a story I would be telling my grandchildren. Never would I have believed that my children would live through what we have experienced these last ten years. I thought it would have been part of history. I don't want to hear talk of the curfew. The curfew was the end of the world, the end of an affair, the end of a love story, the end of a life, the end of the day; it was the door open on fear, the awakening of the senses. All our senses were wide awake. Those are the impressions I have retained of the past ten years. Never again, insh'Allah, never again!

Leaving your country / Ah yes! Ah yes! When I get edgy I leave. And every time I get angry with my country, I want to leave. I left saying, "That's it, it's over! I'm not coming back!" But after two months I was down, I felt sad, because I had taken Algeria with me. I couldn't stand it. I didn't talk about anything except Algeria! By the time two months was up I was harping on so much about Algeria that even my friends told me "Khlass basta! Shut up!" And then I told myself, "I'm fed up too, I have to go home." And I'll tell you something: I prefer to suffer at home than at someone else's place!

Relations between men and women / It's a battle that goes back in time, a fight that my grandmother began, and my mother continued. You know, you always get the impression that Algerian women live in a closed space and that Algerian men are very macho. But I'll tell you something: I always saw my grandmother lay down the law in the house, and my mother always got what she wanted. My father always gave the impression that it was him who decided, but it was really my mother! They used subtlety, the subtle manner of leading the man to think and act as the woman wants him to. During the liberation war I went to school, and lots of uncles said to my father, "What! A girl at school!" And my father replied, "We're fighting for our daughters

to go to school! To learn, to know." So I had this benefit. I didn't wear the veil, like my mother did. I mean that I didn't carry that enclosed space, that women's realm, around with me, whereas, under her veil, my mother took with her all of this enclosed space of the house and family, of the society of the time. But I didn't, and I hope my daughter will never wear it. My daughter will be the equal of anyone; it's a complementary relationship—women are making progress, they're going to bring benefits, they're going to make what they want of Algeria.

The future of your country / Why do you want everyone to be the same? It's impossible! I'm going to tell you an Arabic proverb: El Kerch Djib Sebagh or Debbagh, that means that the brothers and sisters conceived in the same womb don't look alike. But they love one another! That's how I want my country to be! Knowledge with a capital "K," looking forward in time and space so the future is better for everyone. I don't want it to be always gray or black, I want to see colors! I love colors, I love blue, green, red, I love the colors of the Algerian flag, the colors that are all around us. I have a very sunny disposition. So I'd like it to be like that, with a bright, colorful, and radiant future! Even if I know that it's only a dream—never mind, it's not important. If I am able to dream, then my children will be able to dream, so as to make progress. May God give me a long life! Oh, ya raabi laaziz, dear God, I'd love to be still around in twenty years' time. My country will be ... Algeria will be sixty years old, a mature old woman, full of wisdom, full of experience; she'll be able to forgive her children, those who have been unruly, she'll make use of her experience and tell her history. Oh, in twenty years, I hope b'rabbi inch'Allah, with the grace of God, that we will be decent people.

Words / We have a proverb that says, "He lived, he owned nothing; he's dead, he left nothing"—Aache ma k'seb mat ma khella. But I think that every one of us has something to leave. I thank you.

simba Bob

Mina

Frederick

Mariette

WHAT DOES HOME MEAN TO YOU?

Mina / *Lives in Iran*
Yes, I love my village, Shal! Arriving in Shal is like taking a breath of pure oxygen! My village is my inspiration! I don't know if it's like that for you. Home is the sweetest place on earth!

Frederick / *Lives in southern India*
I always felt in exile in Germany, I could never relax, I always felt ill at ease. Frankly, I never really trusted the people I knew. When I arrived in India by boat the first time, a great weight was lifted from my shoulders, and I felt, despite the disorder, I just felt that I belonged here. "Home," that's where you feel you have an attachment, not only to the people but to the country too, from the bottom of your heart.

Where you feel you have an attachment, not only to the people but to the country too, from the bottom of your heart.

Nsimba Bob / *Congolese refugee who lives in South Africa*
At home you can do anything, but when you're somewhere else it becomes difficult. At home I can eat at the table or sitting on the ground. For me it's like a blanket, it's where I was born, where I grew up, where I can talk about everything and anything. When you're outside your home you have to know how to communicate with others.

Mariette / *Lives in Chechnya*
Being at home is very important to me. I live in a studio apartment, and when I arrive and hear the neighbors above and below, I sit on the sofa and realize I'm at home. On one hand, I'm up-to-date on all my neighbors' problems, because we live in miniscule apartments—it's a type of building that was constructed back in Khrushchev's time. But on the other hand, it's so good to know that both above and below me they're still alive! That upstairs today they're laughing during their dinner and downstairs no one is crying. It's great just to know. At home I feel relaxed.

Jade / *Lives in the Palestinian Territories*
When I left Palestine, I felt I would
never come back to Palestine. I thought,
"this is it," you know. This place is too
depressing, it's shit, you know. And
I just want to go somewhere to get a
good job, for my music to spread out—a
lot of opportunities. That's how I was
thinking. I actually told my parents at
the airport that if they ever want to see
me again, they should come visit me in
the United States. And then the first few
months, I was still with that. I was like,
"Yeah, I'll never go back." A few months
later, I was like—everything just
changed, you know. And it also made
me love my home. That's one thing
that changed. I used to hate this place,
because of the situation, obviously.
But when I went there, I realized how
much I loved my home and the people
around me. And that's what made me
come back.

Rose / *Congolese asylum seeker who lives
in France*
Me? I don't know where I come from.
That's a question I often ask myself. As
the country in which I was born . . . took
my father and many things from me. I
don't know where I'm from. But for me,
the country you're from doesn't count.
The problem is being happy where you
are. My grandmother said that when
someone receives you, behave as if you
were at home. When I go somewhere,
I don't wonder what country people
come from. If I feel comfortable with
them, for me, they're my brothers
and sisters.

Waddah / *Iraqi refugee who lives in Syria*
Here in Syria I feel as though I'm at
home. With the people. The first time
I left Iraq, I left for the Emirates before
coming to Syria, but I could only stick
it for six months. I couldn't stand the
place. I felt I couldn't live there. And
when I came here, things became very
easy. When you take a taxi, when you
go shopping, when you talk with some-
one, you don't feel like a foreigner or
a refugee—I feel as though I'm in my
own country. I work, I make paintings,
I deal with storekeepers. It's easy to get
on with people here, it's as if I were a
Syrian and not a foreigner.

Sarah / *Lives in Tel Aviv, Israel*
I have no country, nowhere I call home.
I was born in Canada . . . but it's not my
country. I live in Israel, but it's not my
country. I love . . . I love and try to be
loyal . . . [to] the land on which I walk. I
believe in neither countries nor borders.

When I left . . .
I realized how
much I loved my
home [country].
. . . That's what
made me
come back.

Jade

Waddah

Sarah

Rose

Lidya

Ljubisa

Sashi

Lidya / *Lives in New Orleans*
I think it was the day we arrived in Addis Ababa (Ethiopia) for the first time, a month ago. It was my first return after twenty-six years. It gave me an incredible feeling to wake up there, to go walking there, and to realize that, wow!, it's the place I'm from. To see so many people who look like me, speak my language, eat what I eat. For the first time I thought to myself, "Once again I'm tied to something, I have a history, a culture that extends beyond me." After all, I grew up in the United States, and even if I have always had an association with my African culture—I speak its language, I listen to its music—it's nothing as powerful as returning to your birthplace and living the experience directly.

Sashi / *Lives in New York*
For me the idea of home is very difficult to define. I was born in one city, I went to junior high school in a second, to senior high in a third, to university in a fourth, and I graduated in a fifth. Then I worked in different places around the world. Even in New York, where I have spent most time, I've moved around a lot, first for comfort and then for personal reasons, like my divorce. I am one of those people who have lost their sense of "home." For a long time "my home" was where my parents were, but since I lost my father, my mother has lived in a town where I have no ties, I haven't done anything there, it's her home but not mine. I also have a family house in India where my grandmother lives. It's sad to say, but I'm "homeless"—the whole world is "my home."

Ljubisa / *Lives in France*
I was born in Paris, and everything about me is French: the books that I've read, the music I listen to ... yet I speak Serbo-Croatian fluently. My parents passed that onto me, but it's as though I received it as a gift: I speak the language fluently but no one's ever taught me everything that goes with it, the history of the country, the Orthodox religion ... nobody taught me anything! So I went to search it out. Just as a joke, I sometimes used to say that I felt I was a child whose mother gave him up at birth. Not knowing what lay behind me, that was a real worry, because when you don't know where you come from or where you're going, it's difficult to envisage passing anything down to your children. I made use of photography to solve that problem; it was a pretext to return to the villages where my ancestors grew up. And I found it all. From a photographic point of view, the project was unsuccessful, it was more an opportunity for introspection. But I discovered a village with all my ancestors ... their graves. Now I know.

WHAT DOES HOME MEAN TO YOU?

Mohammed / *Lives in Germany*
Sometimes I suffer from crises of identity. Who am I? I'm not Egyptian. When I go to Egypt, they say I've become European: "You need a fork, a knife, you want an ashtray ..." and so on. I behave like a European. When I come to Germany, in Europe, they say I'm Eastern. So, I wonder to myself just what I am. I'm not Egyptian, and I'm not German. That puts me in a state of confusion. So I decided to be just what I am: I am the result of the experiences I've had among these two cultures. I'm a blend of the two.

Ing / *Lives in Switzerland*
I can't say what I am. That's my problem. The people in Switzerland ask me why I don't apply for Swiss nationality as I've been there for a long time. But why should I? I don't feel Swiss. Instead I have a Dutch education and my mothertongue is Dutch. On the other hand I've never lived in Holland. I've lived in Indonesia and Switzerland, so in the end what am I? I don't know! I feel Chinese because I have Chinese forefathers—that's why I study Chinese. So maybe I feel more Chinese? On the other hand I'm ashamed because I don't even speak the language. Perhaps it's because of my blood, you know there's a blood relationship, that's maybe the reason I feel more Chinese than Swiss, even if I've lived in Switzerland for a long time.

Geoffrey / *Lives in South Africa*
Being a white man in a black continent? You know what? I'm African, and what's more important, I'm South African. I was born here, I grew up here, I spent six years defending my country. I'll never go anywhere else; I come from South Africa, it's as simple as that.

Salwa / *Lives in France*
It's said I think of myself as a house: My foundations are Moroccan, the first floor is Moroccan, the second French. We'll see what the little terrace at the top will turn out to be!

Pierre / *Lives in France*
If I didn't have this bit of land in Ardèche, I would be in exile. I'd be in exile because I'm not French, I'm someone so Europeanized that I no longer feel Algerian, nor even African. I'm a mixture of all that. So what is my home? My home is also my social context, my relationships with friends and the people, and then this place. This place, this is my home, because I've worked this land very much, I've loved it, I've rendered it productive with my sweat and my work. It's my mother, my lover, and my daughter all at the same time. It's everything together, and it's here that I feel at home, to the point that I'd like to be buried in its soil. Outside of that, I'm in exile.

Ing

Mohammed

Geoffrey

Pierre

Salwa

Mary

Lives in Australia

Nature gives me my life. Nature is my sustenance, my inspiration.

Background / My name is Mary Claire—that's my full name. I was born on the 15th of August 1966, which is also my grandmother's birthday so I was given her name; so we both had the same name. So I grew up with my grandmother at home, an only child. My own mom and dad died in their forties when I was born, and I'm forty now. I live here, in the Blue Mountains, west of Sidney. It's a very beautiful place, a conducive climate, easy-going, very rich place with World Heritage National Parks. I'm very privileged to be here. I'm single. I have a daughter, Christina, who is nearly fifteen.

Work / I've just finished doing a degree at the university of Western Sidney, in conservation and landscape management. I've just finished studying, doing a degree in conservation and sustainability. And I haven't yet gotten a job in the field, but I do volunteer work in bush care—looking after the local environment from weeds and things. But I intend to work as a person who restores land. In Australia, lots of clearing happened very quickly, and there's a lot of areas that are now suffering. So restoration projects to bring back healthy soils and water and habitat for animals, that's my aim.

Childhood dream / I have wanted for a long time to work with the natural world and plant lots and lots and lots of trees. I used to do this as a child, well, a teenager. There was a school across the road and I used to plant trees there when no one was looking. I've always had a quest to work with putting back some trees.

Legacy / I wish to pass on to her ... well, I guess confidence in her own abilities to live the best possible life she can, to be able to recognize opportunities, to live full and I guess ... with compassion, I suppose, an awareness for others. A sense of equality

amongst all people—that was something I learned from my grandmother, both my grandmothers, equally at home with the person who collects the garbage and the person who's the mayor of the town. And I grew up with a grandmother who demonstrated this. She spoke with everyone with respect, and I'd like to pass that on to my daughter. Also perhaps my love of the natural world as well, because we share this planet with a whole host of other beings, not just humans. And our life is richer when the habitat is preserved for our inspiration and wonderment.

Hardship / Hardest thing? The courage to have my daughter, I think, because the circumstances weren't perfect. Her dad wasn't there. And I just had a feeling that I had to have faith in this situation. And I did and I was rewarded with the most incredible experience.

Life lesson / Follow your instincts. Life is an opportunity every single day, every hour, to learn something and to resolve yourself some way or another. Choices—every single hour we have choices to go one way or another, to act with honor or integrity or humility or pride if necessary. Opportunity and a test; life is often a test. But it's also very forgiving. I think we're embraced by more hands than we can imagine.

Happiness / Happiness for me: every year watching the blossoms come out, as if it's for the first time; seeing the birds in my garden; seeing a big tree that's managed to survive the wheels of progress. Happiness—simple things: sitting by the fire, visiting the creek, putting my hands in the water, going to the waterfall and standing underneath it, being able to experience through this material life I have. I'm getting older. It used to be sort of scary, but it's got bonuses. As you get older, you realize how fast it all moves and, wow, how silly it is to squander time and opportunities to be happy, simply happy.

Anger / Exploitation makes me angry. And squandering of resources and people's land and inheritance. People who have custodianship over thousands of years of land and culture—to lose it makes me very angry.

Life is often a test. But it's also very forgiving.

Forgiving / It's taken me a long time to come to terms with things like the colonization of parts of the world. But as I come to accept that that's the way it is now—all we have to work with is what we have now. And it's only preceding—we can only go forward. I recently read a book about the early history of Australia, with the invasion of the Europeans and what happened to the aboriginal people, and it was just heartbreaking. This history wasn't told. So it's taken me a long time to come to terms with that. Forgive? Well, you can forgive anything, I suppose.

Changes in the world / Sustainability is progress. Socially there's been a big push towards, kind of success and expression of that, of the individual, sort of individualism, economic rationalism, you know. People seem to be very security conscious for their own resources, have to buy very big houses, and be very—that's a big statement—and living in isolation. There is a lot of that, and I think that's a bit sad. The concern with making a permanent mark, you know—life isn't permanent.

Changing your country / I'd like to see us spend more money on the basic things, like health and education; less on military. At the moment, with the culture of individualism, everybody needed insurance, everybody's living fearfully, security being a problem, there is no safety net, it seems. Everybody is terribly worried about their future and their retirement, when there is ample. So I guess I'd like to see perhaps a return to more socialist practices, ideals put in place.

Enemy of man / Himself. The quest for always wanting more, greed. Emptiness seeking to fill the whole with false gods.

After death / Oh, what is beyond our imaginings? I think that there is a rest. I think that there is a bit of peace for a while. I think that it's quite lovely. And then I think that if need be, we come back and have another life, to learn more lessons, and have more opportunities.

Nature / Nature is ... nature is the place—nature gives me my life. Nature is my sustenance, my inspiration. I call myself a pagan, you know, a person connected to the earth. I take omens from nature. Nature sends a bird, I say, "Whoo, this means something!" Nature is the source of my greatest happiness. Being alive is being in nature, and nature is both mother and father; and teacher and friend; and solace and comfort; and beauty and wonder ... and inspiration.

Francesca

Maud

Cassie

Abdelha

Laetitia

WHAT DOES NATURE REPRESENT TO YOU?

Francesca / *Lives in Italy*
For me nature is a bit maternal, like a mother. She tells and teaches us lots of things, she cleans us, she tells us off, she makes us happy.

Maud / *Lives in France*
Nature is a little like having a big sister. When I think of nature, I see myself once more as a child; until the age of eleven I had the good fortune to be brought up in a house in the middle of the fields. We were four miles from the nearest village. In winter, when there was too much snow, we stayed snug in the house instead of going to school, because the school yard was icy. We used to play with a sled. In summer, we'd sleep outside gazing up at the stars. I had the luck to know nature like very few people in France because most children are brought up in towns. This contact with nature is fundamental; you can get by without it, but I think it gives you a great deal of balance in your life.

Abdelha / *Lives in Morocco*
The best is when you wake up in the morning very early, and you go into the garden where there are all kinds of trees and plants mixed together. There are flowers, and this and that—a wonderful perfume—and once you've smelled it, you can't get it out of your mind. Nighttime exalts the smells of the plants thanks to the humidity. If you go out at midnight or one in the morning, you become heady on the perfumes.

Cassie / *Lives in Great Britain*
I chose to live in the country, and almost every day I have the opportunity to go and sit on a hill, look at a lake, and walk in woods where I can see deer and pheasants. Each time nature gives me energy, it makes life possible, good and beautiful to the human being I am. Each time I'm amazed by the beauty that surrounds us, by the elegance of the plants that grow in my garden: It's all so wonderful! My relationship with nature is very simple: If I have problems, if I have gloomy thoughts or feel depressed, nature is always there to help pick me up again. And even the mist on the hill or gray clouds will help raise my morale.

Laetitia / *Lives in France*
Nature has changed a bit, but not as much as all that. It's changed and is less wild than it used to be, but I think that I've changed too, so I can't say which has changed more. In all those places I go and where I have memories from my childhood or adolescence, if I close my eyes and concentrate, I feel exactly the same sensations. So nature hasn't changed so very much. We've both changed.

Karl Andres / *Lives in Sweden*
Global warming, the foremost topic of the moment! Personally, I think that nature is undergoing a normal change of mood; we have lived through greater changes, even before we knew that oil existed. During the Bronze Age, there were tropical forests here in Sweden, and I'm sure there weren't too many cars either at that time! There's no one single thing that I can point to that leads me to believe that global warming exists. Something has changed, but what is it? In fifteen minutes a volcano spews out as much as the world produces in a single year! What should we do? Should we stop living? I think that there is a certain exaggeration!

Cesar Miguel / *Lives in Mexico*
Fires have ravaged the vegetation. I feel that it's a little hotter than it used to be. There used to be a very lovely river; it's still there but now it's deviated to irrigate the fields during the dry season. So the aquatic wildlife diminishes, there are fewer and fewer fish. And then there's the pollution of the rivers—waste water is poured into them, which is what pollutes them. As a result, the vegetation and animal life have been very affected.

Vincent / *Lives in France*
The sea will always remain what it is but as for what's in it. ... The sea is becoming increasingly impoverished. We won't be able to reverse the situation. It's gone so far! The industrialized countries throw their waste into the sea, and fishing ... over-fishing above all

because the demand is there it seems. The sea becomes impoverished and then there's the pollution too, and I think that if we don't do anything. ... But what can we do? Before long, perhaps fifteen years, fishermen will probably have a very hard time. The sea will only be useful for tourism, so people can go swimming, that's all.

Sovichea / *Lives in Cambodia*
Before there used to be four seasons: the season of the rains, the dry season, the season of the cool wind, and the spring, like in other countries. The season of the rains used to begin at the start of April or early May, but now it begins in mid-May or at the end of the month, and sometimes there is no rain until July. And during the dry season it is too hot. Before the temperature would be around 90 to 95°F; today it can reach 105 or 107 in Phnom Penh. And during the season of the cool wind it's too cold, and the thermometer can drop to 1°F at Phnom Penh.

The sea is becoming increasingly impoverished. We won't be able to reverse the situation.

Karl Andres

Cesar Miguel

Vincent

Sovichea

Jorge

Armando

Fabian

Pedro Luís

Armando / *Lives in Mexico*

In Mexico we don't get good teaching about the environment. It just doesn't happen. The number of trees being cut down in the forests is excessive, and increasing. Economic globalization drags us all along with it. Today, to survive, a Tzeltal [a people] can sell his tree for 10 pesos or 100 pesos, whereas a hundred or a hundred and fifty years ago, before cutting down his tree, or before preparing the ground to plant maize, he would pray to ask forgiveness. Now that's no longer done. The destruction of nature is due to the economic globalization that is making society suffer. That's what we're afraid of, at least that's my fear, but I would like to continue living without a disaster occurring. I would. But with the speeding up of everything, I don't know, I don't know.

Fabian / *Lives in Buenos Aires, Argentina*

I'm very worried about water. In our country we have many sources of fresh water. And as certain countries, for example the United States, are capable of killing lots of people for oil, I wouldn't be surprised if they invade us to seize our water. Perhaps I'm exaggerating a little, but there isn't a lot of drinking water in the world, and when that runs out, if we still have some, I don't know what the imperialist and capitalist countries will do to take control of it. I can see my niece buying a liter of water and water costing as much as a liter of … something very expensive—almost half a salary for water, for survival. The day we have a little water left, it will be sold. I worry about the country's water and about it becoming a desert.

Jorge / *Lives in Brazil*

When people try to destroy Amazonia and the air that we breathe, as well as the water we drink, it's an attack on our freedom. By attacking our freedom, they're attacking us in person. By attacking nature, they're attacking us.

Pedro Luís / *Lives in Cuba*

I've heard people talk about nature, but I haven't had the opportunity to involve myself in it. Seeing how we live in Cuba, we don't have the time to think about nature. Here you don't have the time to realize that you're throwing a food can on the ground, you don't have the time to consider the fact that you mustn't chuck waste anywhere but in the trash. Cubans don't have the time to plant a tree or even a bush—they don't have the time. They pray for it to rain so that they can survive, so that the trees grow, so that they'll have something to eat, so that the fruit will grow, and all that, so that the bushes are pretty, but they don't consider acting on their own initiative. It's very rare to see someone take a watering can and water the plants. Cubans don't do anything for the environment.

Samir / *Lives in France*

I can't say that it's of no importance to me, but it's not a worry to me, and I don't think about it every day. It's like the hole in the ozone layer or knowing that one day or another there's not going to be any water in the tap, because, of course, the water's going to run out. It's true, but it's not one of my major worries. It's a bit of a pity, but that's how it is. Maybe it's because I live surrounded by concrete all the time.

Scott / *Lives in Texas*

I guess I fall into the role of everybody else. I drive a big truck. It doesn't get very good gas mileage. I'm aware that they are environmental problems, and I guess I just do what I want to do, you know. I fall into the role of every American. It sounds bad, but … I enjoy my big truck, and I don't really … I don't really care!

Yasmine / *Lives in Los Angeles*

Nature doesn't play an important role in my life; I don't go hiking, I don't go to the mountains. In fact I'm scared of large mountains, I'm scared of the oceans, so I guess you could say that I'm also scared of nature because it's so powerful. The ocean is so immense, the mountains so gigantic, and then there are those animals. To be perfectly honest, I think I'm scared of nature!

Ferrante / *Lives in Italy*

Nature is something very nasty. All the things in nature exist by eating one another. We continue to think of nature as something romantic, something beautiful, but nature means that all the animals spend their time eating one another. And when we see a flock of swallows, it looks magnificent, but we forget that those swallows are eating insects as they fly. Now, it's my opinion that those insects aren't too keen on being eaten! Consequently, we're there watching a series of murders, and we find that beautiful and romantic! The flock of swallows may give us wonderful memories, but nature is malevolent.

Nature is something very nasty. All the things in nature exist by eating one another.

Samir

Yasmine

Scott

Ferrante

Nancy

Stephanie

Jacques

Atta

Anatoli

Jacques / *Lives in France*
Nature is something I don't like
because I'm one of those people
who believe that the peculiarity of
man is to escape nature, that nature
is savage, bestial, animal, and that
civilization is the complete opposite.
Civilization is what man has created
using nature. So I prefer gardens to
forests, I prefer built things to natural
things, even if I'm a staunch defender
of the protection of nature, and even
if I think that man will not be able
to build anything if he destroys the
environment, he has the privilege to
inhabit. But it's my feeling that our
approach to nature—and all the phi-
losophy of nature—is just an apology
for bestiality.

Nancy / *Lives in Hong Kong, China*
Nature is very strong—when the
winds blow, when the tide comes in—
it's both very useful and destructive.
It's incredible and it's beautiful.

Stephanie / *Lives in Australia*
Nature is part of the spirituality inher-
ent in our culture. We conserve it,
alive, inside us. We dance on the soil
where we were born. In the same way
that we take care of Mother Nature,
Mother Nature takes care of us.

Anatoli / *Lives in Siberia, Russia*
In shamanism, our temple is what
surrounds us. The vault is the eter-
nally blue sky, and what surrounds us
are the attributes of all the temples.
Modern man makes a mistake when
he enters a temple, lights a candle,
says a prayer, and leaves. He thinks
he has done something spiritual,
then he forgets what he has said and
asked from God. When we find our-
selves in our temple, the universal
temple of man, we feel in union with
nature. The sacred Lake Baïkal, the
sacred Saïan mountains, the sacred
cedars, the beeches, and the wild
cherry trees. We Bouriats [a people]
feel we're a part of this nature. How
can we treat nature badly when we
ourselves are only a tiny particle of it?
Everything has a spirit; everything has
to be treated with care.

Atta / *Lives in Taiwan*
It's not like the young or the hikers
of today! They don't perform this sort
of prayer ceremony before setting
out. They only think of reaching the
top of a mountain without having the
sense of respectfulness that used to
exist, without asking through prayer
if the attempt should be made or not.
It's that respectfulness of the past
that I like. If you don't have feelings
of respect in your heart, things are
superficial. We must have respect for
everything we do.

Bruno / *Lives in France*
We are born of nature, but we don't consider it anymore; nature speaks to us, but we don't listen. To know what the weather is we turn on the radio, to know if it's going to rain we listen to the bulletin. But nature will tell you, it's simple! Look, you see there are high clouds on the Cagne massif: When the clouds are high that means the wind is going to blow for two days, so there's no need to worry, it's not going to rain. Are the clouds clinging to the tip of the mountain? Then the wind is coming from the southwest. Are the clouds moving down the valley? Watch out, the southwesterly wind is going to get very strong. Is the sea rising? Take care, it's going to get rough all of a sudden. Are the cormorants heading inland? The northwesterly wind is coming this way. But no one listens to nature anymore, they don't have the time, they're all in such a hurry.

We are born of nature, but we don't consider it anymore; nature speaks to us, but we don't listen.

Thérèse / *Lives in France*
Nature and man are in complete opposition. I live in an absolutely wonderful village, and what do the mayor and the municipality think of doing? Of laying down concrete to give the impression our village is a town. I find that really shocking!

Fujii / *Lives in Japan*
Nature is everything! Everything is nature! Even when I am at the large intersection at Shibuya [Tokyo], with millions of people in the traffic jam, for me that's nature. Nature isn't just beaches, mountains, forests. Buildings, human beings, even technologies come from nature. Silicon comes from oil, so that's nature! Therefore, as far as I am concerned, everything is nature.

Hayrettin / *Lives in Turkey*
When I speak about nature, I refer to the ecosystem. We should follow the example of nature, as in nature every form of life is obliged to live by exploiting others, but no species consumes to the point that another species becomes extinct. So each creature's existence is made possible by others; that means there is a real balance, real rules: To be able to live, you have to make it possible for others to live. Do you want to live? Then you must help others live, because if they didn't exist, you wouldn't exist either. You see, in nature there is this balance: to live we must all work for the survival of the others. When I talk about nature, it's this sort of stability that comes to mind, this balance and sharing.

Hayrettin

Bruno

Thérèse

Fujii

Magalys Dolores

Lives in Cuba

Do you know what it's like to be homeless? Not to be protected from the sun, to have the rain coming down on you?

Background / My name's Magalys Dolores. I'm fifty-three years old. I was born in Guantánamo, but I live in Santiago de Cuba. I have a son aged twenty-nine who is all my life to me. I also have a sister and a nephew. But for me my family is my son.

Family / A family can be very extensive ... for me no. It was always mom, my sister, and me. Mom isn't here anymore, there's only my sister, my nephew, and my son. If we extend the family, my father had thirty-six children! But it's not a family. I don't know them. I've met sixteen of them, but I've never had a relationship with them. My family with a capital "F" is my son.

Learned from your parents / I learned nothing from my father. I knew him at the age of nine, and I had no dealings with him, except what I heard of his life. A father who had thirty-six children is not a good example! From my mother I derived the lens through which I see the world. It was from her that I learned my rejection, though perhaps "rejection" is too strong a word, of men. I inherited this attitude from her in large part owing to the solitude she suffered over the years. I can't stand men's bad behavior. She also taught me to have a goal in life. She didn't succeed, but she tried.

As we say in Cuba, she lived and breathed for communism. If she could see what's going on today, she'd turn in her grave! She had imagined society would be different.

Handing on / What I tell my son, and which he is now succeeding at, is that you have to study, you have to be professional, because in any country, under any system, you can never have too much knowledge. Having a positive attitude to life is a good start. Love others and always help those you are able to. Don't be selfish, don't be ambitious. And always follow the best course possible, provided that it coincides with your aspirations; your aspirations, because we parents cannot impose them on you. We can offer guidance and ideas, but I don't want him to think like me. I want him always to act in the best possible way, wherever he may be.

Memories / What I will never forget … are the blows my mother was given by her husband. All the time. As for positive memories, I don't have any, because my mother also used to punish me often. And my sister used to go and find the belt, the wide belt, and give it to my mother so she could. … I don't know if my sister remembers, but it's a memory that has never left me. Maybe that's why we don't get along. Because the wound remains deep.

Dreams as a child / As the poet Beckett said, "dreams are only dreams." It's important always to have them. In fact, I made very few of my dreams as a girl come true. I wanted to be a ballet dancer. That was my passion, to become an artist. That and being a stomatologist! I didn't succeed, but it wasn't for lack of studying. When my high school diploma was awarded to me, we were graded, and the girl before me took the last place. And that was that. And I couldn't be a dancer because my mother didn't want me to. I pined after what I still miss today: a minimum of comfort. That's why I studied. Because being a black woman. … Oh, racism hasn't disappeared! It exists, disguised, but it exists. It's a handicap. Even if Fidel bans it by giving the same rights to everyone, racism sure exists, there's no doubt about that. I studied to be able to succeed. To have a pretty house, several children, a man at my side. I don't have any of that. I have my son, my only success story.

Job / I was a teacher, I graduated in literature and Spanish. I liked teaching, but I don't do it anymore.

Our economic situation was survival level.

Work / It wasn't difficult at the time, after studying well, to become a teacher. And then the situation changed: We had to put up all the pupils in one way or another to the next class. If we didn't have a certain percentage of pupils going up, our salary would be reduced! Of course, it's impossible that all the pupils could be at the required level. I hated that leniency. If my teaching was good, why reward the pupils who didn't study? The State gave a prize of 100 pesos to the teacher whose pupils all went up! Furthermore, I had to take part in collateral activities. Do you know what a collateral activity is? Obligatory voluntary work of one sort or another. For example, I'm a teacher, but I do farm work and I receive ... what can I call it? ... a bonus. If I don't do it, my salary gets reduced. As a teacher, I was given a derisory salary, and then prices went up—198 pesos for a bonbonne. Do you know what a bonbonne is? For us it's the bottle that is filled with grease, oil, or lard. I used to eat without fat in my cooking because I couldn't afford it. My son went shoeless.

Salary / Your salary depends on your qualification. With my certificate plus my seniority, I received around 5,200 pesos: that's 20 dollars! That's not enough. On that your life is curtailed. Many end up by giving up teaching, utterly dispirited. Our economic situation was survival level. It's useless to dream of eating what you like or of going on a trip. Here it's impossible.

Money / As for ... the quota attributed by the State to everyone, officially we all have enough money. Everyone can buy his quota of food at the supply shop: 5 pounds of rice, that's your share. Only, it isn't enough to last a month. The unemployed and pensioners, they get, let's say, 150 pesos. Their quota at the shop, the starches ... they don't get more than 20 pesos' worth. That's not enough to live on. You have to add the electricity, accommodation, and modern requirements.

Poverty / Do you know what it's like to be homeless? Not to be protected from the sun, to have the rain coming down on you? To get up in the morning with wet shoes? That's how I lived. And don't think I'm talking about 1959. Those were the 1990s. I covered us both, my son and me, with a sheet of nylon so we could sleep. "I have to quit my job so I can try something else," I said to myself. And that's what I dared to do: I gave up my job in order to live better and so that my son would not have to endure what I did. Excuse my tears, but the memories are painful.

Ordeal / I've had to suffer many things: a single mother, studying, without resources. My mother only made 56 pesos. That's all that came into the house. We had nothing to live on. For a young girl, you know, it was very difficult to say to my mother, "I'm pregnant." There's nothing I haven't had to deal with. That, and stopping work, those have been the worst hardships I've faced. Getting up and having nothing to give your child to eat—it's not easy. And all the time having to study. I didn't ask anyone for help. I don't like asking, but I tried to find solutions: "Look, I could do that washing

for you," "I can clean your house for you." I used to help children if they had difficulty with their lessons. I used to do anything so my son could eat. But getting up and having nothing to eat, that's very hard. And not to speak of it, not to go to the door and say, "I don't have anything." Now, as far as is possible, I try to help those who I know don't have enough to eat. If I have some bread, I cut it in two. People say I'm too ... I don't know ... you mustn't be too much of a soft touch, but you have to help one another.

The revolution triumphed, the years passed, and then nothing ...

Love / I can't stand people treating others badly. Cubans. ... are the most chauvinist people in the world. The appalling way they treat the women. It's impossible to tolerate a man who mistreats you and then calls you "my love," who wants to touch you, take you to bed ... that's not love! In love, you have to forget about yourself, if you don't value the other person more highly than yourself, there is no love.

Differences between men and women / That depends on the couple. Some years back the difference was clear. The woman looked after the children, washed, ironed, and took care of the house. The man had to provide the income, repair the roof. These days, fortunately, couples share the tasks. Here, when I come home from work, my son has done the housework, the washing, and cleaned the house. Before it wasn't like that. A man wouldn't lower himself to wash or do the ironing. For a Latin man, that's even embarrassing, as he'd be suspected of homosexual tendencies! But it isn't proof that he's gay, huh? If a child is sick, there are new laws that allow the mother to continue working while the father takes care of him. Before, that wasn't possible. This is a very positive development.

Succeeding in life / My son is my big success. He'll leave me one day, but he's my son. And he loves me. Today most young people are a bit. Well, it's youth, isn't it? Many young people mistreat their parents. Not my son. We get on really well. Probably because of the hardships I've had to face, I don't impose anything on him. We talk.

Freedom / Freedom is all very well, but ... you can think what you like, thoughts are free. I think what I like on economics, politics, society, but I can't say everything I think.

Changing your country / How would I change my country? ... I prefer not to answer. You've just asked me the meaning of the word "freedom."

Revolution / I was small, but I still have some very bad memories from before the revolution. I lived in the street in Guántanamo, and, believe me, the dictatorship was horrible! They treated us very badly. I saw my grandfather given a beating, my mother hit with the butt of a rifle; I can still hear the sound of the incessant gunfire. My mother fought for the revolution, ah yes! I still have the memory of my mother with her huge gypsy clothes under which she took a comrade to the resistance movement. She also carried pistols and bullets. She risked her life for the revolution. The revolution triumphed, the years passed, and then nothing. I was impatient, but not her. My mother used to say that we didn't fight for material gain but for change. Change isn't always positive. But thanks to the revolution, I was able to study, even though I was black and poor.

Education / In 1959 the barracks were turned into schools. Now my son can study for free ... a black man can go anywhere, just like a white. Not at that time. I remember that there was a park the whites could enter and sit down in but the blacks had to stay outside.

Struggle / A very common expression here in Cuba is "I'm fighting." Even if he is sitting down, when you ask a Cuban how he is, he'll tell you he is "in full combat."

Changes in your country / Nothing is perfect, but the only person who'll tell you it was better before has to be rich. That's the only explanation.

Milton

Ramesh

Teresa

Joseph

Edward

WHAT DOES MONEY MEAN TO YOU?

Edward / *Lives in New York*
Money means the electricity won't be cut off, money means that I don't have to borrow from someone, money means that my wife doesn't have to worry, money means my kids don't have to worry, and money means that I don't have to spend my life endlessly sick with fear.

Ramesh / *Lives in Nepal*
Money is no longer like it used to be; it's something very important. Now money is everywhere. And for us poor, if you don't have even ten or twenty rupees, you have to walk, you can't even take the bus. Money is really very important, at any rate it occupies our thoughts a great deal.

Joseph / *Cameroonian asylum seeker who lives in Melilla, Spain*
Today capitalism is what governs the world in all ways; the mentality of people is affected by this economic system. Money occupies an increasingly important place in the society of the world. But even if money has taken that place, there are limits—money can't do everything. But money has its place in society, because without it you can't lead a decent life.

Milton / *Lives in Australia*
Without money you can't do anything! We have to survive, we must live, we aren't anything without money. I can't go back to live in the rain forest and eat and live like my ancestors did!

Teresa / *Lives in Bolivia*
In my life, money.... Well, I was born into a family that has lots of money, lots at least in this poor country of Bolivia. Well, at a certain stage in my life, to me money meant guilt. Having money was not a good thing, because there were people who didn't even have anything to eat. Now it also represents a means to be able to become independent and to survive, and for that I even had to undergo therapy, because I didn't understand the value of money enough. When I accept a job, I don't think of the salary, or of money. So always people tell me off and say, "Why didn't you negotiate something fairer?" Or, "Why don't you ask for an honest salary?" You see, I accept a job if the project interests me, but never for the money. So I decided to go and see a therapist to analyze where this problem with money originated. So I ended up by spending money to try and understand why I have this problem with money! And I think that it's simply because I am not accustomed to making money.

WHAT DOES MONEY MEAN TO YOU?

Jelica / *Lives in Serbia*
It's not easy to make money. You struggle; it's very difficult. Today, if I collect 220 pounds of iron, what do I get? Six or seven dinars, and that's nothing! In a month you earn three hundred, four hundred dollars. How can you live on that? And in winter you don't even work. What you make during the summer has to last you all year. It's impossible to make ends meet. Money, it's hard to earn.

Elizabeth / *Lives in Ethiopia*
Yes, with my eight children, I really had problems. There used not to be any food in the house, nor clothes, nothing. My husband left and took everything there was in the house. It was tough, but I went to see the principal of a school to borrow fifty birrs (about $7). I asked him if I could sell tea and coffee to the children at the school. He asked me how I could do it, and I told him I had absolutely had to work. So I bought tea and coffee with his fifty birrs. Then I made some Ethiopian bread, and I sold it to the children. In one day I had made a profit of forty-seven birrs, which means that I had taken ninety-seven birrs in all. Since that day my life has restarted. My children began to have food. By doing that, by tackling the problems, I have defeated them. To solve a problem, the most important thing is not to refuse any work.

Stefen / *Lives in Singapore*
I left my job as an engineer to become a photographer. I make only a quarter of what I used to earn before. I did that because I felt I had to follow my heart, I had to involve myself in my passion. And I think that if I do well in this field, the money will come as a bonus.

Risma / *Lives in Indonesia*
For me today, money is not important. But we need money. My brother is in his last year of studies, and I need money to repair my house. But I don't want to focus on money because if I only work for money, I'll lose my heart.

Ana Isabel / *Lives in Mexico*
There's an expression that says, "with money you can buy a bed but not sleep." And it's very true. There are plenty of people who, with all the money in the world, still aren't happy.

Manuel / *Lives in Ecuador*
I'm happy in my poverty, because I live happily in my house with my family, my wife. I live happily because. . . . What do you want me to do? Cry over my poverty? I can't do that. I have to thank God for what he has given me, and God says that I must suffer for what I am. As I'm poor, I have to be happy with my family and appreciate what goodness there is in my poverty. So then I live happily with my family, my wife, my son, my grandson, and my poverty.

Jelica

Elizabeth

Ana Isabel

Risma

Manuel

Stefen

Mehrnouche

Kisean

Hugh

Vanessa

Melanie

Mehrnouche / *Lives in Iran*
Poverty is something totally relative; you can't compare someone who lives in the center of France, in Paris, with someone who lives in Africa. Perhaps an African is happier. Poverty is not material; having a television and a satellite dish, a mobile phone ... that doesn't mean anything. I think that in Western society, the poverty of the individual is of greater importance. That is why people take drugs and drink alcohol, to compensate; but in societies that are considered less advanced, perhaps we are happier, even though our financial situation is also less advanced. In my opinion, there is no universal definition for poverty.

Hugh / *Lives in Ireland*
Let me tell you a little story about what happened a few years ago. I was working for a charity and one of our tasks was to visit people on Christmas Day. I remember that we went to visit a man who lived in a real pigsty. Coming from a warm and comfortable house, it was absolutely horrible to see a man live in such filth. After that we went to visit another guy who lived all alone in a small house at the top of the mountain. He had absolutely no family, and nowhere to go for Christmas. He did everything to keep me there, so that I would stay for hours and hours, just to shatter the deep solitude he was immersed in at that time. It's a type of poverty. Poverty of the spirit, of the soul, is much more serious than financial poverty.

Kisean / *Lives in Kenya*
For us Masai, money is not the most important thing: For us the most important thing is our cows. If you have cows, you don't need money. Money is useful if you don't own any cows.

Vanessa / *Lives in South Africa*
For me money is very important. Money is the only thing I dream of. As I always say, if I must have a boyfriend, he must have money. I always say to men, "No, I don't want you because you don't have any money!" And they say to me, "You only want to love me for my money?" No, for me there is no love. I need money, and if he can't give me any. ... I want money, I love money, I need money—for me money is everything!

Melanie / *Lives in Australia*
You come into the world naked, with nothing. And when you leave, the only things you take with you are the clothes you are wearing. You return to dust, there where you came from, sister! That's why I don't hold onto money. I don't save, I don't put anything aside, even for those days when I risk being in difficulty. . . if I have any, I spend it!

Zein / *Lives in Indonesia*
I think money is like my moustache or my beard. If I managed to save, my beard would reach the floor. But when it is too long I cut it and there's no more money. It grows, I cut it, it grows again, and I cut it again.

Maremba / *Lives in Papua New Guinea*
Money drives me crazy. It arrives in my pocket, but it doesn't stay there for more than two or three days, and then it goes. After, I waste time trying to find out where it went!

Petrica / *Lives in Romania*
The story that has struck me the most is when I was in sixth grade. I had made a drawing of a bank note of one hundred leis (about $40). At the time it was a blue note with a picture of Balcescu on it. At home, using a pen and colored crayons, I made a bank note of one hundred leis. It turned out very well. I made several, some drawn on both sides, some on one side only. Just as a joke, I crumpled them up and left them in the lane so that people would find them and be happy. One day, I put one of my nicely crumpled bank notes in the lane. A man, a local farmer, came along on his horse, he came out of the bar, because in Romania the farmers tend to drink, and started to go home, angry that he had spent all his money. When he saw the hundred leis, he jumped down from his horse, snatched up the bank note, went home and, without paying any attention to his wife, he tied up his horse and headed back to the bar!

Ulrich / *Lives in Tamil Nadu, India*
Lots of people, me included, think, "Ah! If I had money, I could. . . ." And people, me included, dream of things that they could do if they had the money. But the day that you have that money, everything seems different. Where I was concerned, it gave me an incredible responsibility, tied to power and also the possibility of being corrupt. You don't think of money as something that belongs to you, but as the possibilities that it offers. In itself money is nothing. If you have a dream, it allows you to realize it. And if you are aware that you have that responsibility, it isn't easy to assume it without falling under the spell that money exerts. For example, when people come to see you to use the money. Having been in such a position where I had money, that taught me a lot of things that otherwise I would never have understood.

You don't think of money as something that belongs to you, but as the possibilities that it offers.

Petrica

Ulrich

Maremba

Zein

She Shiu

Lives in Yunnan, China

During our lifetime we have to contribute to the well-being of humanity. We have to make ourselves useful to others.

Background/ My name is She Shiu. I'm eighty-four years old. I have a clinic of traditional Chinese medicine in the village of Baisha, at the foot of the Mountain of the Jade Dragon. I'm respected by people everywhere. I am very happy. I hope that medicine and ren [the desire to take care of others] will always exist: That is my hope.

Job / Personally, I didn't used to be a doctor. But I don't enjoy good health, and there was nothing to be done about it. Nobody bothered about me, so I started doing some medical research for my own benefit and treated myself. And I got better. So, I began to take care of others too. Some illnesses are common, and others, more difficult, are treated at the hospital. At that time I was poor, like the people I lived among, so I treated them for free. After the reform and the opening up of China, patients came to me from all over the world, many from other countries. I treated them without necessarily taking money from them; they paid me how they could. And that's how I became famous.

Handing on / I would like to pass on traditional medicine to my son and grandson. My grandson is studying in Beijing. In addition, we have patented our treatments. So my grandson has to go to university to get his degree and then to go abroad to complete his studies and benefit from this knowledge. He will have to have a solid body of knowledge to take my place.

Family / I think that family is very important in the Chinese mind. They always told us, "Educate, establish an ordered home, govern the country well, and the world will be at

peace" Education is enlightenment. Order is a happy family. If you can't do that, it's hard to serve a country well. Hence the old saying, "Harmony at home brings peace in the country." My ways are traditional, that's true. I'm very old. You may think that I am stubborn, but I talk to you with honesty about what I believe.

Ordeal / The most difficult moment, alas! It was when I had to take part in physical exercises. I was in bad health at the time, and it was very hard. That's why I started looking into medicine.

Loving your country / I have lived for eighty-four years, so much so that I've become a living history book! I've lived through the war against the Japanese, China's war of liberation, and lots of events since then. In my opinion, it's today that we have the best society. In any case, the Chinese peasants no longer pay taxes. Before, I used to pay tax; today I don't pay any. I even receive allowances. Before, I never saw nor heard talk of a life like ours.

Joy / My greatest joy is to take care of others. When they get better, I am the happiest of men. [He shows a photograph.] That person in red had leukemia. She took my medicines for years. She managed to continue her studies. Last year she finished high school and got a good report! I was very happy. I have kept all the progress reports on her illness. The thing I am proudest of, but of which I shouldn't really be proud because it's my duty, is to have cured lots of sick people.

Money / Many people who don't have money daren't dream of receiving treatment in a hospital. Sometimes I've seen sick people who only took their medicines for one or two days, because they were afraid they wouldn't have enough money for the whole treatment. But I, when I give a prescription, I don't think of money. If the illness requires a month's treatment, I prescribe it. If it's two months, I prescribe it. I don't think about the cost but the sickness. If it's a sickness that lasts a long time, I give them more medicine. If it's a short-lived complaint, maybe medicine only has to be taken for a single day. But there are patients who worry about the price. They say to me, "Doctor, I don't need that much. . . ." In reality it's because they don't have enough money. So I say to them, "Don't worry. Take them. I am not asking you for money. My aim is to cure your illness!"

Progress / I don't have Internet, but others have put me on their site. They have written there what I do. All I have is an e-mail address. It's very practical because even if a sick person lives very far away, we can correspond by e-mail, and I can send them medicines. The world is getting smaller and smaller!

Laughing / I don't laugh much. Usually I'm serious. I don't joke with my patients; it's not good to joke. You have to work seriously and be sincere with other people. I rarely

joke, and I go out very little. I read in a magazine one day, "Doctor H is rather special because he doesn't take things lightly and only goes out rarely."

Crying / Cry? I don't cry very much. Even at very difficult moments in China I didn't cry, and I kept it all to myself. I'm pretty strong. In Chinese we say, "Strength of mind removes obstacles." There! That's my state of mind!

Religion / I'm often asked this question: "Are the Naxis [an ethnic minority in China] believers?" When I was little we had lots of gods at home: The mountain had its god, the bridge had its god, and so on. In Lijiang you find Buddhism, Lamaism, Islam, Christianity ... and all these religions exist in peace. When we were small, we went to church every Saturday. But in our home we are animist. Well, sometimes we go to the monastery, sometimes to the mosque, sometimes to the temple of the Lamas. Either you believe or you don't, but all these religions are laudable. They all tell us to do good and to turn away from evil. The people of Lijiang love peace.

After death / During our lifetime we have to contribute to the well-being of humanity. We have to make ourselves useful to others. I often say that writers live through their books. In the past, many great men contributed to the welfare of humanity, and thus live on in people's memories. After death, if you leave a gloomy memory of yourself, it's because of what you did during your lifetime. If you do wrong during your life, people won't like you and you will leave a gloomy memory behind you. That's why we have to do good things. I don't know what will happen after death, but the image of those who have passed on before us lives on the hearts of the living.

Words / My favorite proverb comes from the philosopher Confucius and exists in a single word: ren. Ren is a word that I venerate. In Chinese medicine you have to take care of others with ren. In politics, you have to practice ren. There are many other fields in which ren can be applied. That's why I love this word and why I write it so often as a present to my friends.

Message / Firstly, I wish everyone peace and good health. If you are rich but in poor health, there's nothing you can do. If there is no peace in your life, there's still nothing you can do. And if there's no peace, it's difficult to have good health. Two words: peace and health! That's all!

Graciela

Lives in Argentina

The goal of life is that no child need cry from hunger.

Background / My name is Graciela. I'm fifty-two years old. I'm Argentinean, from the province of Santa Fe. I have eight children and five grandchildren. I have a handicapped daughter and a young son who will soon be nineteen who has a drug problem: It's a scourge of this country, like, I believe, everywhere else in Latin America.

Dreams as a child / I used to dream of being famous. You're going to laugh ... I sang in the henhouse, and I wanted to become a famous singer who helped the poor! Today I think that that was probably a bourgeois idea—make lots of money so as to help the poor. All the same, I'm poor, a low-paid worker. I fight for what I call "my property," which is to say a dignified place to live. So that I'll be able to live there with my children and say to them, "Look, I'm dying, now it's all yours!" Isn't that right?

Family / My family is everything to me. It pervades my life. What was it like growing up? I lost my parents very young, at the age of seven. I was raised by one of my sisters. She treated me very badly! She used to hit me, she shunned me because of my color, because they were white. My mother married twice. The children from the first marriage are all white. My brothers and sisters are white: white skin, green eyes, blond hair. But I was a daughter from the second marriage. My father was originally from here. We were born dark brown. That's why I felt very rejected in my family. I grew up knowing what it was like to be beaten. Maybe it was the beatings that prompted me to leave. When I was fifteen I thought I was old enough and left home. Life has taught me that the best thing you can do is to strive for your family. That's why today I fight for them. So that my children can be together, and understand and love one another. I came into contact with political activism. I've been involved with politics since the age of sixteen.

257

Learned from your parents / I think I would've liked to have learned to dialogue from my parents. Not to shout—to be good, to give love, to know that life is not built purely on brutality. That was something I had great difficulty in leaving behind me in my family. Because afterward, the father of my children, who was an alcoholic and violent, well, I had to leave him to bring up my three young children alone. All alone. There was nothing of what I would've liked to give them: a good father, a good family, a home, schooling, a job. All alone, I couldn't do what I wanted.

Discrimination / Very early on discrimination prevented me from developing my femininity. I had to play other roles. The clothes I used to wear were half men's, half women's, so that I could defend myself more easily. I was always in my shell, always on the defensive, so that nothing would happen to me. I've passed this attitude on to my children. I call it the attitude "of the suppressed grudge." I told myself, "You're black, no one's going to love you, you're good for nothing. . . ." It's even harder when you're poor.

Politics / Around 1987–1989, when the Argentine system of government changed, I thought that the revolution was coming. And then, on December 19 and 20, 2001, for example [a huge anti-government demonstration was held in the Plaza de Mai, which resounded to the shouts "All of them out!"]. I believed it. I was incredibly happy, convinced that everything was about to change, that we were going to be equal, that there would be no more need for begging, that the rich were going to have their wealth confiscated.

Work / I have always believed that work represents dignity. How can I explain that? I was very demoralized, I thought that I wasn't good for anything. Out in the street I made trouble for people. I thought that I had to be aggressive. When I saw a crowd, I went looking for an argument. In other words, the problems, the anger, the injustice I felt at having nothing in my home, of thinking of everything I could've given my kids if I'd had a job! Later, when I began to work, I felt out of sync with others I knew. That was the time of the explosion of the Piqueteros [the protesters who blocked the roads]. As a result, everyone called us blacks, filthy blacks, blacks who are no use. Work gradually gave me inner strength: having my own belongings, feeding my children. . . . A plate of good food, though no seconds. . . . Giving them a good education.

Handing on / The most difficult thing to teach my children is to explain to them what their mother has done for them. It's true that I have often left them alone. I haven't listened to them enough, understood them, helped them with their homework, like all mothers do. That's not what I wanted to do; I had to engage politically. That's what I held dear. Perhaps now they're beginning to understand why their mother worked, why she was an activist, why she struggled. I did it so that this country would change and so that my kids can have a better life than I have. I'd love all children and the

young to grow up normally in a house, to have a bed, breakfast and dinner, an education. All those things I never had. Sometimes I'm scandalized by the condition of women in Argentina, especially single women. It's for them that I fight, so that they and their kids won't live through what I've had to.

Ordeal / My worst experience? It was about two years ago, when my daughter fell. She threw herself from the roof of the house. When I saw her on the ground, I felt a part of my life leave me, that she was going to die. I fought and argued with the doctors and all. It was a terrible experience that really made me suffer. We had battled to occupy some land. The police intervened, chased everyone away, and smashed down all the little houses that had been built. My daughter thought we'd never get that land back and fell into depression. In the end she wanted to kill herself. It was a terrible shock for me to go to her aid. My daughter has psychiatric problems. When her baby was born, she fell sick. Because of our financial situation, the father of the little boy took him away. And she. ... I'm used to seeing others suffer and going to help them, but this time it was my turn. A very bad turn. It's hard to accept the idea that tomorrow I'll be pushing her in the street in a wheelchair. It's a dreadful experience.

Difficult to say / The most difficult thing to say to my kids? That I would be ready to give them up for the revolution. The armed revolution of my people. They wouldn't understand. If I get called tomorrow and someone says to me, "Hey, black woman, we're forming an army," if I have to go, it would be hard to tell them. But I'd do it. They'll think that I don't love them. I explain to them that we must never accept defeat, but continue to fight for a better society. It's hard for them to understand, very much so.

Killing / Would I kill someone? Ah yes! The murderers of those killed in the struggle. Like Massi, Dario, and the thirty thousand "disappeared." Yes, I wouldn't hesitate a second. Yes, a Macero or a Videla, because they were pitiless, they killed fresh souls, young souls, souls that wanted to end our suffering. Prison sentences in this country are very light. Someone who steals a chicken is severely punished, maybe even condemned to death. But those murderers can stay at home under house arrest. It's completely unfair.

Meaning of life / The goal of life is that no child need cry from hunger. Perhaps my children are hungry because I went hungry as a child. Hunger in all senses of the word. You get my drift?

Yasmina

Jamie Nicole

Ibrahim

James

Herwig

Juliana

Kahana

WHAT IS THE MEANING OF LIFE?

Yasmina / *Lives in Algeria*
It was an Italian philosopher who said, "There are three stages in man's life: birth, life, and death. He does not feel himself being born. He forgets to live. And he is afraid to die."

Herwig / *Lives in Germany*
I'm no philosopher, I can't talk about that! As far as I am concerned, I think that the meaning of life is to go out on the town on Friday nights with my friends to drink beer in my favorite pub.

Juliana / *Lives in Los Angeles*
The meaning of life is love. Love for your friends, your family, your husband or wife, your children, your partner, whoever that may be—but it is definitely love.

James / *Lives in Australia*
The meaning of my life ... I don't know. I'm not sure yet. Ask me again in twenty years, and I'll probably have a much better idea.

There are three stages in man's life: birth, life, and death.

Kahana / *Lives in Ethiopia*
The meaning of life for me? Working in the fields, making and selling sorghum beer, and finding food.

Ibrahim / *Lives in Israel*
The meaning of my life is love, kisses, flowers, good food, fish, a nice car, and God, too—God first, obviously.

I think that the meaning of my life is the same as that of everyone else's life.

Jamie Nicole / *Lives in Ohio*
I think that the meaning of my life is the same as that of everyone else's life. Why did God create us? So He wouldn't be alone. And I truly believe that. That's not part of my church but my personal belief. I think that God created people so that He wouldn't feel alone.

WHAT IS THE MEANING OF LIFE?

Mary / *Lives in Great Britain*
The meaning of your life! Is there any meaning to any life? Is there any point at all to life? I would suggest that there is probably no meaning, that there is probably no point. I don't know why we're all here. I don't know what we're here for. I don't know what we're supposed to do. I don't think there is any particular meaning to life, and I've never thought there was much point to it. That's a very sacrilegious and non-religious point of view.

Shigeru / *Lives in Japan*
Even at seventy years of age I don't know what the meaning of life is. Life goes on until it reaches the end, and we wonder: What's it all about? What's it all about?

Xavier / *Lives in France*
I don't understand the question, it has no sense! Listen, nobody asked me, "Do you want to go out?" "Do you want to go on Earth?" Nobody asked me that! I'm here, good, and that's that!

Esefa / *Lives in Bosnia-Herzegovina*
If I didn't have kids, my life would have no meaning. It would have no meaning. I've often wondered, when my own disappeared, why I wasn't dead as well. My kids have kept me alive, and give meaning to my life. I live for them now.

Payana / *Lives in Ethiopia*
What gives meaning to our life is our culture. Culture—here, for example, this is the generation tree. One is planted by each chief every eighteen years. Each village is next to a generation tree; it's part of the Konso life. If these trees aren't planted, our lives aren't complete—if a chief doesn't plant one, his life has no meaning.

Anca / *Lives in Romania*
The meaning of life on Earth is not to have children, not to procreate, but to find what lies within. What are we creating? Are we just here to eat and have children? Ah no! We are small pieces of God. What do we give to the Earth? We consume and give nothing? That's the meaning of life, otherwise it would be meaningless.

Salwa / *Lives in Egypt*
This life has two doors. One we use to enter, the other to leave. An intelligent person passes through the exit with plenty of good things about him. Someone who does many good deeds will receive a reward that will allow him to enter Paradise. All life is suffering, but we must endure it to be able to enjoy the life to come, in Paradise.

Mary

Payana

Salwa

Xavier

Shigeru

Esefa

Anca

Ali

Laya

Lucie

Erick

Aïcha

Ato

Erick / *Lives in Cuba*
The meaning of life right now, in this era of humanity, is to fight, brother. Fight for everything—for love, for yourself, the world and those around you, for humanity and nature. Fight to achieve happiness … never give up, love the fight. That's the meaning of life.

Laya / *Lives in Mali*
I can give meaning to my life, because I have a reason to live. I lived, I've had my time. I served and I continue to serve my people. Right now, I'm president of the CAFO, the Coordination of Women's Association and NGOs. I represent the entire circle. I put my body and soul into it. I give meaning to my life. I am fighting for women, to get out of the rut. That's something.

Lucie / *Lives in France*
What motivated me to leave to do humanitarian work is that I was not doing anything to benefit the society I lived in. I worked, I made good money, but for what? I said to myself one day, "Why am I doing this?" Travel has always been something I wanted to do. I went to university to do an intensive course of English so I could leave. And war broke out in Bosnia; I already spoke a second language, which was Yugoslav, at that time, but which today is Serbian. And I said to myself, "Perhaps this language that has never been of any use to me except for communication within the family can at last be used for something." And I went to a humanitarian organization near my home in Lyon, and they snapped me up immediately.

Aïcha / *Lives in Mali*
Every day of your life your mind develops a little more. Your eyes will open more, and you will learn things that you didn't know the day before. You don't wake up today with what you had when you lay down to sleep yesterday. That's the purpose of being alive.

Ato / *Lives in Shanghai, China*
The meaning of life is to profit from your senses. Because your senses are the closest. I believe in the "here and now," I don't like distant things. I believe in the things that are closest to us: my skin, my senses, my eyes—I profit from them all. That's the greatest gift of life to me.

Ali / *Lives in Israel*
Life, it's a smell. It is colors. Life, it's a painting. This is life—when you dress well, it's part of life. When you take a shower, it's part of life. When you give birth, a child is born, it's part of life. When the change of the seasons—it's wonderful, life: the snow, the desert, the south, north. This is life. Life, for me, it's by herself; it's the meaning. In the word "life," you have the life!

Allen

Lives in New Orleans

And I have an unconditional—
unconditional, unquestionable—
faith … I'm a firm believer. It's not
about religion; it's about believing.

Background / My birth name is Allen—a-l-l-e-n. I go by Al; everyone knows me as Al. I'm fifty-nine years old. I'll be sixty September 8th. My brother is five years older than I, and we're born on the same day, like, um, five years and twelve hours apart. I'm the third child in my family. I'm married—I have a beautiful wife named Linda. We've been married over twenty-five years. We were married either in 1980 or '81, neither one of us can really remember until we look at the documents. I am on a disability now; I don't work full time. My profession has been an entrepreneur and a producer of events. I produce festivals and New Orleans cultural events all over the world.

Dreams as a child / That's a strange question! My grandfather was a barber and he had a very successful barbering business here in New Orleans. And when I sat on his knee—I would go with him as a little kid to his establishment—he always would tell us to be a doctor, a lawyer, or an Indian chief. And being an Indian chief piqued my curiosity so I would question him, "What is an Indian chief?" and his response was, "It's a jack-of-all-trades, master of none." So in my life, I've tried to learn many, many things and have been successful at many different jobs and many careers and professions, all because of my grandfather's influence. So business is the thing that I got from my family. And to be on time—my mother's last words spoken to me was that it is important to be on time.

Legacy / My parents passed on several things to me. The most important thing they passed on to me was pride, integrity, and honor; to be a man of my word, not to lie

267

under any circumstances, to be self-sufficient, always be in a position to turn the other cheek, love my neighbor, and to be big enough to help other people who need help.

Current dream / My life has been so fulfilled; God has blessed me. I've traveled the world, gone on five continents. I don't have a dream for me. I have a dream for people, for people to rise. My dream is for my younger family members and for my community to be made whole and healthy. I've had a wonderful, wonderful life. And I'm still having it. And it's going to continue. But, I'm a doer. I don't dream, daydream, anymore. I do whatever I decide I want to do.

Work / OK, I've worked many jobs; I've worn many hats. And I still wear many hats. Ultimately I became a producer of events, a special event coordinator, planner—event planner. I've done everything. I've done laborious jobs. I can do anything. I can sweep. I can perform great feats in business. I've sold life insurance, health insurance, automobiles; I've planned major festival and events. I've worked in the hotel industry. You name it, I've done it. Today, my job is … I have a disability, a respiratory illness, so I guess I would say that I am on a disability retirement. But I still function in my community as an organizer. New Orleans is fragmented right now and we need leadership, and I'm trying to provide some of the leadership that we need, in terms of leadership for our youth and education and schools, and what direction this footprint of New Orleans will take on.

Joy / One of the happiest moments of my life was being able to go to South Africa. Particularly, I was very, very excited to stay on top of Table Mountain—what I thought was the most beautiful scenery in the world. And I really realized what an artist God is to have painted that portrait that I saw, that landscape. Visiting Africa after always hearing the stories of Africa and watching the Tarzan movies here in America, I feel a connection to my ancestry, and I've always yearned for it and I had an opportunity to visit not only one time, but several times and to make many, many friends that are like family to me now.

I think the biggest fear in life is fear itself.

Hardship / The most difficult and painful moment in my life was the death of my daughter at the age of twenty-six. She was in need of a heart and lung transplant. Watching her suffer for six months, she was very gallant and brave; never once said, "Why me?" or complained. I learned that there really was a God, and Jesus Christ was a real entity. And in that … it solidified the things that I thought, and made me a better person. That particular moment, looking into my daughter's eyes as she died and was sent for by Jesus Christ, and the presence of Jesus Christ and my parents there to receive my daughter into the Holy Kingdom, was a very challenging and pivotal moment in my life—having to deal with that.

Religion / It doesn't matter what religion you practice. I'm Catholic. I practice Catholicism, but it's my relationship with God and Jesus Christ. I felt the presence of Jesus Christ when my daughter was dying, and I felt the presence of the angels that he had with him, which were my parents coming for my daughter. I knew they were present. I felt them, yeah. I'm a special person. I'm a person that was born with what they call a veil over your face. It's a film from your mother's womb, but I have depth and perception in what I see and I believe. And I know just growing up in New Orleans, it's been a tough, tough environment, and God has always been with me, and Jesus Christ primarily has been with me, and the Holy Spirit. And I have an unconditional—unconditional, unquestionable—faith that there is a God and that Jesus Christ ascended into heaven and is sitting at the right hand of the Father. So I'm a firm believer. It's not about religion; it's about believing.

God / To me, He is unimaginable. He is so great, He is so big, He is so powerful. I see Jesus in a human form, just like all the pictures that we've seen, you know, bearded like me with long dreadlocks, hair of lamb's wool, brown complexion, you know, working with children and elders. I just see the goodness and the aura, the aura of God, but I see the physical being of Jesus. I see the Trinity when I think of them: God the Father, God the Son, and God the Holy Spirit.

Fear / I don't have a lot of fears in life. I fear … ignorance. I think the biggest fear in life is fear itself. And because I walk with God and Jesus Christ, I don't have fear. I don't fear anything.

Killing / I'm going to always take control of myself. "Thou shalt not kill." That's one of the commandments. I may say it, but I won't do it. It's not for me to take a life. That's not my place. That's God's business. That's God's work. That's not my work.

After Death / Oh, I imagine it's very wonderful! I imagine it where there wouldn't be any disease, there won't be any crime, won't be any lying. There will be plenty of beautiful flowers and beautiful people. We won't have to hide. We won't have to wear clothes because there is nothing to hide, just as God intended it, you know, when

he created man. I see it being very beautiful. I see never being hungry, never disease, never going without. That's how I see it.

Forgiving / What I cannot forgive is deliberate lying, deliberate bearing false witness, deliberate stealing, murder. It's just hard to forgive when people bear false witness. It's just difficult. It's forgivable but it's very hard, you know. An old New Orleans cliché is, "Don't piss on my leg and tell me it's raining." So, I'm that kind of guy, you know. Don't try to tell me that urine is rain. I know better.

Anger / The government—the way they are operating in this post-Katrina environment. The federal government—the way they have almost abandoned us; our state government not being decisive in making decisions; our local city government just being a lame duck, you know. That irritates me. You know, it's been nineteen months since Katrina occurred. We're on our second hurricane this season since Katrina. And you can see from my railings on my porch here, we're still all dismantled, and waiting for insurance companies and federal government aid and help, and it's just not happening quick enough, you know. So a lot of us—my home is still all torn up. I can't even invite you in I got so much stuff in the way! Trying to get through this piece by piece. And yet I'm more fortunate than most people. I'm in better shape than most. It's no fun living in a Katrina FEMA trailer.

Future of the world / Well, I think with the depletion of the ozone layer and the melting of the icebergs in Greenland and Antarctica, I think that we're in for a lot of trouble. I think that the waters are going to rise and there is going to be massive flooding, and I think that the landmass that we have today, a large portion of it will be lost to the water.

Power / I don't make the policy for the world or for the United States of America or for New Orleans. I'm just one person trying to live amongst all of the ills that have already been created by the powers that be. It's the big guys. The big, rich guys that's making all the money and creating all the problems. It's not the little guys like me. I'm trying to survive, you know, just trying to live.

Love / I'm in love with my wife! We have been together since the day we met—the second time we met. And we've been together ever since. She loves me dearly; I love her. It's not all about sex; it's about that inner thing as well. It's an emotional thing. She is a lovely person, beautiful. I'm very fortunate and blessed to have her in my life. and I hope she feels the same way about me. Me, personally, I love exploring different things and the passion. I love the passion of it, you know. I love physical orgasm and mental orgasm. I love smiling and flirting, and I love sexuality, but I don't like the exploitation of that. I love women. I think women were created for me to enjoy. And I think that there is power in love and I want to make sure that you feel that it

transcends what you're feeling. And, it makes me very happy. And I'm very pleased with the gift God gave me as a man: the body of a woman; the soul and the spirit of a woman. I love that. I love you guys. I just think you're the best thing going. I would rather look into your eyes and tell you that I want to have an orgasm with you than look into your eyes and tell you that I'm going to spend the rest of my life with you. You know, one is truth when the other is total dishonesty because I won't leave my wife without my money, but I will have an orgasm. That make any sense to you at all? I guess I'm of a different mindset than most Americans. I'm not a polygamist, but I have some pretty strong beliefs that, you know, I wouldn't turn down certain things. I wouldn't encourage it, but I also wouldn't run away from it. And I guess that reason is that I want to be honest with myself, you know. I want to be honest with who I am, with my sexuality, you know. And sometimes, if you've been used to apples, sometimes an orange helps you to appreciate the apple a little more.

Changing your life / My big ambition in life now, and what I really want to achieve, is good health. I have a respiratory illness that is—I'm working on a lung ailment. I want my lungs to regenerate and I want to be healthy again, all the way healthy, so I can do some of the things that I like to do, like travel, you know, like swimming and stuff like that. So I'm having some difficulty with that. I wouldn't have smoked for forty years; I would've quit. I would've been reasonable and quit a very long time ago, when everyone else was adhering to the ills of cigarette smoking, and perhaps then I wouldn't have this ailment that I have, you know. So, if I could change anything, it would be that.

Message / My message would be: If you smoke, stop! Stop! Your body and your life are just too precious. I am fifty-nine years old—I'll be sixty in September. I'm a very virile, vibrant, young-at-heart male. But because of smoking cigarettes for a number of years, I've had to shut down the activities that I love—travel, dance, swimming—because I can't breath that well. I'm only operating on fifty percent of my lungs. So if you're indulging in smoking because it's cool or because you think you're hooked on it, please stop. It's no good.

Yovana

Marcos

Naba Manega

Dominique

Cut

Agnès

Alohosty

WHAT DOES GOD MEAN TO YOU?

Naba Manega / *Lives in Burkina Faso*
Have you seen God? I was born hearing God's name, but if you've seen God, come and show me!

Cut / *Lives in Indonesia*
You can't see Allah. He is felt, looking at the world. All this is His creation.

Alohosty / *Lives in Madagascar*
I don't know how to explain it to you, but we Malgaches [inhabitants of Madagascar] pray to God saying, "Oh God, help us to catch fish today!" But in fact we don't know where God is to be found. That's how I can explain it. You can only clearly explain that that you see. In the morning, you simply say, "God, give me luck!" You don't know where He is. They say He is up high, but you can't see His face. This is how I explain that: Is He up high or among us? We don't know.

Marcos / *Lives in Brazil*
I remember a young Indian girl, the first time she flew in an airplane, she looked through the window and asked, "Papa, is that the sky?" "Yes, that's the sky," replied her father. Then the little girl asked, "Where's God's house?" What reply can you give to such a simple, yet at the same time such a complicated, question?

Yovana / *Lives in Bolivia*
My God is a good and great person with a good heart, and He's African, like me.

Dominique / *Lives in France*
My god is my wife, and He is wonderful. He smiles at me every morning, I think that is the most beautiful thing.

Agnès / *Lives in the Netherlands*
I think that God sits on a mountain. Like the gods of Olympus in Greek antiquity, but let's say that on this mountain there's but One. He is looking at this fucking world, and He is cracking up. He's a mean little man, who's traitorous and lazy. He is sitting on his ass and watches this world falling apart.

You can't see Allah. He is felt, looking at the world. All this is His creation.

Nermeen / *Lives in Egypt*
As for my God, He is not the same as others'. I created my own God. We talk, have fun, kid each other—stuff like that. For me, God is a fun friend.

Houria / *Lives in Algeria*
I tell Him things that I don't tell anyone else. In France they can confide in a priest, for example, and the priest isn't allowed to say to others what he has been told. We don't have that in Algeria. If you want to confess to an imam, he's not going to listen to you, so you confide in God. To my mind God's our best friend.

Nadia / *Lives in Morocco*
I reckon it's all just chance. It's chance that the Big Bang happened, but we can call that God too. It's chance that plants get pollinated, perhaps it's God. ... It's chance. These are the two ideas that get mixed up in my head: divinity and chance, the balance of things.

Sune / *Lives in Sweden*
Living surrounded by nature, it's easy to believe in God. As a miracle each year, leaves grow, the sun heats the earth, birds have offspring. But at the same time, I know there is no proof that God exists. Believing in God is personal. I hope there is a God in whom we can trust, if we need to. But it's hard.

I've tried to believe in God, but I've never been able to convince myself. I guess I'm an agnostic, really.

Françoise / *Lives in France*
I absolutely don't believe in God, I believe that I am. ... There's not an ounce of mysticism in me. It's not even that I don't believe, it just has no interest for me. That whole question lies outside of my life. If God existed, OK then, he exists, but it wouldn't change anything in my life.

Galina / *Lives in Siberia, Russia*
During the Soviet regime, all the churches were destroyed, and the people were atheist. We thought, "What's this?" There was propaganda. But with time, we understood that God existed.

Burwell / *Lives in New Zealand*
I've tried to believe in God, but I've never been able to convince myself. And so, I guess I'm an agnostic, really.

Nadia

Burwell

Nermeen

Françoise

Sune

Houria

Galina

Vairava Sundaram

Rafaela

Sabine

Ann

Jamie

Lakshmi

Sabine / *Lives in Berlin, Germany*
When my mother died, I decided that God doesn't exist. If He made my mother suffer like that, such a kind woman. ... No, there's no God! When I have problems, I don't pray to anyone, but I hope. I guess that's also a type of belief, I hope that everything will be all right. Everyone tries to find his own belief, and for me it's hope.

Ann / *Lives in Hong Kong, China*
I think that I am my own goddess. Everything in your life is under your own control. You have to count on your own capabilities, on your own will, and on your own decisions to live the way you want. So I think that I believe more in me; I rely more on myself than I believe in something specific.

Rafaela / *Lives in Cuba*
I believe in myself. I don't believe in God. I believe in that which I see. I believe in our commander who brought progress. I believe in my parents. I believe in man. I believe in that which I see.

Vairava Sundaram / *Lives in Tamil Nadu, India*
I don't believe in man. Since I've had a true faith in God, I've only had good things in my life. I really don't believe in man. I don't do anything wrong, I avoid all conflict with others, and I more readily turn to prayer.

Lakshmi / *Lives in Tamil Nadu, India*
When you question me about it, I feel embarrassed, because this is like saying, "Do you have a nose? Can you bleed?" or "Do you sleep?" It's that simple as that. We exist with the idea of God, and it's something that is natural to us. We don't have to explain it.

Jamie / *Lives in New Orleans*
I was a priest for about six years, and it was a very happy time in my life. But in the course of that, I was teaching, and someone starting questioning the way in which I was teaching—some of the resources that I was using to teach scripture and the Gospels. And ... my bishop called me in and said, "Someone has accused you of heresy," and I went, "Heresy? What are you talking about?" He said, "Well ... " I went on to explain I was using these things to make people think about what it is that they believe. And his response to me was, "Your job is not to teach people to think. Your job is to teach them to believe." And with that, there was this light that went off inside of me, and I went, "You're right. You're right. And that's not me. I'm not here to teach them to believe. I'm here to teach people to think." And with that, I sort of became disillusioned with organized religion, and ... I simply said, "You know, you're right, and I need to move on." And so I moved on and started teaching. And hopefully I'm getting people to think.

Walid / *Lives in Algeria*
I believe in God; I believe in a just God. But to tell the truth, it sometimes happens that I doubt, because it seems too easy just to say that God exists. Sometimes it's said that He exists to make the task of living easier, because life is tough and nasty. We generally say, "There's a good God, even if now I'm not doing very well, later I will, I'll go to heaven." Sometimes I tell myself that God may just be an invention that we've created to reassure ourselves. But in spite of that, I'm a believer. Maybe I'm wrong, perhaps I'm not being honest with myself, but if it's a lie, it's a salutary lie, a lie that does good. So it doesn't much matter if it's true or false: I believe in God.

Sophie / *Lives in Great Britain*
When I was a teenager I began to ask myself questions. And it's true that when I was eighteen. . . I don't know if it was the fact that I came of age, but in any case I obviously wanted to distance myself from all that. I thought that religion allowed people—what I'm going to say may be a little strong—to avoid asking themselves questions. It's comfortable. It gives them answers to all the big questions, regarding the universe, creation, and everything that follows on from that.

I believe in God when it suits me, sadly . . . or rather, happily.

Josiane / *Lives in France*
I believe in God when it suits me, sadly . . . or rather, happily. I was raised in a convent, I'm not a church-goer, but when my children or grand-children have the slightest health problem, I turn to Him.

Charlene / *Lives in Los Angeles*
I will be honest with you—after I got sick, I had a hard time honoring my God, because I was very, very angry. It didn't do me any good. I had to go back to that place. I still don't talk to my God as much as I used to. I used to say my prayers every day. I'd asked for . . . I would tell Him, "Thank you for my blessings and forgive me for my sins." I still do that on a pretty much an everyday basis. But I don't honor him quite as much as I used to.

Claude / *Lives in France*
My religion is a personal one. I don't need anything or anyone, nor ready-made solutions. Religion is no different from refrigerators or cars: there are different brands, which all serve exactly the same purpose. For me religion is not making trouble for anyone and people leaving me in peace. My god is the sun. Every day when I sit on my bench eating my sardines, I raise my glass to the sun and I say, "Phoebus, I drink to your greater glory!"

Josiane

Walid

Sophie

Claude

Charlene

Marie-Jeanne

Lysiane

Shabnan

Cristina

Bassem

Lysiane / *Lives in Tahiti*
Personally, I believe in God. But I don't believe in the God that we've been inculcated with since we were tiny, by which I mean the God of Jesus and Mary and all that—all that Catholic religious education. I am Protestant, but I believe more in the god of nature, I believe more in the wind, the rain, the sun, the bird that flies overhead. Bizarrely, there is a small bird with a long beak that spends all its time on the coast, beside the sea; it sometimes makes a small cry, and every time I hear it, some bad news always arrives. It's weird. I believe in that.

Cristina / *Lives in Italy*
I think that it's antiquated. I think that in 2006—and I'm firm on this point—believing in God is like believing in Santa Claus, which you stop doing when you're five. Why do you keep believing in God? What does it change? God was created by Man's imagination. People insist upon believing. It's such a big business.

Marie-Jeanne / *Lives in Rwanda*
God? Before everything that happened, we believed in God and felt close to him. Today, when we begin to believe, we feel belief escaping us. We see a man, who killed our family, pray to God. When we think of what he did, what he did to us, God disappears and we start to think of that man.

Bassem / *Lives in the Palestinian Territories*
What is God to me? Well, sometimes I think that he is sleepy—he is in a big nap. And sometimes, I don't know if there is a God, even. Because if you see … what is really happening in the whole world, what they're changing … it gives you less of a faith there's something called God.

Shabnan / *Lives in Gujarat, India*
I have seen people all around telling you that every religion talks about peace—but every religion talks about peace where? They talk about peace somewhere in some abstract form. But in practice, when you see what religions are doing, they're only making people kill each other and spreading hatred. I've never seen any religion doing any work for peace. It's only in theory. And even if you start reading a religious book, you realize that there are so many problems. I mean … I don't want to talk about it because the moment you open your mouth it becomes blasphemy. But you read any religion, and forget every other issue, just read them from the point of view of the gender justice. There is no religion which gives any equal status to women. Whether it is Islam, or Hinduism, or Christianity—nothing. I have strong feelings about that, but the moment anyone points that out, it creates an enormous scandal, there are five maulvis (imams), five pundits who rise up and make trouble.

Nasra / *Lives in Turkey*
I never forget my prayers. I pray in the afternoon, and at night, too. It's not only prayer, I obey Allah. I never lie. You mustn't kill. You mustn't hit anyone. Why would you leave the right path to follow the wrong one? That's it.

Gemdasu / *Lives in Papua New Guinea*
When religion arrived, everything that I had learned of my Tumbuan ancestors became less important. To me the distinction between Good and Evil is all confused. I believe in God, but I want to be mummified. After I die, I'll discover if the Christian or tribal laws were right. I'll be placed in a cave about my village. That's what I want.

I believe in God but I want to be mummified. After I die, I'll discover if the Christian or tribal laws were right.

Kanha / *Lives in Cambodia*
God created us, and the earth. In school, the teachers taught me that God did not create the earth, that it is was created from galaxies in space. Science differs from religion. It's all mixed up in my head.

Aviva / *Lives in the United States*
Well, my mother was Parsi, Zoroastrian, and not practicing. My father was a non-practicing Hindu. And I had a Jewish godmother, so I have a Jewish name.. . . So I'd gone to synagogue a few times. I have Jewish friends. Then I got thrown out of an Episcopalian Sunday school for saying Jesus was Jewish. And, um, then went on to a French school in San Francisco, so I had Catholic catchetism. Then I went to a British boarding school where I was Protestant, Anglican—Church of England. So I've … been around that way. And I guess for me it's all the same. I mean … I'm not very dogmatic. I believe in spiritual things, and I'm touched by all kinds of different religious things that may not even have anything to do with my past.

Aviva

Nasra

Gemdasu

Kanha

Stephen

Lives in Papua New Guinea

I've had a couple occurrences where it was so very obvious that there were spirits about.

Background / My name is Stephen. I am originally from Australia. I've lived in Papua New Guinea since 1977.

Work / I came here for a holiday, to see how the place was and to see whether I liked it. And fortunately my wife liked it, too. My children liked it. So we decided to stay on. My background in Australia was farming. I mean, my father was a farmer. In Papua New Guinea there was more opportunity to do things that were not the norm. There is a saying in Papua New Guinea that white men are usually one of the three M's: they're mercenaries, missionaries, or misfits—and some are a bit of each. So the attraction was the lifestyle. And when I came here just after the independence, it was still a country where, because you had skills, you had an opportunity to make good money. There was always plenty of work, so it was just a different lifestyle that appealed to me and my family.

Family / What does my family represent to me? I guess … I don't have a partner, I have a wife. I haven't been modernized. I have very old-fashioned values and standards. And so, I'm not a man that goes along with women's liberation. I guess I'm a chauvinist. But then I leave in a chauvinist country. Papua New Guinea is a chauvinist country. Family is—I mean family is what life is about. I mean, single men—the word that comes to my mind is always a bit pathetic. But then if I look at the modern Western world, family doesn't seem to exist anymore. Everybody is for themselves and that's the reason we can't maintain marriages. Self-interest exceeds the values that people put on family. As for my immediate family—brothers and that—I have very little to

do with them. I live here and they're in Australia, so I see them every couple years for a week, and consequently we don't interact very much at all.

Love / The question is: Do I think that I give enough love? And the answer is probably no. I'm not a huggy-type man. I was born and bred in a different world than huggies. Hugging and kissing isn't part of my system, and therefore … I mean, I'm not into the love thing, I'm into respect. And there is … I would rather, much rather, people respect me than love me. I guess if they respect you, they do love you a little. But I don't spend any effort in my life getting people to love me. That's not important to me. If they like me, that's the result of who I am, and that's OK; if they don't, then that's their opinion, and they're entitled to it.

Hardship / I guess the eruption of the Rabaul volcano would have been the most significant event in my life—or in our lives—because it changed our lives quite considerably. If the volcano hadn't erupted, I wouldn't be here, I wouldn't be doing what I'm doing; I would be living an entirely different life because I had a fairly good business. It was growing. It had lots of potential. And as a result of Rabaul volcano that eventually went away. So if it hadn't happened, my life would've been doing what I do. But then, that happens to everybody more than once. So it's sort of just … the volcano erupted. It was the most interesting time I had in my life.

Abandon / I can't think of anything in life that I had to give up. Nothing was tormenting enough to remember. I mean, it's the same thing. If you're brought up with a very strong sense of reality, you probably consciously don't dream too much. And whenever you set out to do something, you set out to do it realistically and you generally succeed.

Crying / The last time I watched a sad movie. Yeah, I'm pretty good at having to cry. It's not hard at all. I don't do it in front of people, of course, but yeah. I have a lot of trouble with children, though. But otherwise, I own a factory and we build coffins, you know. And we sell 250 coffins a year or something. People are born, they live, and they die. So somebody has to build the coffins, and my factory builds the coffins. But I always have problems with the little ones. Small coffins are always hidden out of my sight.

Joy / Obviously children! I like children, you know. And children like me, strangely enough. I'm getting a little bit old by now. I'm a bit grumpy. But yeah, watching children, meeting children, which is very different in your world, because children in your world can't be children very much, thanks to computer games and Red Cordial and things like that. But here, in this country, children are children, you know. They're just little people that play and enjoy themselves. I always enjoy children. And sailing. I love sailing.

Violence / I'm a very violent man by nature; very violent man by nature. I've never been guilty of violence to any extent—a couple times when I was a young man, somebody did something that I didn't like, but, yeah, my nature is violent. And my father's

286

nature was violent, and all of his brothers and cousins as well. I come from a breed of people very capable of violence. But, I don't like it. So the fact that I have a violent nature doesn't mean to say that I have ever been violent. I do have the bad habit of threatening to be violent to people who annoy me. But I'm a big man, so you know, if you're a big man, you can use your bluff to get out of it. So violence, I abhor! But the truth is that my nature is violent. I have some great temptation at times to hit people with my fist, but I'm always able to control it. I would hate to be a man who was naturally violent and couldn't control it. You'd feel like drowning yourself, I'm sure. You should, anyway.

Anger / Lies. Dishonesty. Cowardice. Lack of principle. If you want a slap on the side of the face from me, tell me a lie. And when I catch you, deny it. And then you've got your problems, because that makes my blood boil. Dishonesty. Thieving. I hate being robbed.

Nature / I find great, great beauty in the ocean. I always like the way that it can be so placid one minute and so angry the next—a bit like me.

God / I have a belief that human beings can't exist without religion. And the Western world has given up religion as in churches to a big extent, and I think they haven't replaced it with another religion and they've replaced it with materialism. And as I observe my friends and family and people that I meet that come here, that's their obsession. They work hard so they make a lot of money, and it's always about buying things. Do I believe in God? So I said, I don't disbelieve in God. I'm a very hardened realist. So nobody has even shown me or told me anything that ever convinced me that there was a God. I've never heard him talk or a promise of that, but if I look at nature, I have to believe that it wasn't a coincidence. So if you say there is no God, then you say that all of nature is a coincidence. The universe just happened by chance? I find that a bit hard to believe.

After death / You can only believe in life after death, if you know that there is a God. So I'm like a lot of other people: I'm just going to have to wait and see. However, I must admit that a couple times in my life, I have been subject to the presence—I've been subject to a phenomenon where I had to suspect that ghosts existed. So if I allow myself to believe that there is a ghost, then I have to believe in life after death. I've had a couple occurrences where it was so very obvious that there were spirits about. Just places I've been and things that happened, and for some reason, I've had this feeling or premonition or whatever—but I wasn't drunk. So, but suggested that there was spirits. That either was or wasn't, so I just leave it be, but at that time if you'd asked me if I thought that there was life after death, I would have probably said yes. Now I've had time to think about it, and I go back to the argument that I don't know. Time will tell.

Nico

Olga

Marie

Fernando

Stéphanie

WHAT DO YOU THINK HAPPENS AFTER DEATH?

Nico / *Lives in France*
Death doesn't exist, nothing ever dies, nothing! Even a sound does not die; it goes around the Earth indefinitely but it doesn't die, nothing ever dies. A shooting star is not a star that's dying but a star that is evolving, that's changing dimension.

Olga / *Lives in Ukraine*
Death comes whether you are afraid of it or not. No one escapes death. We live for the time that God allots us. It's no use being afraid. Dying in peace is a good death. You mustn't be afraid to die, but no one wants to die. The old have to die; what's sad is when the young die.

Fernando / *Lives in Buenos Aires, Argentina*
Death represents losses, lots of nightmares, and nostalgia. Death has been present in my life since my youth. I have had to live with the death of loved ones since my childhood. It's something I haven't gotten over yet nor properly absorbed. So death is constantly present. Very present. It's something very familiar for me.

Marie / *Lives in La Réunion, France*
Today I accept my own death and that of others. If I can offer something, I will be there for those who remain. That's something we don't know how to do any more. When someone dies, those remaining need support. The person who has died is gone, but those left behind don't know how to cope. To get to the point where I am now ... at the time it happened [death of her husband], I told myself that I had to accept what had happened, that I had to get over it and not continue to live in the past. It was my first reflex, of life, or survival, but I've seen so many people unable to get over a death that I said to myself, "No!, I have to get over it." We have to live our lives right to the end. And not live wrapped up in the life of the person who has passed on.

Stéphanie / *Lives in France*
The greatest test I have had to face was the death of my grandfather. I think that everyone experiences this one day or another. But it's a terrible wrench, it's a bit of yourself that is taken away. The dreadful abyss of the unknown opens up; your certainties are shattered. You're faced with the feeling of the deep injustice of existence. It's total helplessness, distress, vertigo. And it's also very beautiful at the same time, because it's all connected with the beyond, and that allows you to feel that it isn't only what you see that counts and that exists, but that we are caught up by something that is much greater than us, which for some is called death, by others the next world, and for yet others metempsychosis, renewal. We don't know, but in any case something that lies beyond human existence.

Fabrizio / *Lives in Italy*
What do I think happens after death? There are two possibilities. One, that there is nothing at all, but it's terrible to think that. It's a very serious possibility because all modern proof points in that direction. The second possibility is that there is something, justice, that there is heaven or hell, I don't know, but if it does exist, it will be very interesting to find out.

Amparo / *Lives in Spain*
To practicing Catholics, after death there is the Glory, where we think we'll go because we haven't been bad, but kind.

José / *Lives in Spain*
I don't know what happens after death, so I'm not bothered. I don't worry about it. I prefer and hope that there isn't anything, because eternity … the idea of eternity. … As Borges says, "the idea of eternity is far more terrible than the idea of death in itself."

Tono / *Lives in Spain*
I hope that there's something after death. Because all those people who act so badly, all those criminals who have killed thousands of people … would find themselves in the same place as someone who has devoted his or her life to doing good, who has dedicated his life to others? I think there must be something.

Hamideh / *Lives in Iran*
I think we'll find all the acts that we have performed on Earth there in the next world: They will return to us like an echo. Instead of speaking, it will be our arms and legs, all the limbs of our bodies, that will speak for us on all that we have done and said.

Salma / *Lives in Bangladesh*
What will the next world be like after death? I think a lot about that. I don't pray, I don't observe Ramadan—I can't. Perhaps I'll be burned in the next world. As we're unable to handle the suffering that exists in this world, how could we ever tolerate it there? I'm afraid of that.

As Borges says, "the idea of eternity is much more terrible than the idea of death in itself."

Hamideh

Amparo

Fabrizio

José

Salma

Tono

Sovichea

Jocelyn

Violette

Wayan

Joël

Saskia

Violette / *Lives in Lebanon*
No, there's nothing after death, nothing at all. Heaven and hell—it's all here, on Earth.

Jocelyn / *Lives in New Zealand*
I think we're like animals. When a cow dies in its field, the farmer comes, digs a hole, and places the cow in it. In my opinion, it's the same for us.

Sovichea / *Lives in Cambodia*
I think that nothing is left after death, like the flame of a candle. When you light it, it gives off light—it's like our body. When our body dies, it's like the last puff that extinguishes the flame. There's nothing more; all that's left to do is to throw away the candle. I don't think that anything lives on.

Joël / *Lives in Yunnan, China*
So we arrive here just to produce offspring and then afterward we disappear? If there's nothing to come, it's all very sad! So we have to believe in something. I think that the day I die … I've thought carefully what I'll say to the people around me. If I still have my faculties, I'll say, "Now I'm off on another adventure."

No, there's nothing after death, nothing at all. Heaven and hell—it's all here, on Earth.

Wayan / *Lives in Indonesia*
After death humans can't choose what will happen to them. It's God, Sang Hyang Drama Kawi, who chooses. That depends on their acts during their past life. If they've been good, they will enter heaven and will not be reincarnated, otherwise perhaps they will be reincarnated as a human being or, worse, as a plant or an animal.

Saskia / *Lives in Germany*
I had the impression that all my children already had their personalities—their souls—when they arrived in the world. They were not blank sheets of paper. Where does that come from, where did they get it from? I don't know. Perhaps it's because they were already in the world. I don't know if there's reincarnation—I don't know—but I'm sure that we'll find out what there is after death.

Myriam / *Lives in New Orleans*
I believe in reincarnation in a very strange way, in the sense that I know there are plenty of things in a body: There's zinc, and iron, and there's gold. And I think that when the body disintegrates, we go into the ground—we return to the ground. And perhaps afterward we come back as a tree, in a river, and afterward maybe that little bit of gold that's in me will be found by a pioneer, and maybe he'll make a ring out of it! I'll come back as a ring on someone's finger! I don't know, perhaps the calcium or magnesium will help a fruit tree to grow, and people will eat its fruit … I don't know. I think that this is how we get reincarnated. I don't believe in heaven, or hell, or purgatory, or anything else.

Kole / *Lives in Ethiopia*
When someone dies, we Hamers [a tribe] think there is nothing afterward. But the people of the town came to our village to explain to us that after death your soul goes to heaven. But we still believe that death is all there is.

Dulcie / *Lives in Australia*
Of course there's a life with Him. Some people believe it, others say no, we only live this life here. But they will be astonished when their soul reawakens! Why? Because we're very spiritual beings. This body is only an envelope. Inside us there's a spirit that will keep us alive. That's why we, an Aboriginal people, live in the world of the spirit— because we know that there's life after death, that's for sure. Some people say it isn't so. And then, when they finally leave their carnal envelope, they'll be amazed. "What! I'm still alive! So there's another life!"

Scott / *Lives in Ohio*
I know what happens after death! I've had three overdoses; I've died. The first time I left my body. Three hits of acid, vodka … I wanted to be like Jim Morrison—he's my hero—or like Bob Marley. And I died that night, it all went bad. I died! How did I know it? I was outside of my body, I was in the air, and there was a guy to my right, a black guy, who said, "Are you happy to be dead? Are you sure about that?" And I said to him, "No, pal, I don't want to be dead!" So he sent me back down to my body. That was the first time I died.

Tamara / *Lives in Siberia, Russia*
As God gave me the gift of clairvoyance and communication with the spirits, I think that our loved ones, after their death, live forever, but in another world, and they take care of those who are left on Earth.

I'll come back as a ring on someone's finger!

Scott

Dulcie

Myriam

Kole

Tamara

Luigi

Galina

Iosif

Nadeem

Angele

Immaculée

Galina / *Lives in Siberia, Russia*
I think that after death there'll be a sacred life in which I'll find my daughter again. Belief in this next life brought me peace after her death because I tell myself that I'll see her once more. When people say that there's nothing else after death, I don't believe them. I get angry, and I reply that it's not true. I say that there is another life because it's the only hope I have of seeing my daughter again.

Angelo / *Lives in Italy*
I think that after we die we start a new cycle, that there life continues. Once I was on a school trip to St Peter's Basilica in Rome—it was the first time I saw a very important statue: Michelangelo's Pietà. At that moment I was about fourteen or fifteen, and I thought, "How is it possible that this sublime statue is still here and that nothing remains of the thought and spirit of its creator?" I don't think that there's nothing after death.

Luigi / *Lives in Italy*
For me, after you die there's nothing apart from the memories of those who knew you and the remembrance of the things you did. It's for that reason that I chose my profession, that of university lecturer and researcher. I wanted to be able to leave something tangible: my books, my research, and the teachings I pass on to my students.

Iosif / *Lives in Moscow, Russia*
I don't know what happens after we die, but the one thing I would like is that those close to me don't forget me. That my children, wife, and grandchildren visit my grave, and that they say hello and goodbye to me.

Nadeem / *Lives in Pakistan*
The thought of death gives me a greater desire to live. The older I get, the more I think about it. If you don't think of anything but death, you can't really experience things fully. Life is not infinite. Our time here is limited. The more aware I am of death, the more I want to experience things intensely. That's important.

Immaculée / *Lives in Rwanda*
Given that I'm not dead, I think that after death there is no reason for me not to hold out the hope that there will be a better life to come, but at the same time my children live happily because I'm still here. There's no reason for me to think of bad things while I'm still alive. I think of the near future, what's to come, and as I'm still alive, it's to the world of the living that I turn.

The thought of death gives me a greater desire to live.

Raatiraore

Lives in Tahiti, French Polynesia

Words are no longer golden. Today, try hard to make your words golden!

Background / Raatiraore. My first name, Raatiraore, literally means "no chief." But if you look at it another way, it becomes "equality." I'm fifty.

Family / I've had twenty-four children in my life. Seventeen are mine, but that didn't stop me from adopting seven others. If I had to start over, I'd have forty-eight. I wanted to have children without being their "owner." They are the owners of their future, not me! I'm only their parent. In fact, when I see them, I call them "my spermatozoa." For me family is first and foremost about being responsible for one's children. When you have children, you have to be authoritarian. Authoritarian about what? About real life! That's family! And not about being treated like sardines in today's society! People are like sardines: They're jam-packed and stressed. It's awful to see them! With my twenty-four children it's as though they weren't my children anymore. I'm free, I'm living my second youth. Therefore family one day, and another it is just myself, my job, and my friends. Children have to become friends and no longer children.

Ordeal / The hardest thing in my life is to survive. When I was twelve, I heard the doctor say that I only had three months to live. Today I'm fifty, he [the doctor] is dead. I've already been to piss on his grave.

Success in life / It's having survived a death sentence. At the time I wasn't even a teenager, I had all my youth ahead of me ... and to die in three months. What a thought! So I lived life differently. I forgot the sickness. That became something different than a sickness: something I had to fight against. It was that or die. Over the years I tried to find out what had happened. Then I understood it was because of the bombs. I was just a kid and, while the rest of the population had to go inside, I stayed outside to work in the faapu, the kitchen garden, or to feed the pigs. So it was completely normal

299

and logical: I must have absorbed a few specks of the radioactivity. I had to fight, and I often say to those who suffer from the same thing, "Only you can make yourself better. No one else. Your attitude, your way of seeing things. . . . It's everything."

Crying / Cry? When I cry, it's never because I'm sad. On the contrary, I laugh when I'm sad, and I cry with happiness! And when I cry, it's really for joy. The last time I cried for joy was a week ago. I cleaned up a youngster who'd spent seven months living in filth. I was able to wash him, clean him. And after, when I saw his beaming smile, when he looked at himself, dressed, hair washed and brushed, with a completely new look, and he didn't even recognize himself in the mirror . . . I burst out laughing, and I cried . . . with joy!

Laughing / It was one day on Bora Bora. I was on a small dinghy. There were four of us: a Japanese, small Buddha, two pretty Tahitian women, and me. The boat had a tiny six-horsepower motor, so we weren't going very fast; it was hot. All of a sudden, I jumped in the water, and the Japanese did the same. But when we had to get him back in the boat . . . he was like a hippopotamus! Half an hour later, I let him follow me in the current, but then, at a certain moment, I shouted out, "There are sharks!" I saw him swim and jump up in the boat as light as a dragonfly! Ah yes! Whenever I think of him or of any Japanese, I start laughing!

Money / Money can be the reward for success. For those who want, who work, I say: The reward for work can be money. Before, my forefathers used to barter. And then the whites arrived, and that's when we saw money. Now we're deep in it. So you have to have money. Everything is bought and sold: There's even a song about it. So today you've got to have money. But first, you have to slog your guts out. You have to make your money by the sweat of your brow. You shouldn't steal someone else's! Money must be clean. Money is simply the reward for your work.

Poverty / Poverty? Maybe I'm mean, but I think there are plenty of bone-idle people who prefer to accept handouts. Personally, I weave coconut fiber. I don't need anything more than coconut fiber to live well. When I say "live well," you have to understand that before I chose this job I sat down and thought carefully about it. I mean that I considered whether what I would do would give me what I wanted—by which I mean, if it could meet my needs. It's only coconut fiber, but coconut fiber allows me to live decently.

Progress / Progress just now? If that's what stresses folks out, thanks, but no thanks! That's not my thing at all. Frankly, progress . . . screws you up completely. It's stupid! But progress . . . you only have to push a button to have what you want, so progress certainly has some benefits. But if it's going to stress people, no thanks! Not for me! And then, me being Polynesian. When I see that in the motherland [France], which

for us is the metropolis—it took three centuries for progress to arrive! And me, I've only been alive for half a century! You really have to swim against the current the same way they did. It's the pits! Progress ... I've come to realize that all you have to do is understand ... everything that's written in all languages. So progress is the ability to speak the languages of the Frenchman, the German, the Briton, and when you know their language, you know what they're talking about. So, for me, progress is to be able to follow their stress without stress! That's why I took up weaving, so I would never have to get stressed in this era of progress!

God / When I was a child, God only existed when we were at the table. We had to pray. And then we didn't ask ourselves too many questions. We said a prayer; it was a habit. Little by little, at the age of fifteen, I entered a temple for the first time. It's there that I saw that there was a God, and I even followed the scriptures. And I realized that those who followed Him were doing just the opposite of the God they worshiped. So I quit that religion to enter another one. Later, I understood that the real religion, when you look, is not to say the name of God. Why? Because as we are only human beings, we are not worthy to do so. So, in my opinion, God doesn't exist, but something exists that has no name.

After death / After death, if you want, comes the life of the spirit. Why? Because with regard to the beliefs of my ancestors, the spirit exists: the Mana. The spiritual Mana, the Mana that comes from Rao Nui, that is to say that God whose name we cannot mention. He exists. So for me, when we die. ... I had an accident. ... I left for the other side, and I came back. And I didn't want to come back to this world. So when I had to return to this earthly body ... yuk! I had the feeling I was returning to a cesspool. But I had no choice! Death isn't the end. On the contrary, I'm anxious to die. I don't want to commit suicide, not at all! But I'd be happy to die naturally. I'm eager to die—though I'm going to make the most of life while I'm human—because life is better when you're a spirit. I know, I can tell you because I experienced it.

Poem / I've traveled right round the world. And I've noticed that it's like the sand on the beach, it's all disintegrating and my knees bent, at Rurutu, before Tunua Toho No He.

Message / Me? A message for the planet? They used to tap us on the fingers: be polite ... courtesy ... love. And then I realized that all those who came and destroyed what my forefathers used to observe don't even practice anymore today! Why? Because words are no longer golden [considered binding]. Today, try hard to make your words golden! And in addition words must be written down. Because when you promise something, your words should be sacred! So my message is to all politicians: "When you make your policies, your words should be golden! OK?"

Yovana

Sembal

Danielle

Carolyn

Cristel

WHAT WOULD YOU LIKE TO SAY TO THE INHABITANTS OF THE PLANET?

Danielle / *Lives in France*
I think that, so that my message can also be understood by all those who don't speak French, I'll do it like this: [see photo].

Yovana / *Lives in Bolivia*
I'd like to know if people are as complicated as me, because I'm very complicated. Are the people who live elsewhere on this planet like that too, or is it just me?

Cristel / *Lives in the Netherlands*
A very, very simple message: I'd very much like people to dance a little more. Not just in the places where you're supposed to dance, but also in the streets, the shops, at work, in the office. Do a little pirouette as you walk toward the door; it's great to see people move. Above all Dutch men—they really should dance more.

Sembal / *Lives in Ethiopia*
I want women to understand that we really must take our lives into our own hands. We don't have to wait for our rights to be given to us, only that they should be recognized. We have these rights! To protect them, we must be strong. Be strong and independent, and at the same time we must not forget to pay attention to others.

Carolyn / *Lives in Great Britain*
In my wildest dream, I have this idea that all the women of the world will mobilize themselves, whether they are under the thumb of the Taliban, their husbands, themselves, their personal history. That each one will rise up and say, "Enough! Let's try something different! Let's try the path of peace and acceptance, let's see to it that all medical treatment for AIDS is free, let's try to be vegetarian for a whole year, and let's see what happens." I have a whole list of things, and I think that that's what I would ask. I'd ask all the women of the world to stand up and say together, in a strong, steady voice, without screaming, without shouting, without fighting, "That's enough. We have to do things differently, so let's try something else!"

I want women to understand that we really must take our lives into our own hands.

Herminia / *Lives in Bolivia*

I'd like to send a message to the mothers and fathers who suffer from violence. I have lived through this experience, this awful experience. I have known three types of violence, so I send this message to my children. I tell them, "No more violence! Enough abuse and injustice! It has to end with you my children, so let your father be the last. You, you're another generation, that's enough now. Let violence end right here!"

Ionel / *Lives in Romania*

What could I say to others that has something to do with my life? That I struggled to go to high school, that I struggled in the tunnels of the coal mine in Petrila. To make something happen, you have to dream. Down there, in the dark tunnels, I thought of the light that gives warmth, and we managed to create a cultural association. It wasn't simple, it wasn't easy—there were lots of hold-ups, but each one of us can succeed if we think of ourselves as a long-distance runner and have a motto like, "Don't be afraid to go slowly, but don't allow yourself to stop. Always dream, always fight, and struggle to make your dreams come true."

Bjorn / *Lives in Sweden*

Everything is possible: Remember that and believe it. Keep love in your heart and remember that everything is possible. I smashed my skull—I was living in New York, I was always in a rush, I lived life to the full, I lived like the people you see in films on New York. I ran in all directions, I ran to the agents, I ran everywhere, I got myself knocked down by a car. I had multiple fractures, and I fell into a coma. Everyone was saying to me, "You'll never be able to walk again, you'll never be able to do simple things alone, you'll need help to dress for the rest of your life." I didn't listen because right from the start I knew that everything was possible. When someone said to me, "Today, Bjorn, you're going to learn to go down the stairs without holding onto the handrail," I had already practiced in secret for two or three weeks. People have always told me I'm so pig-headed that I'm difficult to be around, but sometimes it's an advantage to be stubborn. Believe in yourself, believe in life.

Zohreh / *Lives in Los Angeles*

Live as though you were living the last day of your life. As the Sufi poet Rumi said, "There is only the present, the past is gone, the future is undefined—there is only the present." Make the most of each moment, as though you were going to die tomorrow.

Inoussou Asséréou / *Lives in Benin*

What I would like to add is that, beyond whatever you are searching for as an individual, we must have a communion of human beings on the Earth. There must be more love between people regardless of the color of their skin. History is history, and if we study it, we see we are all one. You're white, it's just circumstantial, a color due to migration. Humanity must know that we are one race, insofar as we are

Herminia

Bjorn

Zohreh

Ionel

Inoussou Asséréou

Mohamad

Tarek

Andrew

Rodrigo

all human beings on the planet. The color of our skin is simply a climatic phenomenon. What can we do to safeguard the human race? That's our most important task, and all civilization that does not fight to do so will be a prey to ideology.

Mohamad / *Lives in Iran*
I would love to send a message to the president of the United States. A message to your president as well as to my president: that they will use their power to open a path that will benefit all people and not to repress or make people disappear. What fault has an African child committed? That of being born in Africa? It's God who wanted that child to be born there. I might have been born in the United States, then I would be an American citizen, or perhaps in your country! That's why you have to consider all humans as equal.

Tarek / *Lives in Egypt*
Take me, please. Accept me, please. Love me, please. I can't cope all alone! Between the ages of eighteen and twenty, I thought I could live in the desert, live in paradise, sheltered from others, with nobody else. That was about sixteen years ago. At present I couldn't imagine living without social contact. These social relations are filled with tears, frustration, disappointment, longing, war, hate, racism, discrimination, cruel individuals,

everything. I beg you, take me. You see this face: I only need to shave off my beard—I should show you photos of myself. You'll even recognize me without the beard, moustache, and dirty hair. But I'm the same moody person. Please take me as your human brother. Invite me to drink a coffee with you or a good meal. And I will do the same.

Do you feel you're a member of the human race?

Rodrigo / *Lives in Spain*
Do you feel you are a member of the human race? If yes, do you feel we are brothers? And if you feel you are my brother, do you love me? My answer to that question is: I love you.

Andrew / *Lives in France*
Listen carefully: Follow your dreams, fill your head with good memories, live your life, live each day. Go and see your friends, tell them you care about them, and show them you mean it by your actions. Show people that you're there. Show them that you're present. The rest is of no importance!

Sanubabu / *Lives in Nepal*
I would like to send a message
to Bina, who lives in France [her
daughter was adopted in France]. I
hope that she is as happy as can be,
that Alexandre is resting in peace,
and I hope that she will come to
Nepal from time to time. That's
my message.

Fatima / *Lives in Chechnya*
I would like to say to people not to
judge me when they hear me or see
me! Probably I seem very mournful,
but it's the war that has made me so
gloomy. I would love to smile with all
my heart; sometimes the fact that I
can't gives me pain. I'd so much like
to be happy, but I'm not, and I don't
wish that any woman, any individual,
live through what we have known,
what I have personally experienced. I
would like to say to people that they
have to love and respect each other,
and that they must always ensure that
there is no more war anywhere, ever.

Yannis / *Lives in New York*
I'd like to ask, "Why do people make
war?" For me the message is, "Leave
us, me and my war photographer col-
leagues; let us become unemployed.
We'll find another job, that's for sure!"

Yehuda / *Lives in Israel*
A message in particular for the
Palestinians? That's something
very hard for me, I know how they
have to live. The Palestinians are
the people who pay the highest
price for what goes on here without
being responsible, without having
chosen this outcome. Nobody asks
them what they want. Their leaders
have always dictated their conduct.
The proof of that is that the leaders
have gone as far as killing their own
people. During the riots of 1936, they
killed more Arabs than Jews. Each
Arab who had a little money or who
thought that coexistence between
Arabs and Jews was possible was
forced to leave the country. You can't
talk to those people because they
shoot at each other. That's why my
heart goes out to them. I know some
people among them who are so truly
humanist that anyone who meets
them should take off his hat to them.
They're very humanist, but who lis-
tens to them when the leaders put a
rifle in your hands and tell you what
to do? Today in Gaza they commit
massacres amongst their own people.
What can I say to them? That I wish
they would do something? They'll be
shot at if they say anything. I don't
know what to say to them.

I would like to say to people not to judge me.

Sanubabu

Fatima

Yehuda

anis

Nasser

Amal

Olga

Nasser / *Lives in the Palestinian Territories*
This is the message I would like to give to an Israeli: "As an Israeli, it's essential that you know what the Palestinian people suffer and understand what the Palestinian people endure. You should mix with the Palestinians to know what they go through. As long as you watch only Israeli television, the information that it gives you is poisoned. Poisoned information! You have to open yourself up more and know how to be reconciled with the Palestinians, spend moments in their company, interest yourself in their ideas, and communicate your own to them. It's through thoughts and mutual discussion of the misery suffered that we can find a middle ground of understanding that will bring us together, for the good of our children and yours." We Palestinians are asking for peace. We ask for peace, nothing more. We don't want to kill Jews. We, the Palestinian people, ask and demand to live in peace beside the State of Israel.

Olga / *Lives in Ukraine*
The world has learned. People have to travel. People have to know how other people live and what their needs are.

Amal / *Lives in Yemen*
I would just like to ask one question: Are we satisfied with the current situation on our planet? In the Muslim countries? In other countries? Are we always going to remain like we are today, without moving, just looking at things they way they are, without having contact between each other, just because of fear? Nobody says to himself that this fear is going to threaten our children in the years to come. Nobody thinks of what is waiting for them in the years to come. It's a question but a message at the same time. I hope the world will pay attention.

Are we satisfied with the current situation on our planet?

WHAT ANSWERS

Take part in the 6 Billion Others project by replying to

The interview begins with a general introduction in which the person gives his or her name, age, profession, family situation, and nationality. Then there are a series of questions:

What is your job? Do you like it?

What does family mean to you?

What would you like to hand on to your children?

What did you learn from your parents?

What subject is difficult to talk about to one's children? To one's family?

What gives you greatest joy?

What is your greatest fear?

What makes you most angry?

What did you dream about when you were a child?

What is your greatest dream today?

What have you renounced in your life?

Are you happy? What is happiness for you?

What would you like to change in your life?

What does love mean to you?

Do you think you give and receive enough love?

What was the last belly laugh you enjoyed?

When was the last time you cried? Why?

What was the most difficult ordeal you have had to face in your life?

What did you learn from it?

Do you have any enemies? Why?

For what reason would you be ready to kill someone?

For what reason would you be ready to give your life?

Do you forgive others easily? What would you not be able to forgive?

WOULD YOU GIVE?

the questionnaire on the site: www.6billionothers.org.

Do you feel free?

What could you not do without in your everyday life?

Do you love your country?

Have you ever wanted to leave your country? Why?

What does nature represent to you?

Have you seen nature change since your childhood?

What do you do to preserve it?

Do you live better than your parents? Why?

What does money mean to you? Why?

What is progress for you, and what do you expect from it?

What is man's greatest enemy? What is man's greatest friend?

Why do people make war?

What can we do to lessen the incidence of war?

Do you give an account of your thoughts and actions to God every day?

What do you think happens after death?

Do you know a prayer? Can you say it for me?

What do you think is the meaning of life?

What would you like to say to or what questions would you like to ask the people who will watch you?

What is your favorite song? Can you sing it for us?

What do you think of this interview, this exchange?

What do you think is its purpose?

Would you like to add something to finish?

BEHIND THE SCENES
In pictures

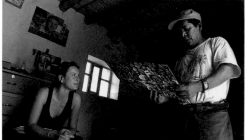

In Mali and Bolivia, the mosaic of faces filmed around the world is the best way to explain the 6 Billion Others project. The diversity of the faces very often astonishes and amuses those approached.

Each meeting is handled differently, whether improvised or prepared, often with the help of the interpreter and the production team in Paris. Here, Isabelle's interpreter, a school mistress in an Indian village two hours by road from Potosí, has just introduced her to Patricio, a farmer, to whom she is explaining the project with the help of the face mosaic. (Bolivia)

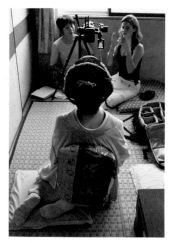

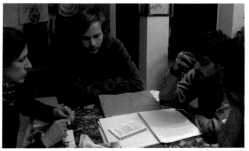

After a first day of interviews, Baptiste and Sibylle review all the questions with their interpreters to find the most accurate translations. (Pakistan)

Accompanied by Yoko in a hanamachi (geisha district), Isabelle has met Sachiko in her okiya (a geisha house). Sachiko accepted the interview without a problem: for once, she was the center of attention! (Japan)

OF 6 BILLION OTHERS

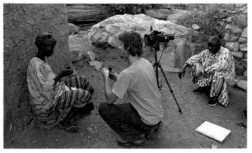

Nicolas arrives in a Dogon village. The conversation gets under way with a few words. Saïdou takes over to translate and explain why Nicolas has visited the village. Distrustful, Aïssata doesn't seem to want to reply to questions and be filmed. Having arrived in the village, she disappears into her house without a word. Ten minutes later she reappears, dressed in a new boubou and a new turban. She is ready: "When does the interview begin?" (Mali)

Close cooperation with the interpreter is essential. Feelings pass between the three people through looks and words, and the speed of translation is crucial to keep the conversation alive. (China)

Before beginning the interview with He Zhe Hua, not far from Lijiang, Chloé adjusts the camera's colorimetric controls by filming a white sheet of paper to calibrate the white balance. (China)

Hussein has taken Baptiste to a village an hour from Lahore where he knows a family of farmers. Unlike interviews in which intimacy is sought after, here it is a cooperative venture! Mohammed prefers to speak surrounded by his family to give him confidence. Silence is in short supply: Everyone reacts, jokes, and wants to participate! (Pakistan)

The interview at Salfiyt, in the Palestinian Territories, is held between Hani's house and the separation wall. Médecins du Monde is sometimes a valuable go-between and facilitates our meetings. Here a Palestinian coordinator for the NGO introduces Hani to Sibylle and provides the translation. (Palestinian Territories)

Dominique has just finished his interview with Valeri, a fisherman who lives on Olkhon Island in Lake Baïkal. Whereas only the face is filmed during the interview, the last shot is always a full-length portrait. (Russia)

After several days shooting, Nicolas and Sibylle spend a few days at Gargando, north of Timbuktu, with Intagrist's family. In the evenings the "first view" session begins, in which they listen again to the recordings to select the answers to keep. Nicolas is working with the third interpreter since the start of the trip! After those that spoke Peul and Dogon, Abdallah translates from Tamasheq, the language of the Tuareg.

Isabelle completes all her translations the day before her departure as it will be difficult to find a translator from Quechua in Paris. (Bolivia)

Next, the teams return to Paris where they complete their translations. The editing team (Solveig, Sabrina, Véronique, Romain, Emmanuelle, Anny) examine the interviews and take over from the interviewers. Then the production team (Anne-Laure, Florent, Claire, Florian) prepare the forthcoming shooting trips.

THEY FILMED, EDITED, STANDARDIZED, PREPARED, TRANSLATED, CORRECTED, ETC.

THE TEAM OF 6 BILLION OTHERS

Alexa / Nicolas / Anne-Laure / Emmanuelle / Ulla / Baptiste / Camille / Chloé / Christophe / Claire / Dominique / Anaïs / Estelle / Florent / Florian / Galitt / Giorgio / Inta / Isa / Juan / Julian / Juliette / Manu / Michel / Nico / Anne / Yann / Pierrick / Romain / Sabrina / Sibylle / Solveig / Solveig / Pierre / Véronique / Fanny / Virgile / Willfried / Anny / Thomas

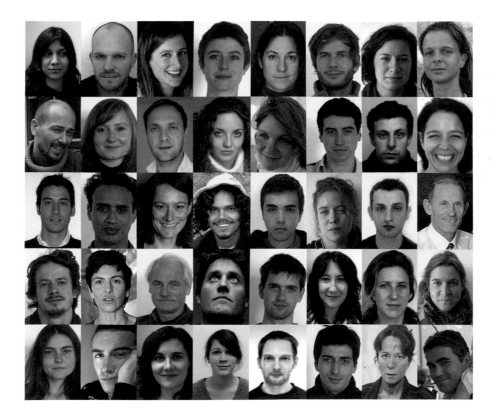